The Moon Landings

One Giant Leap

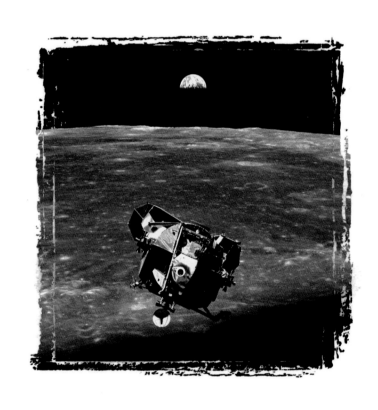

Publisher and Creative Director: Nick Wells
Commissioning Editor: Polly Prior
Senior Project Editor: Josie Mitchell
Picture Research: Taylor Bentley
Art Director & Layout Design: Mike Spender
Digital Design and Production: Chris Herbert
Copy Editor: Ramona Lamport
Proofreader: Dawn Laker
Indexer: Helen Snaith

FLAME TREE PUBLISHING
6 Melbray Mews
Fulham, London SW6 3NS
United Kingdom

www.flametreepublishing.com

First published 2019

19 21 23 22 20
1 3 5 7 9 10 8 6 4 2

© 2019 Flame Tree Publishing Ltd

Image Credits: Courtesy of **Getty Images** and © the following: 8 Science & Society Picture Library; 13 STF/AFP; 15, 50 Photo12/UIG ; 16tr Oxford Science Archive/Print Collector; 16–17 Roger Viollet; 19 H. Armstrong Roberts/ClassicStock; 20i, 22, 31, 59, 79, 83, 85tr, 85br, 86, 87, 88, 180 Sovfoto/UIG; 21, 37, 58, 61, 64, 81, 109, 110, 199 Bettman; 23, 52, 186 Universal History Archive/UIG; 26 Underwood Archives; 30 Jim McDivitt/NASA/Roger Ressmeyer/Corbis/VCG; 41, 106–107 & back cover, 132, 135 NASA/Corbis; 46 Brian Skerry ; 66, 116, 117 Rolls Press/Popperfoto; 72 Nnehring; 89 Sergei Savostyanov/TASS; 100 Ralph Morse/The LIFE Picture Collection; 112, 113tl Space Frontiers / Stringer; 121, 126 Otis Imboden/National Geographic; 128 VCG Wilson/Corbis; 130tr NASA/ullstein bild ; 145 Lee Balterman/The LIFE Picture Collection; 153 AFP/Stringer; 165 Visual China Group; 175 Charles Payne/NY Daily News Archive; 174 Santi Visalli; 177 Pat Carroll/NY Daily News Archive ; 178 Robert B. Goodman/National Geographic; 182 China National Space Administration/China News Service/VCG; 184tr ADRIAN DENNIS/AFP; 183 GENE BLEVINS/AFP; 185 ROBYN BECK/AFP; 184l Mark Brake / Stringer; 187 Chip Somodevilla / Staff. Courtesy of **NASA**: 1 & 139 & front cover, 3 & 159, 4, 6, 24, 25, 28, 29, 40, 44, 48i, 49, 49i, 51, 54, 55, 56, 60, 62, 63, 67, 70, 73, 75, 76, 77, 91, 92 93, 94, 95, 96, 97, 98, 99, 101, 102, 103, 104, 105, 108, 114 & 192, 115tl, 115tr, 118, 120, 123, 127, 129, 130tl, 133, 134, 136, 137, 140, 142, 143, 144, 146, 147, 149, 150, 151, 152, 154–155, 157, 158, 164, 167, 168bl, 168br, 171, 172, 173, 176, 181, 188, 189; and the following: 36, 42 Bob Nye; 57 Bill Ingalls; 160–161 Jeff Williams; 169 Jack Fischer; 170 Scott Kelly. Courtesy of **Shutterstock** and © the following: 10–11 TuiPhotoEngineer; 53 shaineast; 162 John D Sirlin. Courtesy of **SuperStock** and © the following: 7, 34 World History Archive; 9 Image Source; 18 4X5 Collection; 38 Science Photo Library; 43, 68–69, 74, 84, 113tr, 124, 131, 148 NASA; 45 Ian Cuming/Ikon Images; 47, 141, 166 Stocktrek Images; 78 Universal Images; 80 Interfoto; 82 Science and Society; 90 Pete Vazquez Photography; 138 fototeca gilardi/Marka; 179 marka/eps/Marka. Courtesy of **Topfoto** and © the following: 14 Granger, NYC; 65 ITAR-TASS.

ISBN: 978-1-78755-302-6

Printed in China

The Moon Landings
One Giant Leap

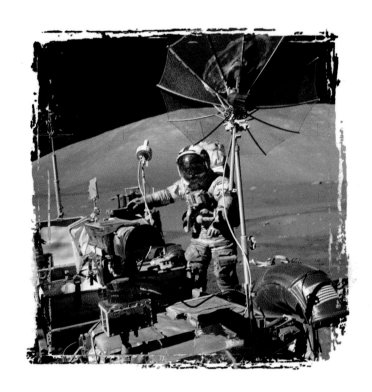

Colin Salter

FLAME TREE
PUBLISHING

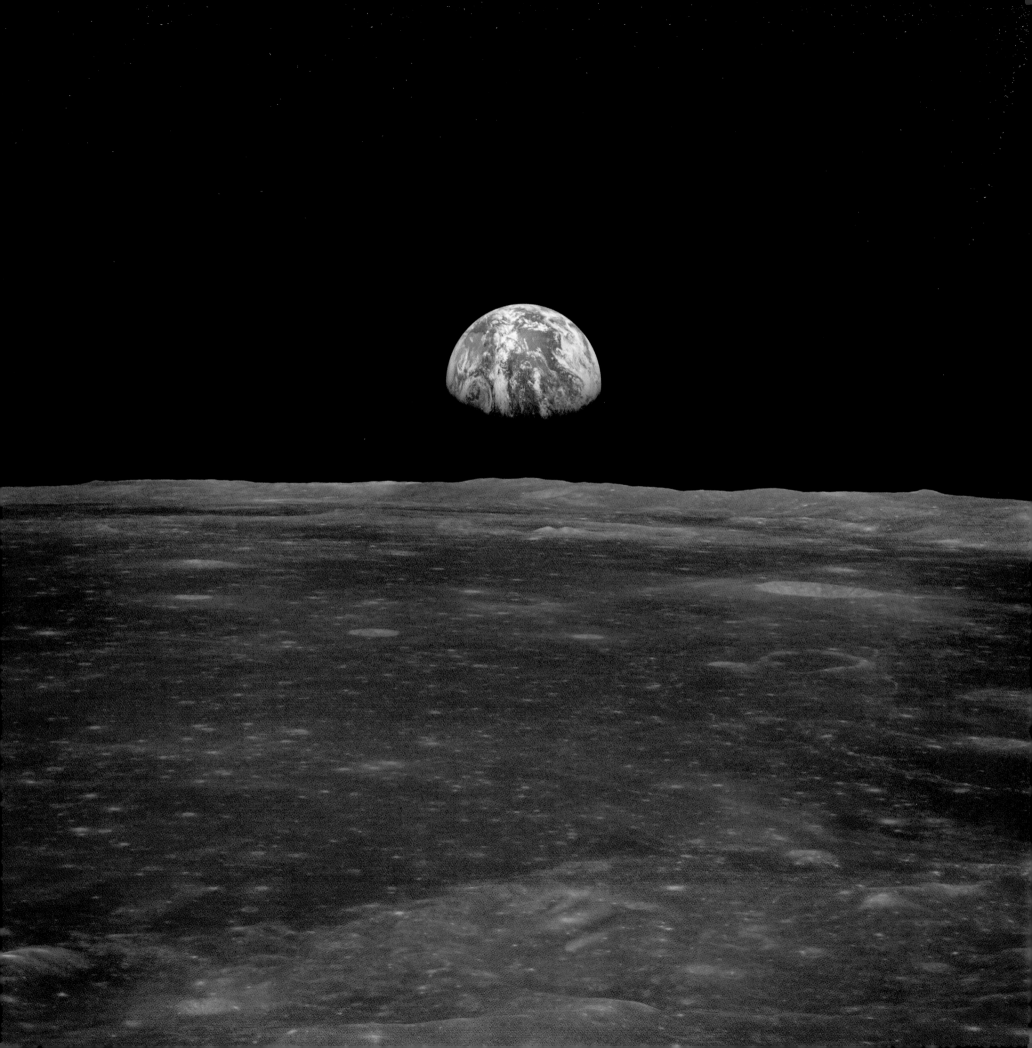

Contents

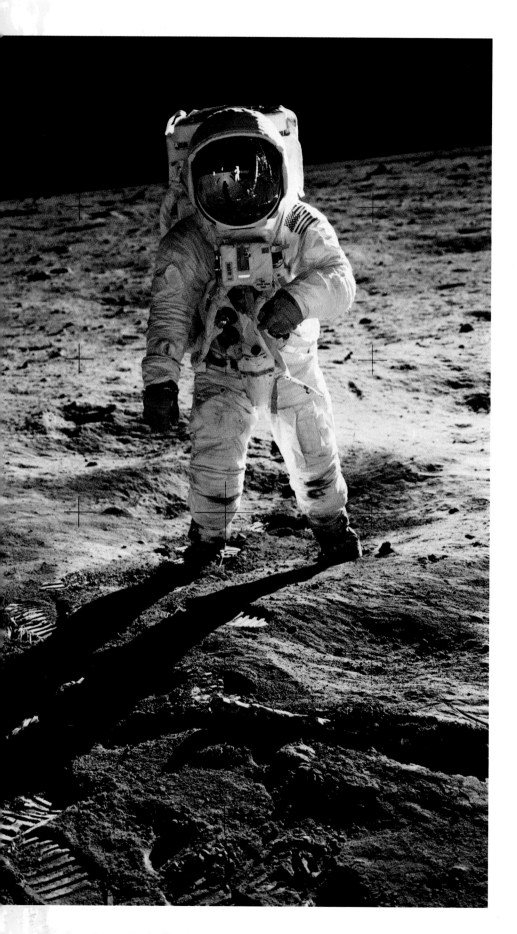

Introduction

Even now, 50 years after Apollo 11 landed two men on the lunar surface, the Moon remains a magical object in the night sky. The changes in its appearance help us chart the passage of each month and its regulation of the tides measures the quarters of each day. On a clear starry night, the full moon is a wondrous yet reassuring sight. It has exerted a strong pull on our imaginations throughout human history.

Near and Yet So Far

Neolithic Man positioned and designed his greatest monuments in relation to the Sun and the Moon, two otherworldly influences on the lives of early humans. The patient observation of their annual movements in order to align stone avenues and circles towards them was perhaps mankind's first scientific study. Two-and-a-half thousand years ago, astronomers in Babylon and China were able to predict solar and lunar eclipses.

The Roman mathematician Ptolemy fairly accurately calculated the diameter and its distance from the Earth in the first century AD, and in 1609, Galileo Galilei drew the first detailed sketches of its phases from his observations through a telescope. American astronomer William Bond took the first photograph of the Moon through a telescope in 1849.

The early superstitious worship of the Moon was based on its genuine influence on the world we live in, and the more we observed of the heavens, the more the Moon became part of the broader study and superstition of the cosmos, as astrology. The separation of astrology from the more scientific subject of astronomy is a relatively recent event.

Left: Apollo 11 Astronaut Edward 'Buzz' Aldrin on the surface of the Moon. Neil Armstrong's reflection can be seen in Aldrin's visor

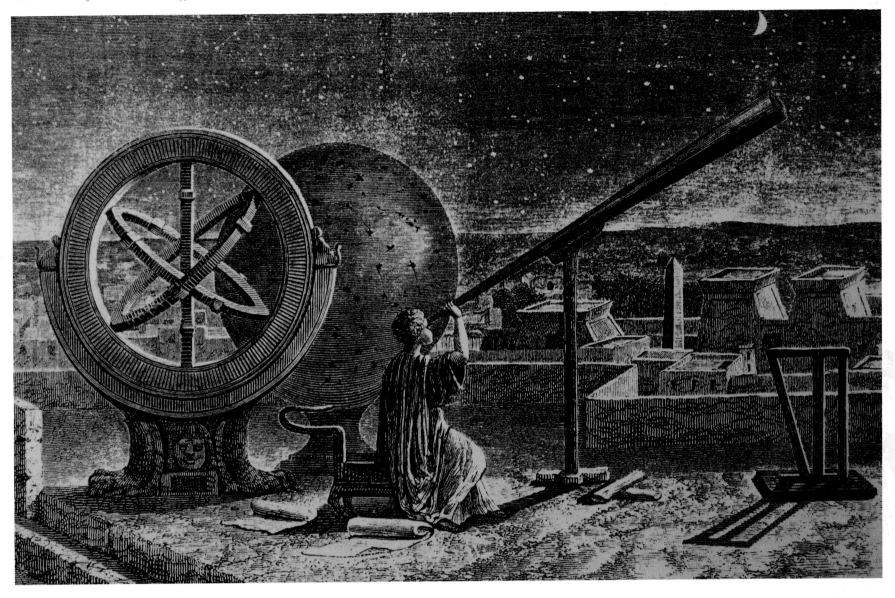

The Moon, Madmen, Merriment and Maternity

The Moon has not always been seen as beneficial. A mooncalf was a bovine stillbirth deformed by the influence of the Moon. Dogs apparently howling at the Moon gave rise to tales of werewolves and human madness – the word 'lunatic' is derived from *Luna*, the Latin for 'moon'. Even today, there are those who see a connection between the lunar cycle and, for example, the occurrence of seizures.

A perceived connection between the Moon and the menstrual cycle led the ancients to believe that women were more fertile during the full moon, and that childbirth was more likely at that time. Perhaps this is why in China it is considered unlucky to sleep in direct moonlight.

The Harvest Moon, the full moon nearest the autumn equinox, was considered a particularly provident one. It appears larger than other full moons because of its proximity to our planet, and its light gives farmers a longer day in which to harvest their crops. A completed harvest associated with this moon is still

grounds for a party. The Moon's time, the night, is a time for both gloomy solitary contemplation and darkness-dispelling communal festivity.

Lunar Ambitions

For most of mankind's history, travelling to the Moon was never seriously considered. Such early references in literature that survive – for example, the tenth-century Japanese story *The Tale of the Bamboo Cutter* – are tales of fantasy and imagination. In 1865, Jules Verne sent the protagonist of his novel *Journey to the Moon* to the lunar surface via a huge cannon. It may have been the first time that practical consideration was given to the means of space travel.

From then on, it was more or less a matter of making a big enough rocket. But what would astronauts find when they got there? Although the first unmanned close observations of the Moon were still 100 years away, scientists in the nineteenth century were able to produce remarkably accurate studies of the Moon's landscape. In 1836, German astronomers Wilhelm Beer and Johann Heinrich Mädler published their *Mappa Selenographica* – *Selene* being the Ancient Greek word for the Moon, from which we get the female name Selena.

The *Mappa* included the heights of Moon mountains, measured as mathematically accurate as observation from Earth would allow. Further observations towards the end of the century concluded that the craters on the surface were not volcanic eruptions from within the Moon but collisions from without. By the beginning of the twentieth century, the scientific discipline of lunar geology was a serious study.

The Space Race

When the USSR stole an unexpected lead over the USA by launching Sputnik, the world's first satellite, it was an embarrassing blow to the pride of the American psyche. In retrospect, it seems to have been an easy matter for NASA (National Aeronautical and Space Administration), created after

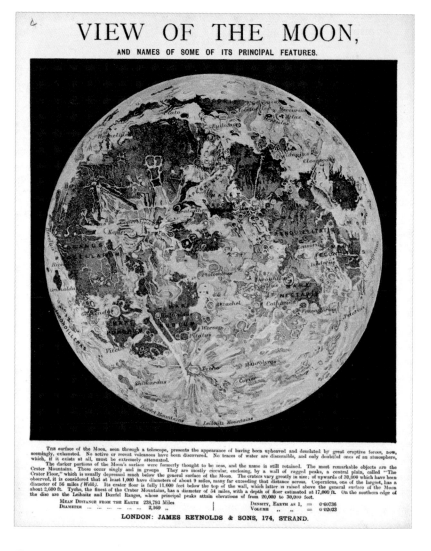

Above: A teaching card depicting the features of the Moon, published around 1850

Sputnik's flight, to catch up and overtake the Soviet space effort. However, the contribution of the USSR to the exploration of space should not be underestimated. It pioneered manned space flight and spacewalks, and the country's lunar probes led the way with the first hard and soft landings – deliberate crashes and careful touchdowns – on the Moon.

Nevertheless, a series of setbacks and political changes in the USSR in the mid-1960s gave the US the time it needed to pull ahead. The incremental ambitions of successive launches gave NASA the know-how and the confidence to attempt the previously unimaginable: to put a human on the Moon and bring him back safely.

Neil Armstrong's first small step on lunar dust on 20 July 1969 was – and remains – the greatest achievement of human endeavour in the history of our species. There have been many milestones during mankind's history, including, amongst others, the invention of the wheel, of language or print, and there have been scientific advances since the day man first stepped on to the Moon, but the combined effort of thousands of men and women of all nationalities to make that one small step possible has never been equalled. As President Nixon told the crew of Apollo 11 after their splashdown in the Pacific Ocean, their achievement had drawn the world closer together than ever before.

What Next?

Apollo 11 and the five Moon landings that followed it inspired a generation. The individual bravery of the astronauts and the collective effort that made their flights possible made us reconsider what human beings are capable of.

Jeff Bezos, for example, never forgot watching the Apollo 11 landing on television as a five year old. It taught him tenacity, and drove the success of his online trading company Amazon. In 2000, he founded Blue Origin, one of the companies now planning low-cost human spaceflight. And in 2013, he took it upon himself to recover from the depths of the Atlantic Ocean the rockets which launched Apollo 11. Others, including Virgin's Richard Branson and SpaceX's Elon Musk, have been similarly inspired.

In 1919, mankind's greatest achievement was the ratification of peace at Versailles after the end of the 'war to end war', as H.G. Wells optimistically described the First World War in 1914. Fifty years later, building on the technical developments of later wars, we landed a human on the Moon. It is such a short period in the timeline of human history, but a lot can happen in that time. Who knows where we will be in 2069?

Right: A SpaceX Falcon 9 rocket above Cape Canaveral, FL, carrying a Dragon cargo ship bound for the International Space Station.

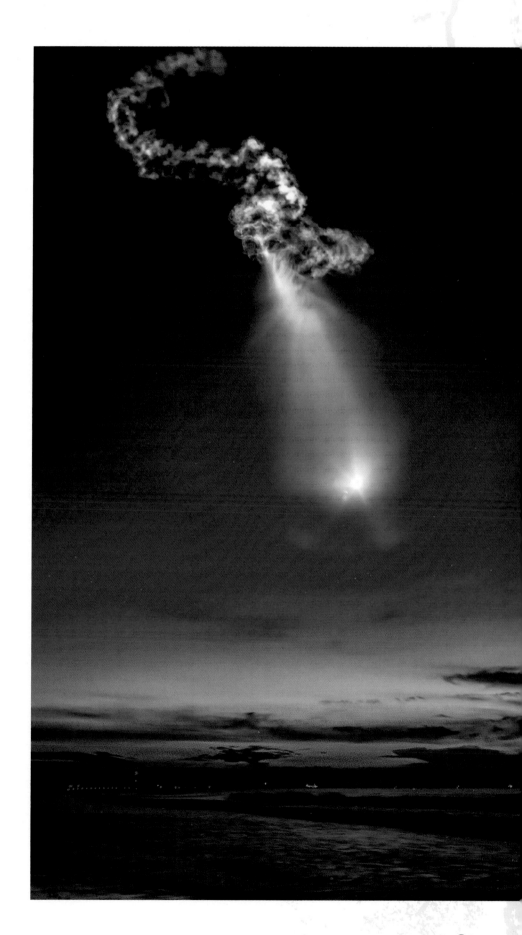

The Race into Space

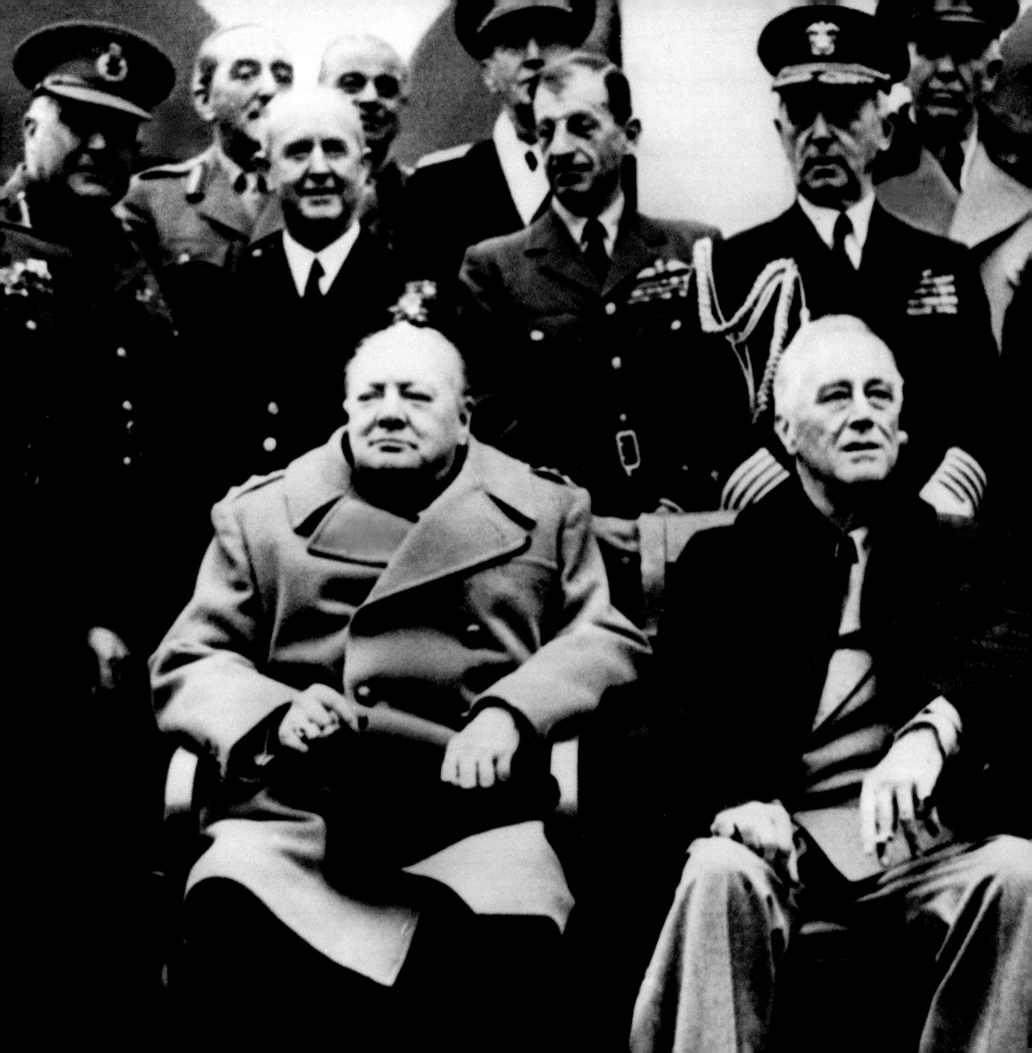

Approaching the Start Line

When did we first start to think about going to the Moon? When did all those celestial bodies stop being mere magical lights in the sky and start being places that we might one day visit? When did it become a race rather than a collective human endeavour?

Although the USA and the USSR were allies during the Second World War, they were united against a common foe rather than by common ideologies. As victory over Hitler became inevitable, all governments began to look to peace.

Origins of the Race

It was clear that the world would be very different after the war. Empires were collapsing: Austria-Hungary and the Ottoman Empire had been broken up after the First World War;; Japan's expansionist ambitions were being crushed in the Pacific; and in Africa and Asia, rising national sentiment would soon lead to the dismantling of the British Empire. In the new world order of 1945, the USA and the USSR quickly emerged as superpowers vying for influence among newly independent nations.

It was a genuinely ideological struggle. The USSR, formed out of revolution only 28 years earlier, had much to prove on behalf of its Communist philosophy. The US, itself the product of revolution not so very long ago in historical terms, was defending a traditional European form of capitalism, the very ideology which the USSR had overthrown in 1917. As the Cold War between the two nations got underway, it was fought on the ground and in the air and, eventually, among the stars.

Previous page: *Full Moon on a dark night: mankind's fascination with it is as old as time*
Left: *After World War Two, the Cold War: Churchill, Roosevelt and Stalin at the Yalta Conference*

Above: *Eliah's chariot flies to the Moon in Ludovico Ariosto's 1516 tale 'Orlando Furioso'*

Moon-gazing

In prehistory our ancestors designed monuments around the Moon's cycle.

One of the earliest examples of a lunar journey appears in a tenth-century

Japanese folk tale (*see* page 8) concerning a lunar princess who came to Earth

and returned to the Moon, and the sixteenth-century Italian poet Ludovico

Ariosto was one of the first to consider how such a journey might have been

made, when in 1516, one of his characters travelled to the Moon like the

Right: *Soviet space propaganda poster – the USSR was eager to demonstrate the technical achievements of Communism*

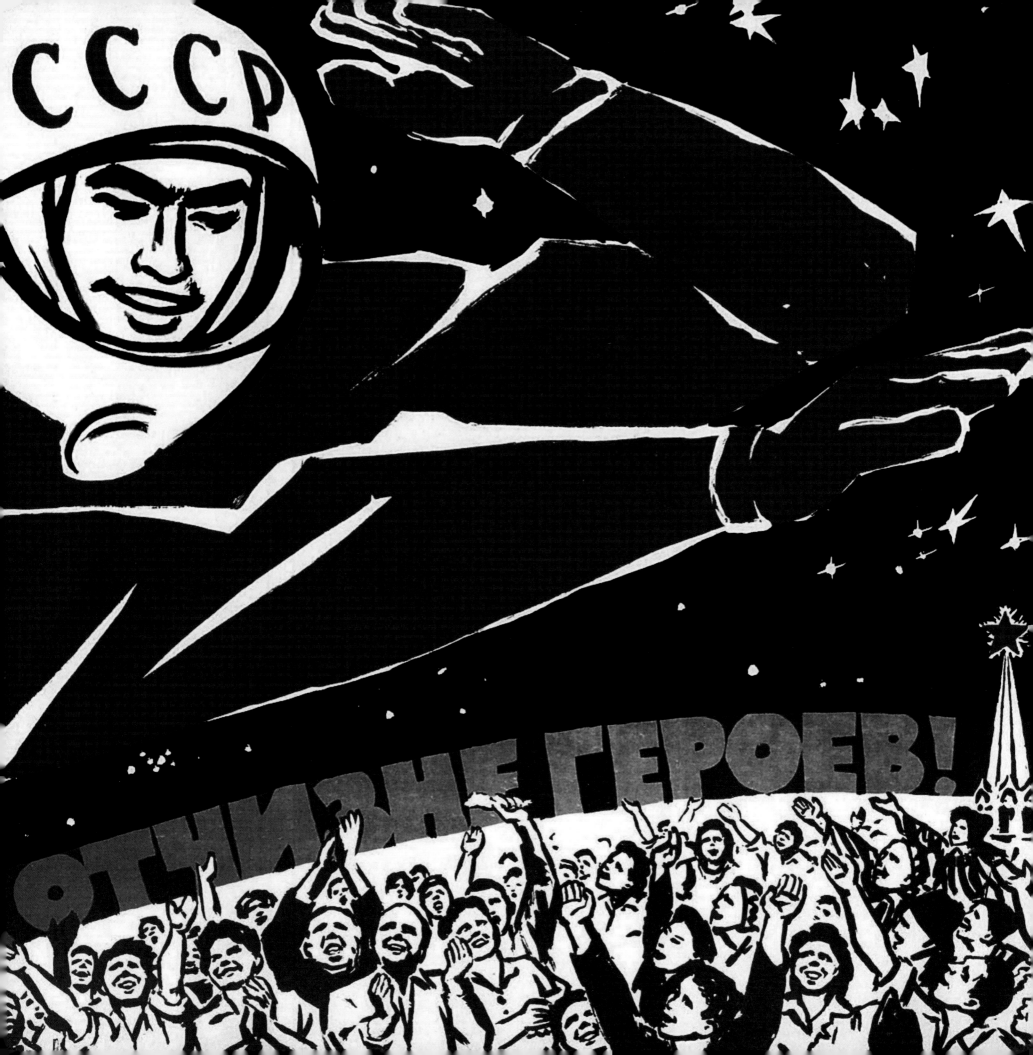

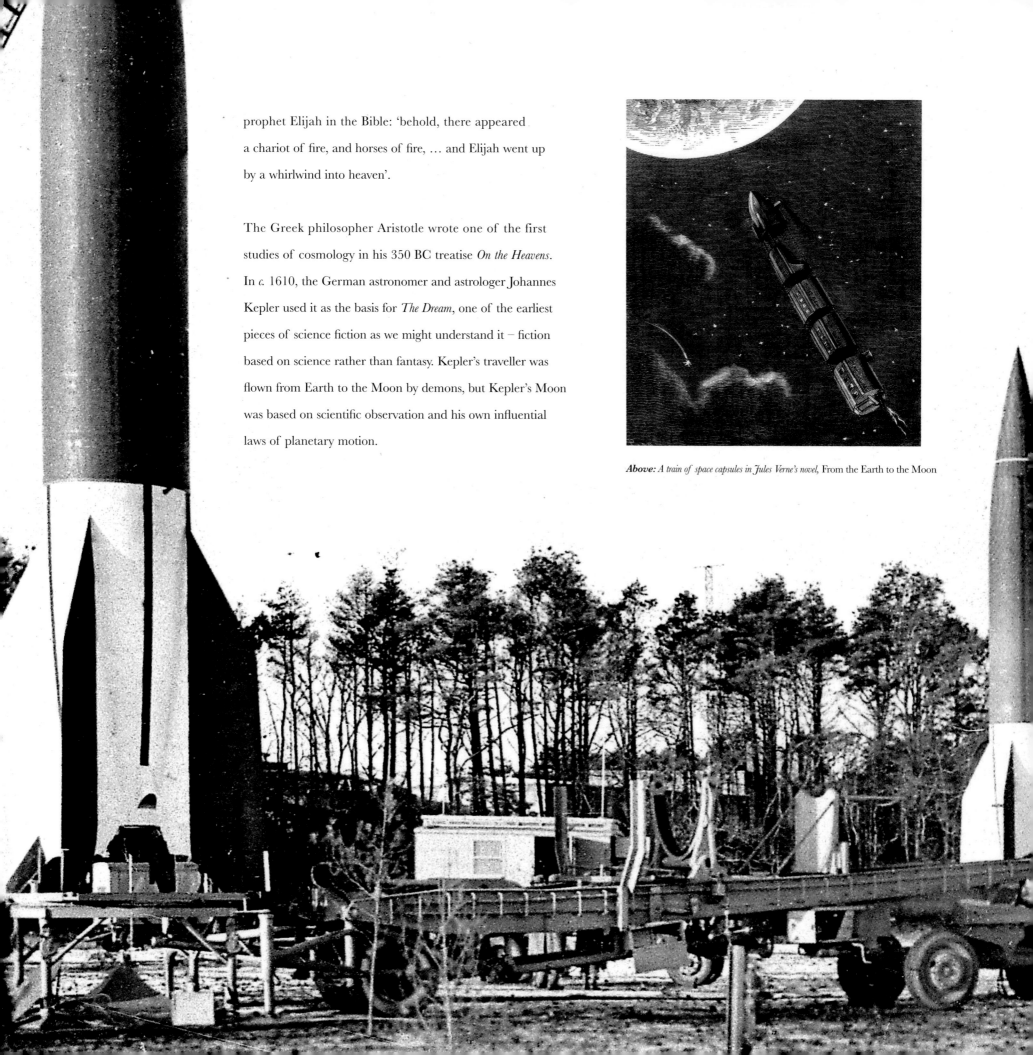

prophet Elijah in the Bible: 'behold, there appeared a chariot of fire, and horses of fire, … and Elijah went up by a whirlwind into heaven'.

The Greek philosopher Aristotle wrote one of the first studies of cosmology in his 350 BC treatise *On the Heavens*. In *c.* 1610, the German astronomer and astrologer Johannes Kepler used it as the basis for *The Dream*, one of the earliest pieces of science fiction as we might understand it – fiction based on science rather than fantasy. Kepler's traveller was flown from Earth to the Moon by demons, but Kepler's Moon was based on scientific observation and his own influential laws of planetary motion.

Above: *A train of space capsules in Jules Verne's novel*, From the Earth to the Moon

Practical Possibilities

Daniel Defoe imagined a machine called a 'Consolidator' to carry his protagonist into space. Russian agricultural journalist Vasily Levshin described the first Russian voyage to the Moon on man-made wings in 1784 – less than 20 years after the US had become an independent nation. Others have described flights by balloon (Edgar Allan Poe), magic galoshes (Hans Christian Andersen) or giant moths (Hugh Lofting's Doctor Doolittle). However, as the pace of scientific discovery accelerated in the nineteenth century, Jules Verne more or less nailed it in his 1865 novel *From the Earth to the Moon*, where he described a spaceship being launched in Florida and returning to the Indian Ocean – remarkably prescient of the Apollo missions. From then on, writers and scientists began to give serious thought to the mechanisms that might turn all this fiction into fact. As technology developed, two great sci-fi authors – Isaac Asimov in 1939 and Arthur C. Clarke in 1951 – predicted that a lunar landing would happen in the mid-1970s.

Developing the Technology

War was the unfortunate spur to technical advances in the field. In the twentieth century, ballistic weapons were sending bombs and bullets further than ever before.

Below: In 1944 and 1945, Germany launched more than 3000 V2 rockets at Allied targets

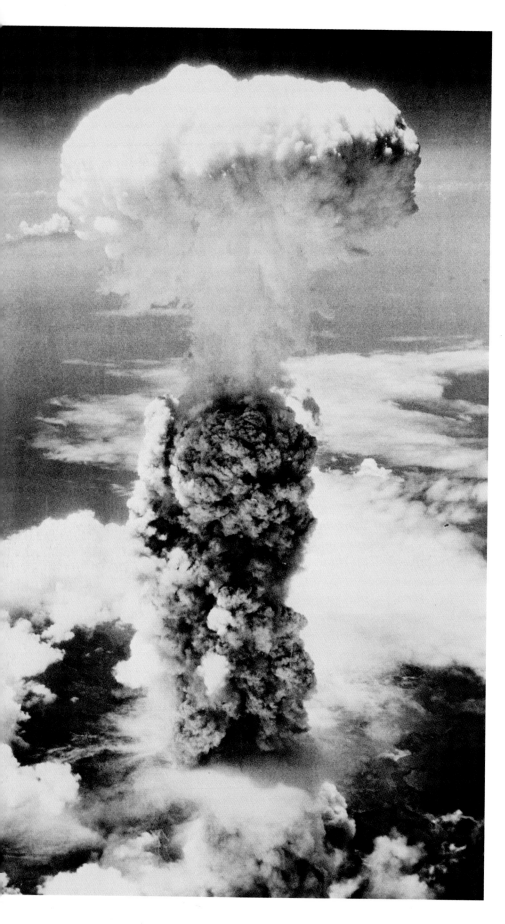

Independently, both English air mechanic Frank Whittle in 1930 and German physicist Hans von Ohain in 1936 invented jet engines. During the war, Germany developed the V1 jet-propelled bomb and the V2 rocket. The V2, designed by Wernher von Braun, was the first long-range guided ballistic missile and the first man-made object to leave Earth's atmosphere to go into space.

As the war reached its conclusion, the US and the USSR raced to capture both the men and the technology behind these German innovations and both countries produced copycat weapons by reverse-engineering examples left by the German retreat. Thus, at the end of the war, both nations had the know-how to produce the next generation of rockets. The US, in addition, had already demonstrated the deadliest weapon ever devised by man: the atomic bomb.

The Race is On

Each superpower felt threatened by the other, fuelling the arms race. It was a race that no one could win. Terrifying weapons of mass destruction, borne on ever-larger rockets, were relabelled as 'deterrents', whose purpose was not to attack but to frighten the other side into not attacking. The only possible outcome of any actual engagement was Mutually Assured Destruction (MAD).

The French talked about *la guerre froide* in the 1930s to describe the period of non-conflict before inevitable war in Europe. George Orwell was the first to use the term 'Cold War' in a 1945 article called 'You and the Atom Bomb' to describe the fear of living under the shadow of nuclear attack. The US and the USSR jostled for advantage by espionage and the expansion of their ideological influence over the rest of the world.

Right: US Civil Defense fallout shelters stoked fear of a Soviet nuclear attack in the 1950s

Competing technologies

The threat of nuclear warfare was real and terrifying. Images of the devastation of Hiroshima and Nagasaki were a sobering illustration of the unimaginable power of the new weapons. When the USSR developed its own atomic bomb, the two superpowers squared off. The possibility of mutually assured destruction on a massive scale triggered an arms race as each side sought to deter the other by devising bigger and more destructive bombs and rockets with which it would retaliate in the event of an attack.

Sputnik

Thus, when the USA declared in 1955 that it would send a satellite into space within three years, the USSR not only announced its own three-year program, but delivered it in two years. Russia scored a huge propaganda coup with Sputnik, whose cheerful orbiting beep was heard by short-wave radio enthusiasts all around the world. A second Soviet satellite, Sputnik 2, further embarrassed the US Navy, which had been tasked with delivering for the US. Worse still, it was the US Army that finally launched the nation's first satellite, Explorer 1, six weeks before the Navy's own Vanguard 1. Eight weeks later, in May 1958, the USSR sent up yet another rocket, Sputnik 3.

A Man in Space

Sputnik had taken the US by surprise, and worse was to come. A year later, the USSR's Luna 2 unmanned spacecraft landed on the Moon. On 12 April 1961, Russian cosmonaut Yuri Gagarin, on board Vostok 1, became the first man to fly in space, three weeks before Alan Shepard repeated the feat for the US. Shepard's achievement was small comfort for the US, embarrassed

Inset right: Sputnik 1, the first artificial satellite, launched by the Soviet Union on 4 October 1957
Right: Soviet Premier Nikita Khrushchev poses with German leaders in front of a replica of Sputnik 3, 5 March 1959

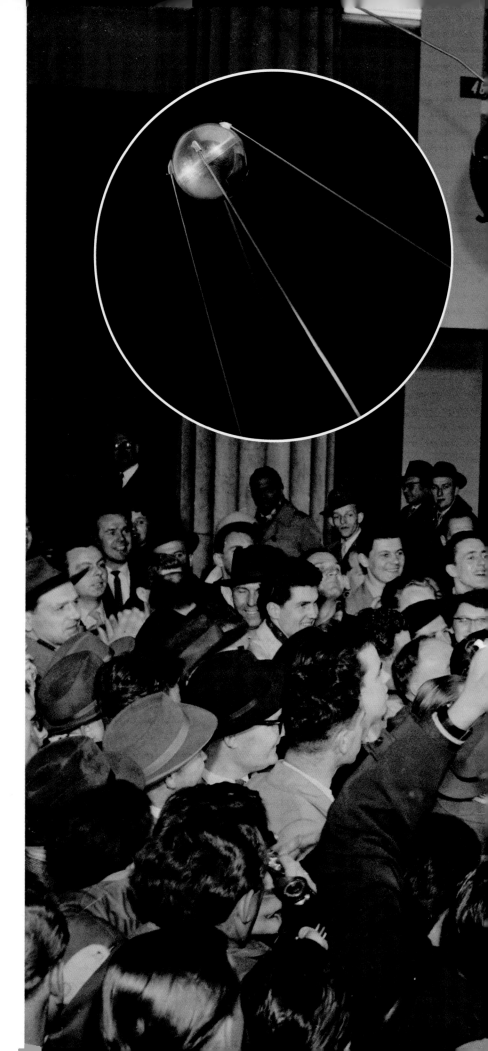

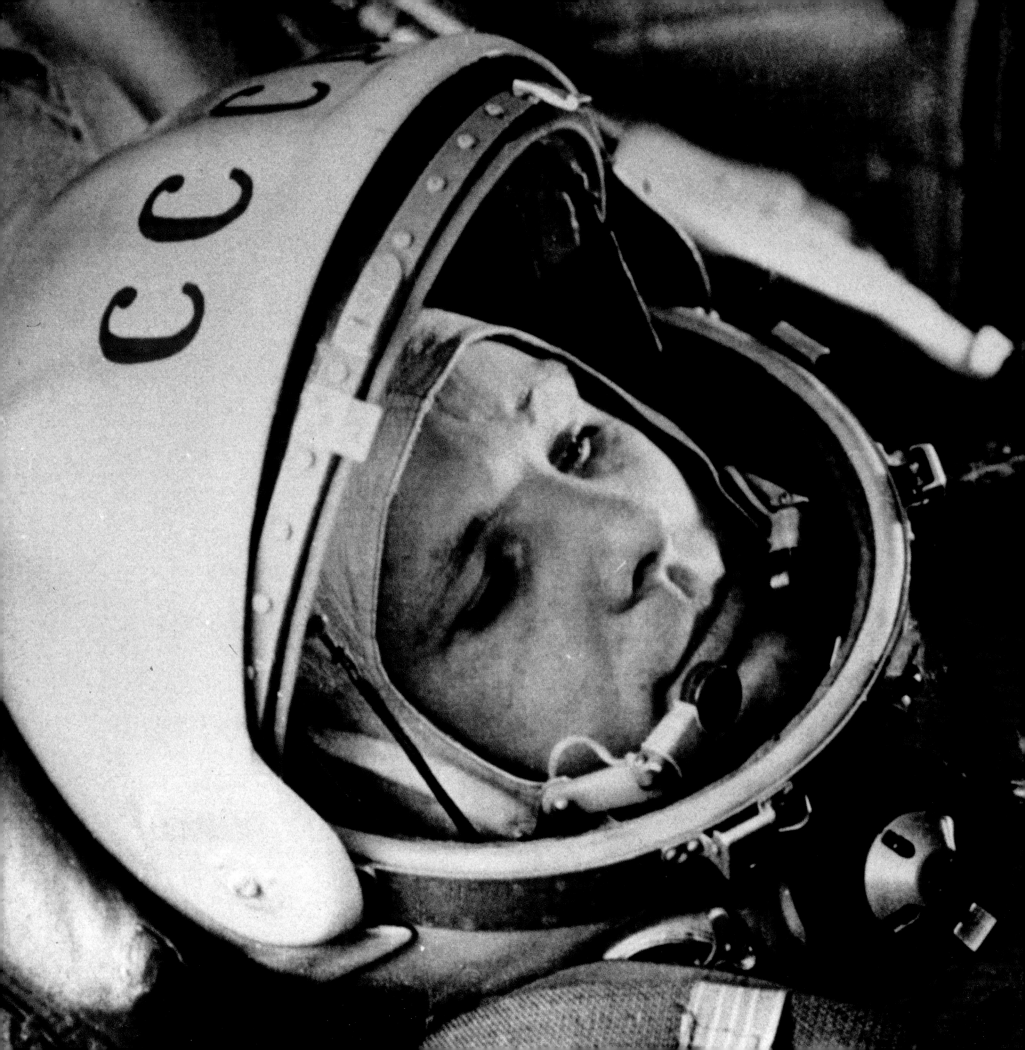

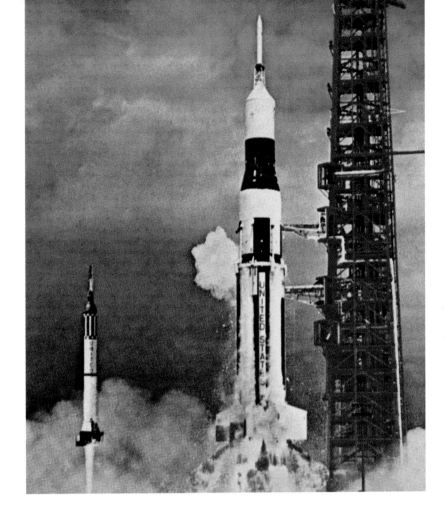

after both Gagarin's successful flight and the US's failed invasion of Communist Cuba at the Bay of Pigs, which followed it five days later.

President Kennedy had authorized the Bay of Pigs fiasco and was only four months into his presidency. 'Only when our arms are sufficient beyond doubt,' he had told the crowd at his inauguration, 'can we be certain beyond doubt that they will never be employed.' But he had also used the occasion to appeal for scientific co-operation with the Communists: 'Let both sides seek to invoke the wonders of science instead of its terrors. Together, let us explore the stars.'

Now he raised the stakes. Speaking in Congress in 1961, three weeks after Shepard's flight, Kennedy stated that 'this nation should commit itself to achieving the goal, before this decade is out, of landing a man on the Moon and returning him safely to the Earth'.

Above: *Postcard comparing lift-off of Mercury 3 (left) carrying Alan Shephard,
the first American in space, to the Saturn I launch vehicle (right)*
Left: *Yuri Gagarin, the first human in space, in the capsule of Vostok 1 in 1961*

NASA

Kennedy acknowledged the huge cost of such a program. He used the public purse to order a significant expansion of the activities of NASA, the National Aeronautical and Space Administration.

NASA had been established in the wake of the USSR's Sputnik propaganda coup, taking over from the National Advisory Committee for Aeronautics (NACA), set up in 1915 to co-ordinate the US's research into flight. Now NASA had a very specific mission with a very short deadline, and its budget rose from $100 million in 1958 to $5.5 billion in 1962.

Kennedy Commits

NASA spent some of the budget developing its resources at Houston, Texas. It was on a visit to Houston in September 1962 that Kennedy delivered one

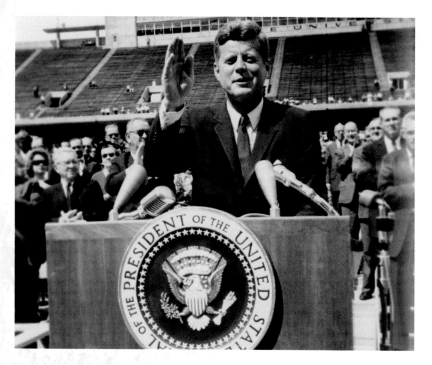

Above: *'We choose to go to the Moon'– President Kennedy in Houston on 12 September 1962*
Right: *NASA's creation in 1958 meant a name-change for the former NACA Lewis Flight Propulsion Laboratory*

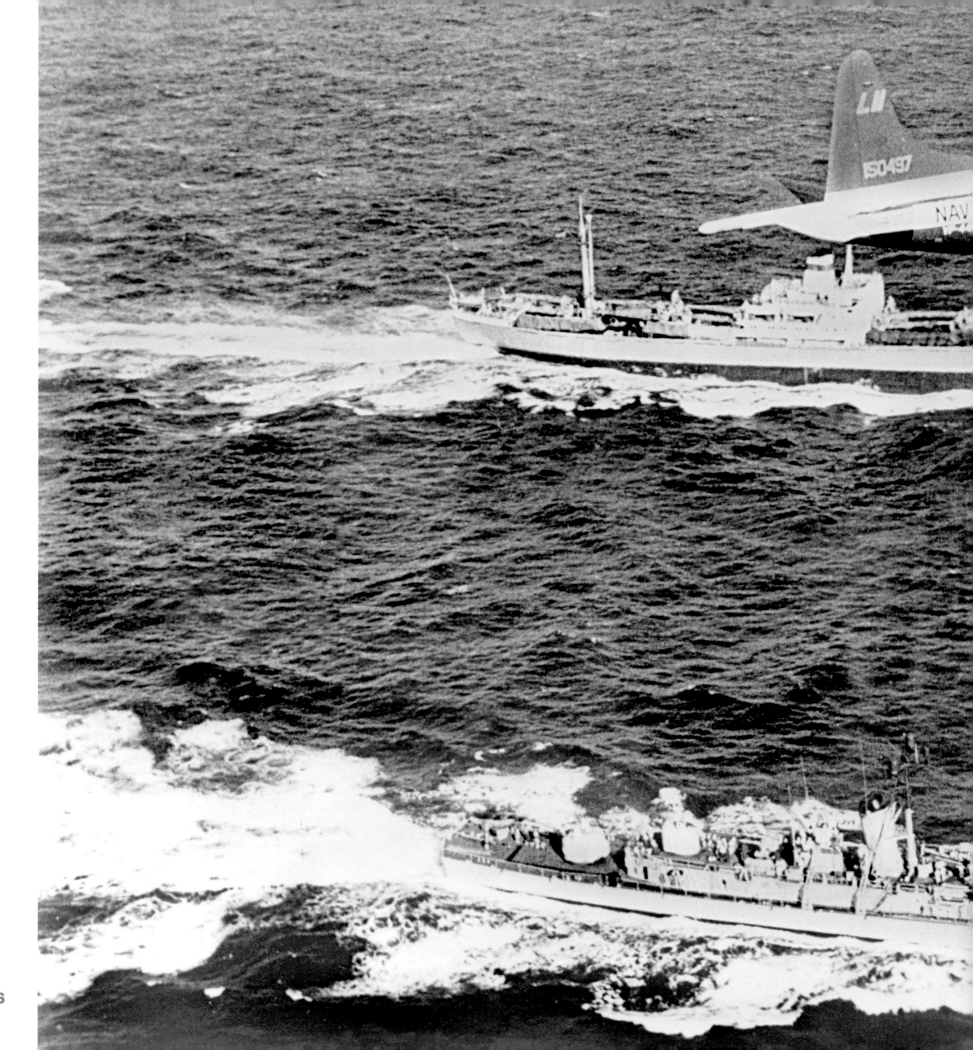

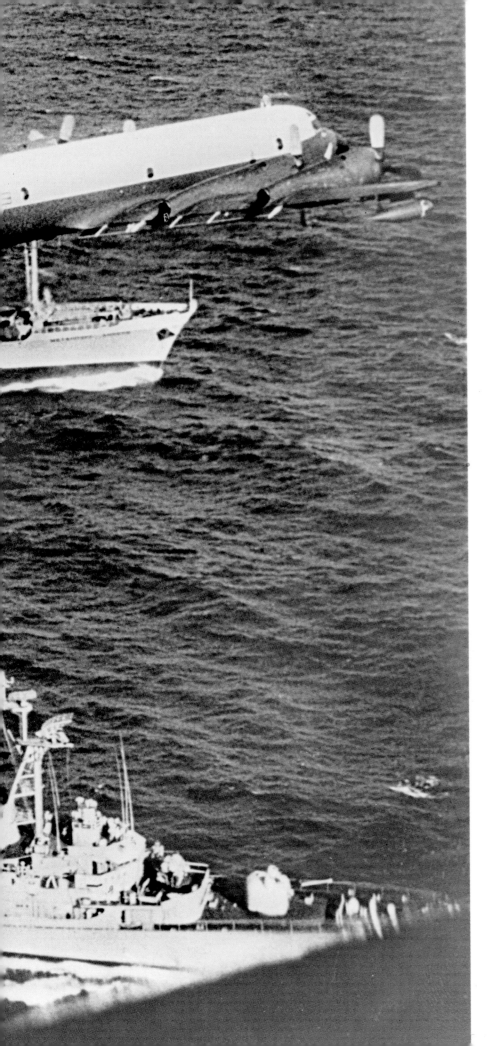

of his most inspiring speeches about the Space Race. It was a speech for public and international consumption, but also aimed very directly at NASA, which (behind closed doors) had expressed doubts about whether it was possible to send a man to the Moon.

'All great and honourable actions are accompanied with great difficulties,' he stated, 'and both must be enterprised and overcome with answerable courage.' He was quoting William Bradford, who said the very same about the 1630 founding of the Plymouth Bay colony. Kennedy continued: 'Why, some say, the Moon? We choose to go to the Moon. We choose to go to the Moon in this decade and do the other things [that challenge us], not because they are easy but because they are hard.' He then invoked mountaineer George Mallory, who gave as his reason for attempting to climb ount Everest, 'Because it is there.'

'Well,' said Kennedy, 'space is there, and we're going to climb it, and the Moon and the planets are there, and new hopes for knowledge and peace are there. And, therefore, as we set sail, we ask God's blessing on the most hazardous and dangerous and greatest adventure on which man has ever embarked.' Without doubt, Kennedy's commitment to space exploration is his great legacy.

Cuban Missile Crisis

The noble goal of expanding human knowledge was an uplifting distraction from the realities of the Cold War. Barely a month after his Houston address, Kennedy was confronted by the Cuban Missile Crisis, which brought the world to the brink of open nuclear war.

Provoked by the establishment of US nuclear missile sites in Turkey and Italy – well within range of the Soviet Union – the USSR responded by sending nuclear warheads to Cuba, 90 miles off mainland North America.

Left: The Soviet freighter Anasov (top) returns nuclear missiles from Cuba to the USSR, escorted by a US Navy plane and the USS Barry (bottom), 1962

After a tense stand-off, humanity prevailed. Kennedy and his Soviet counterpart, Nikita Khrushchev, agreed to dismantle their bases in Turkey and Cuba respectively, and the world breathed a collective sigh of relief.

Off the Starting Blocks

NASA's early efforts were not wholly successful, although they all informed the development of the space program. Its earliest focus for space travel was the X-15, a rocket-propelled plane. It included technical innovations that would prove useful for future missions, including the idea of a space suit, but it was soon abandoned in favour of ballistic launch vehicles – space rockets.

The first five launches of NASA's Ranger unmanned lunar probes were failures. However, its Project Mercury, also known as MISS (Man In Space Soonest), was more successful. John Glenn became the first American to orbit Earth, in Friendship 7 on 20 February 1962, with three orbits compared to Gagarin's one. In 1963, the USSR sent Valentina Tereshkova, the first woman to

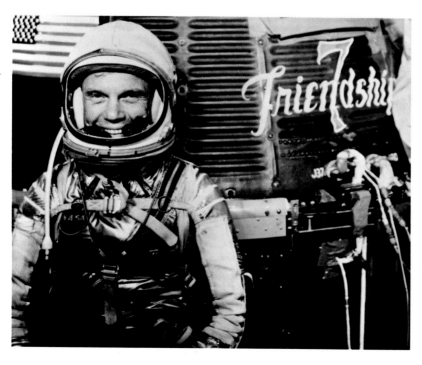

Above: John Glenn beside Friendship 7, in which he became the first American to orbit Earth
Right: Pilots of NASA's experimental space plane X-15 at Edwards Air Base, 1965

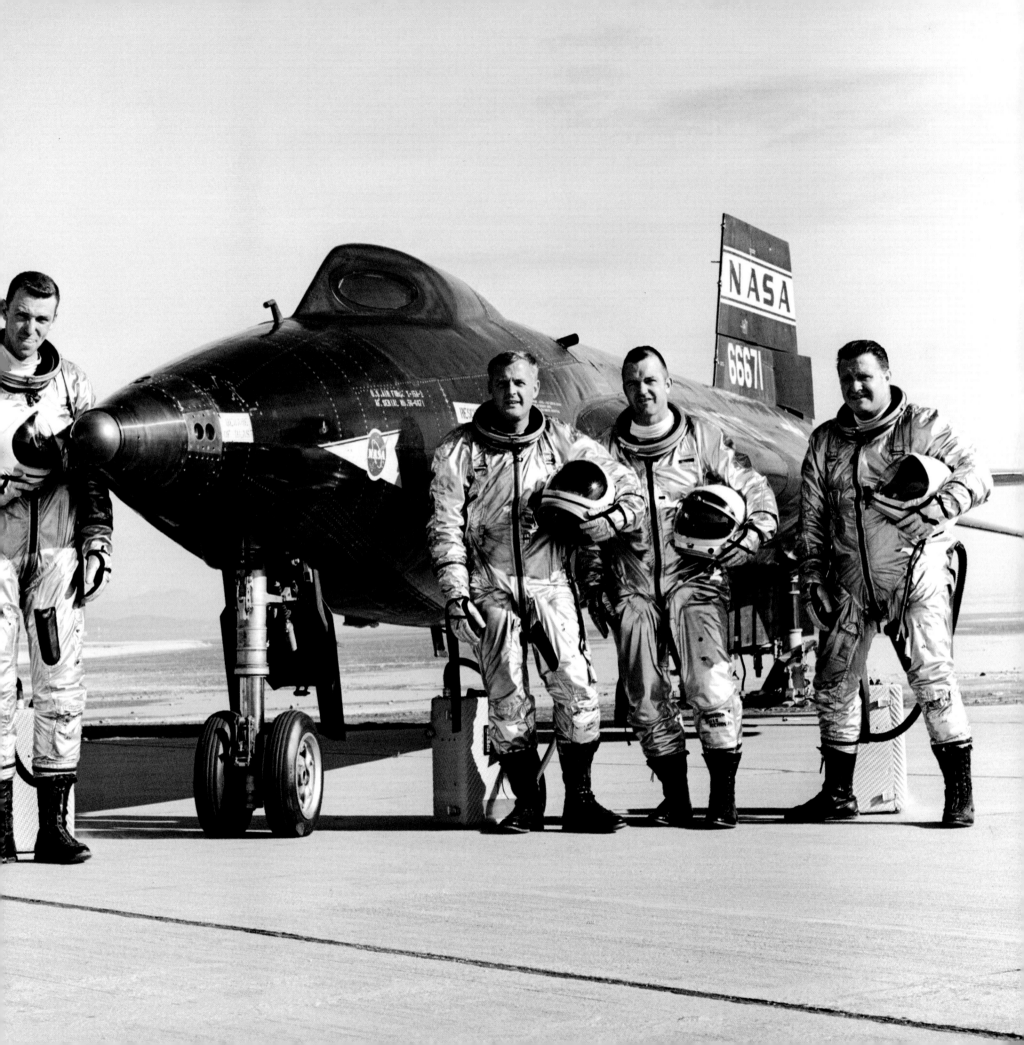

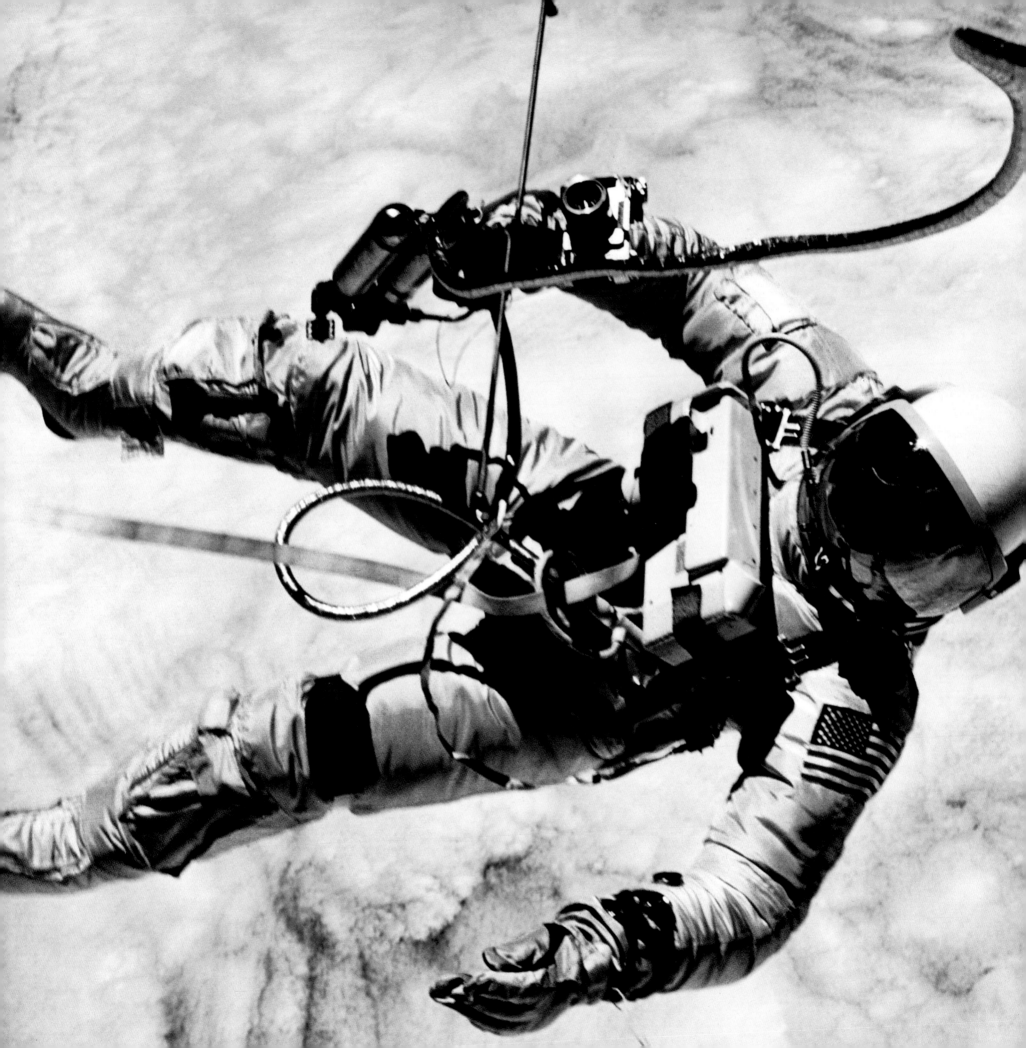

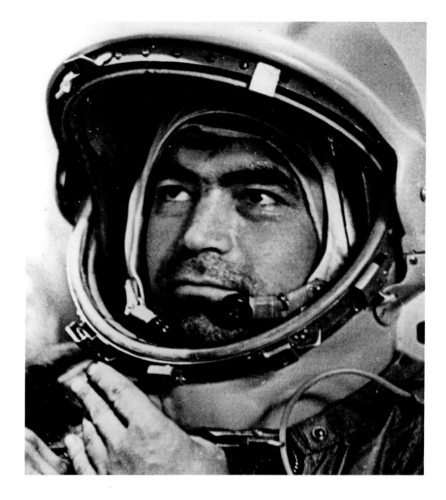

go into space, on board Vostok 6. In the same year, US astronaut Gordon Cooper achieved 22 orbits in two days on board Faith 7, however, Soviet cosmonaut Andriyan Nikolayev had previously stayed up for nearly four days in one of two Vostok missions that ran concurrently in 1962.

With Project Gemini, NASA expanded both the crew and the activities of its space missions to include rendezvous procedures and extra-vehicular activities – spacewalks. Ed White was the first American to leave his capsule on Gemini IV on 3 June 1965. But Alexei Leonov had beaten him to it on 18 March, from the USSR's Voskhod 2 spacecraft. In the Space Race, the US was catching up and having more successes than failures. By the end of 1965, the Space Race was anybody's to win.

Above: Soviet cosmonaut Major Andrian Nikolayev, who orbited the Earth 64 times during a 4 day spaceflight aboard Vostok 3 in August 1962
Left: Ed White making the first spacewalk by a US astronaut, 3 June 1965

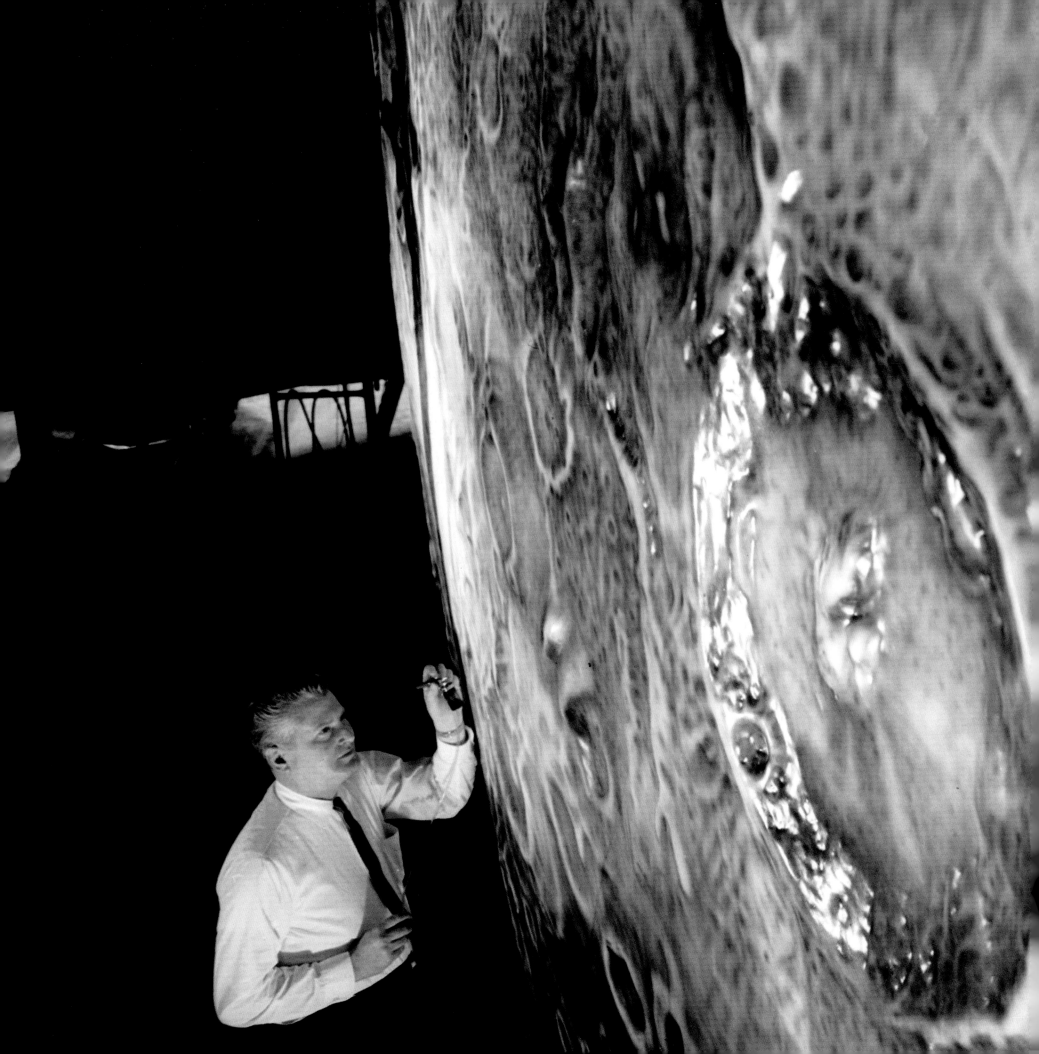

The Science

Our Nearest Neighbour

In the years since the Moon landings, our understanding of the Universe has expanded beyond all imagining. It is easy to forget how little scientific knowledge of it – and even of our own Moon – the human race had at the start of the Space Race. We did not even know what Earth looked like from space, and had only seen the Moon through a telescope. After all the science fiction and fantasy, it was time to start examining the science of a place to which we were proposing to send a human being.

An Impossible Dream?

It is no wonder that NASA had initial doubts about the feasibility of landing a man on the Moon. The technical challenges of getting astronauts there, bringing them back and keeping them alive throughout the mission were immense and innumerable.

Although both US and Soviet probes had landed on the Moon, it was another matter entirely to transport three human beings and their life support systems. Apart from the vehicular problems, a human on such a journey would be removed from the environment in which he had evolved over millions of years. In the hostile environment of space, astronauts must be completely self-sufficient.

For both NASA and its Soviet counterparts (several different Moscow design bureaux), the first leg of the Space Race was to run missions which gathered scientific information. The USSR's Luna series, and the US's Ranger and Lunar Orbiter program, all returned valuable information about radiation and electromagnetic conditions on the Moon, and thousands of photographs

Previous page: NASA built four huge Moon models for simulations of lunar orbit and landing approach (LOLA)
Left: A French illustration from 1740 showing telescope observations of the Moon and planets

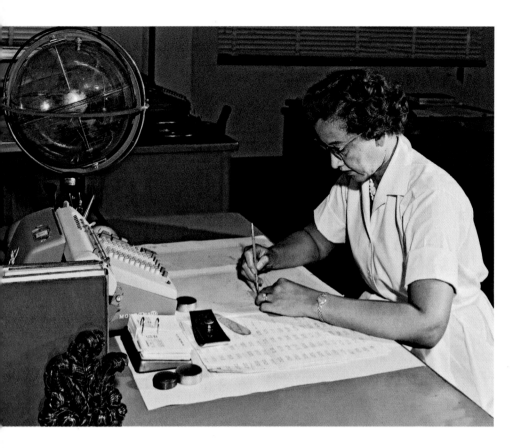

Above: African-American mathematician Katherine Johnson, whose calculations of orbital mechanics made US space flight possible

of the Moon's landscape both from orbit and from its surface, including the dark side of the Moon which is never seen from Earth.

The Moon

The Moon has a dark side (or far side) because the time that it takes for the Moon to rotate on its axis matches the time that it takes for the Moon to complete one revolution around the Earth, so as it orbits it always shows the same side to us. It goes around Earth as Earth goes round the Sun, and the complex relationship between the three affects our climate and tides. Even in this scientific age, we marvel at the magic of a lunar eclipse, one of the consequences of this complicated dance between the Sun, the Moon and Earth.

Right: A boy watches live pictures of the Moon from the Ranger 9 probe in 1965

FROM THE MOON

It is now believed that the Moon was formed by a collision of Earth with another planet-sized object, Theia, around 4.5 billion years ago. Most of Theia was absorbed by Earth and some scientists now suggest that the Earth's nitrogen and carbon, the elements which make up much of our bodies, came from Theia. Some material from both was thrown upwards by the impact and was trapped in Earth's orbit. This debris, scientists think, coalesced into our Moon.

Evidence for this comes from comparisons of the geological composition of the Moon and Earth, and similarities between Earth's spin and the Moon's orbit. In 2019 a piece of 4.4 billion year old Earth rock composed of feldspar, zircon and quartz was found among samples brought back from the Moon by Apollo 14. The Moon's low density and small iron core are consistent with the theory, and it is possible that the whole Solar System may have been formed by such massive collisions.

Theia was smaller than Earth – around 6,800 km (4,225 miles) in diameter compared to Earth's 12,742 km (7,918 mile) diameter. The Moon is only 3,474 km (2159 miles) across, and although it is our nearest neighbour, it is still a long way from Earth – about 384,400 km (238,855 miles) – and is slowly drifting further away.

The first samples of lunar soil were not obtained until Apollo 11's landing in 1969. Until then, the geology of the Moon remained largely unknown, although scientists knew from studies of impact craters that the surface is covered in dust.

We can see the larger craters from Earth; there are also hills and volcanoes. The dark areas of the Moon are the so-called Seas – the Sea of Tranquillity, for example, where Apollo 11 landed. They are, in fact, lava flows from volcanic eruptions. The oldest occurred over four billion years ago, the youngest a mere one billion.

Left: *The Moon was formed from debris after a collision between the Earth and another planet*

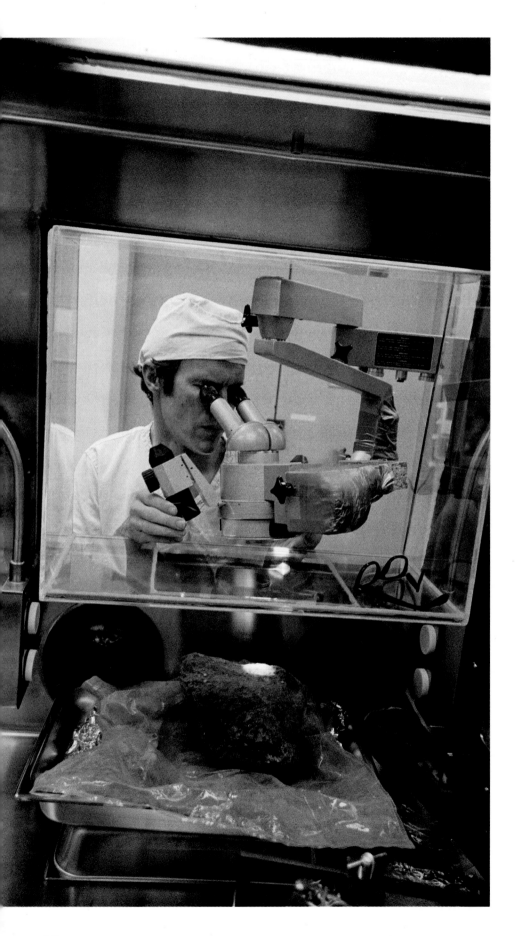

Green Cheese

The Moon, it transpires, is not made of green cheese, and nor did anyone ever really believe that it was. There are versions of the phrase in several European traditions, concerning the reflection of the Moon in a puddle of water resembling a young ('green') round of cheese. We now know that the most common elements, at least on the surface of the Moon, are iron, silicon and oxygen. Hydrogen is concentrated at the Moon's north and south poles; and there is almost no carbon or nitrogen, suggesting that there are no carbon-based life forms.

Around 383 kg (844 lbs) of moon soil have been brought back to Earth, all of it now rusted by exposure to the greater oxygen and moisture in Earth's atmosphere. Water has been detected on the Moon, but only in small quantities in the colder polar regions. Whether it is chemically produced on the Moon or has been deposited there by impacts from water-carrying meteorites is a matter of debate.

Earth

Although the early unmanned probes were fact-finding missions to the Moon, they did present us with moments of childlike wonder about our home. In 1966, Lunar Orbiter 1 sent back a grainy photograph of the Earth seen beyond the lunar horizon, the first ever view of the Earth from the Moon.

In 1967, Lunar Orbiter 5 relayed the first pictures of our whole planet. We take the image for granted now, but here was something we had known from globes for centuries but never actually seen: our blue Earth, small enough to see in its entirety against the vastness of space.

Left: Examining a large piece of Moon rock brought back by Apollo 14 in 1971
Right: An astronaut's bootprint in the lunar soil, photographed during Apollo 11's historic Moon mission

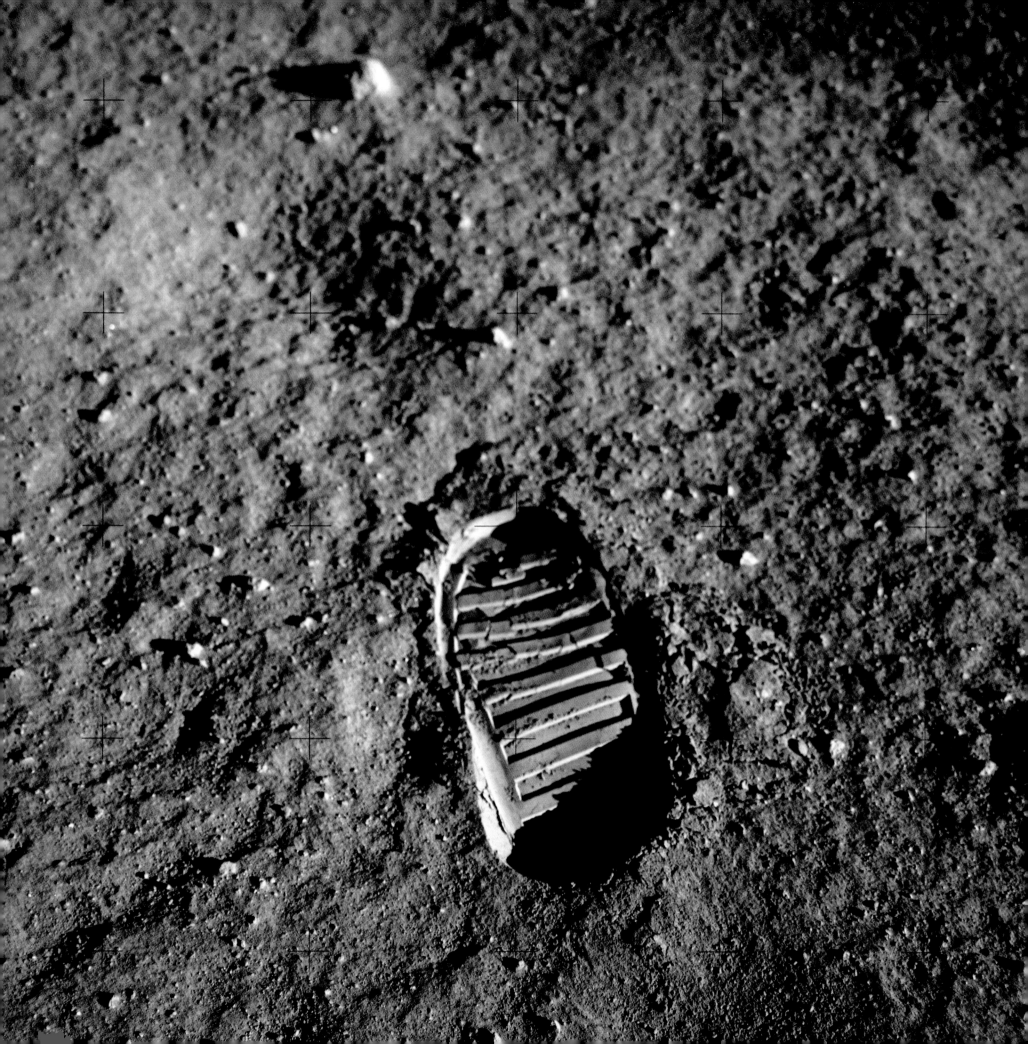

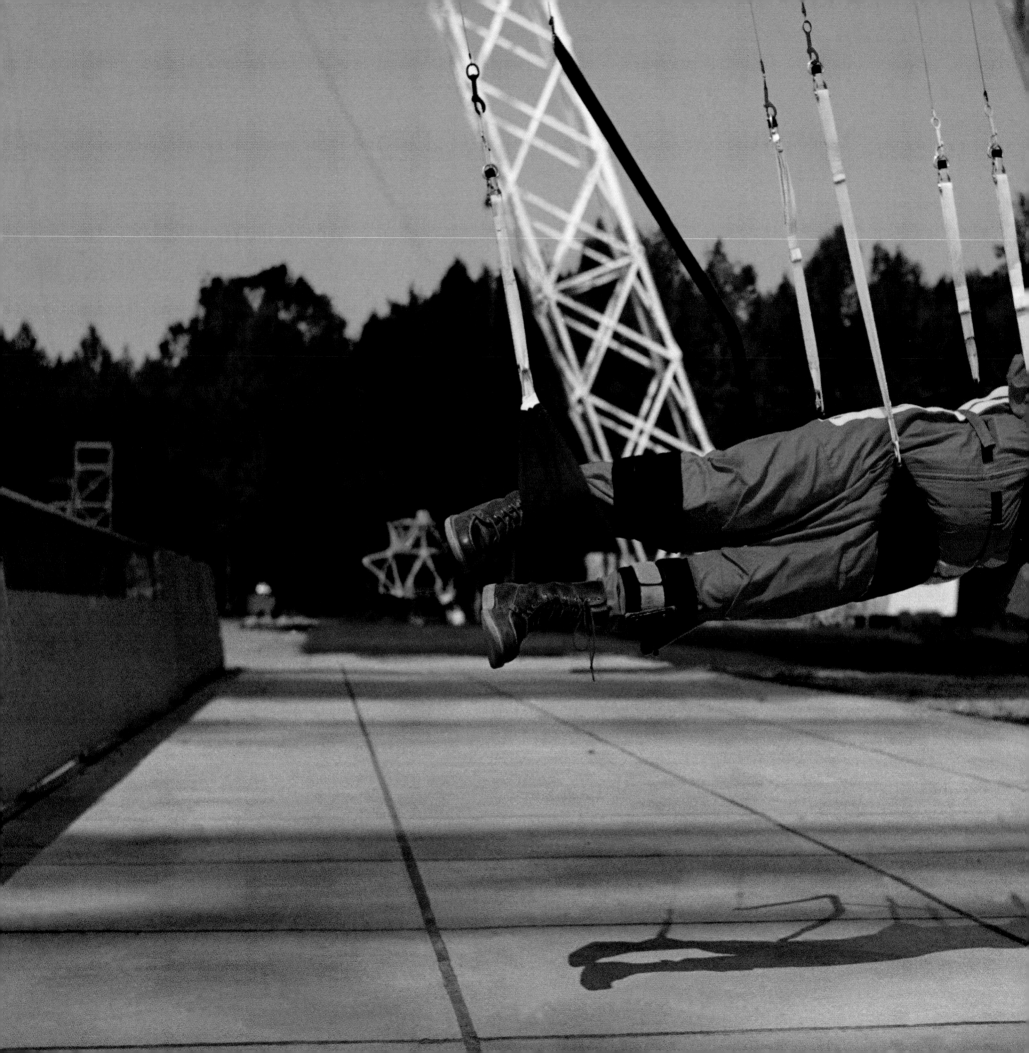

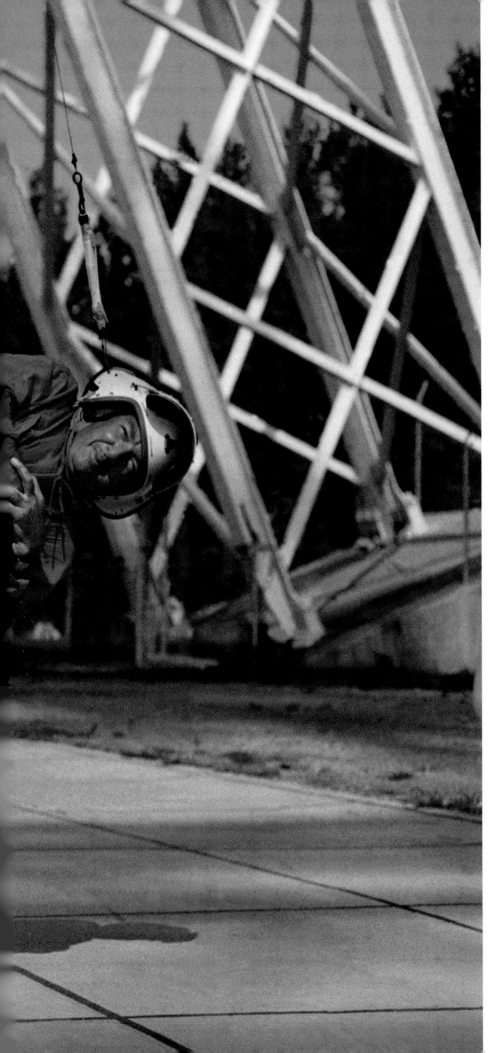

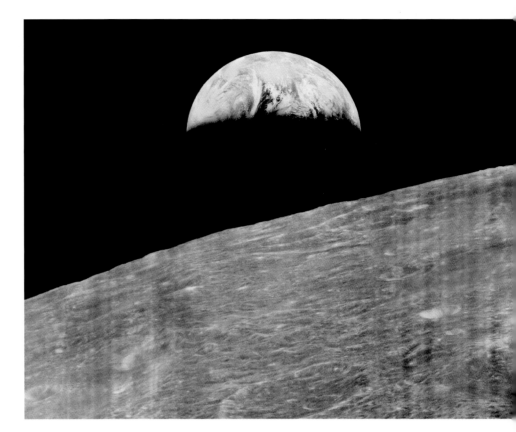

Above: Lunar Orbiter 1's 1966 photograph of the Earth in the partial shadow of the Moon

Could we really be the only planet that supports life? Certainly life on Earth has evolved to take advantage of its very specific environment. We are accustomed to Earth's gravity, for example, which is six times stronger than that of the Moon. Lack of gravity, or weightlessness, has an impact on the skeletons, muscles and organs of astronauts.

Gravity Matters

Because Earth is larger than the Moon, Earth's gravity holds the Moon in its orbit. However, the Moon is large enough for its own gravity to have an effect on the moveable parts of our landscape – the large bodies of water – that are not anchored to Earth's crust. The Moon creates the tides, which

Left: US news anchorman Walter Cronkite tries out the Apollo astronauts' Reduced Gravity Simulator in 1968

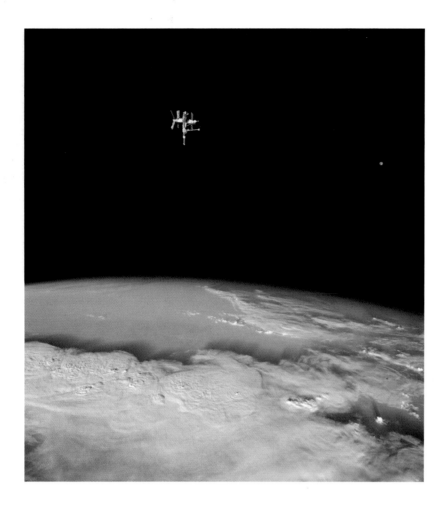

Above: Russia's Mir space station and the distant Moon photographed from space shuttle Discovery in 1998

are measurable even on larger inshore lakes on Earth. Without gravity, Earth's water would drift away in floating spheres as it does in the weightless environment of the International Space Station, for example.

Because Earth spins on its polar axis, gravity is weakest at the equator. Gravity thus increases slightly and regularly with latitude. The Moon not only lacks magnetic north and south but also displays irregular gravity 'hotspots' called mass concentrations (mascons) caused by very large historic impacts. These powerful collisions have condensed the ground at the point of impact, increasing the gravity to cause problems for orbiting spacecraft passing overhead.

Right: A digital impression of Africa, the Atlantic Ocean and the Moon over the equator

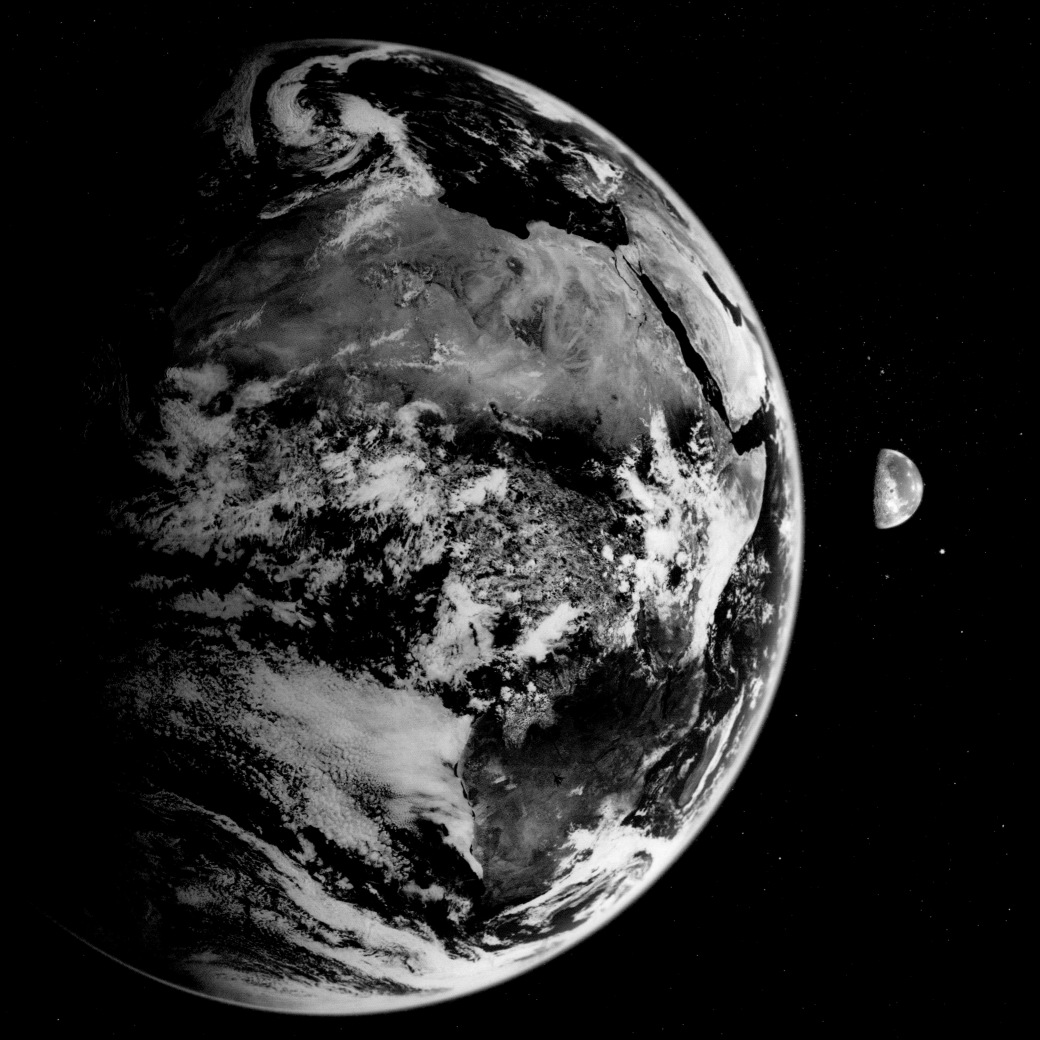

We breathe our own atmosphere on Earth, while the Moon has almost no atmosphere. A typical cubic centimetre of air on Earth contains 10 trillion molecules; on the Moon it is barely a million (that is one 10-billionth of Earth's), and composed of rare gases such as helium, argon and neon.

Life on Earth and Elsewhere

We humans depend on the physical qualities of our environment. We get our nutrition from other carbon-based life forms that have evolved in the same environment, be they plants or animals. We are made of the same raw materials as them and need to replace the materials in us when they are used up by the activities of being alive. However, recent discoveries on Earth of sulphur-eating bacteria surviving on inorganic material from thermal vents on the ocean floor show it is perfectly possible for life forms to evolve in

alternative environments to our own. Therefore it follows that this is possible even on other planets..

Sending humans into space takes us away from this natural life support, and as NASA paved the way for manned space flight, it had to develop alternative systems.

Mankind had already found ingenious ways around many of the problems of hostile environments through the exploration of earthly extremes of heat, cold, high altitudes on land and great depths under water – breathing apparatus and pressurized vehicles, for example. A far greater technical challenge was the question of how to escape our comforting atmosphere and familiar gravity.

Above: Like fighter pilots, astronauts experience the physical strains of flying at altitude and at speed
Left: Underwater exploration technology has provided some solutions to the problems of sustaining life in space

Fly me to the moon

To get to the Moon, you have to escape the Earth's gravity field. We can all do that – jumping up off the ground is an act of gravity defiance. It is much harder with a pack on your back, and impossible to sustain after the initial jump-off. The challenge for rocket scientists is to sustain a leap long enough to travel the 100 km (62 miles) or so into space.

A rocket must carry everything with it: a crew of humans and all their life-support systems, navigation aids and field instruments. The bigger the load, the bigger the rocket and the bigger the engines required to lift it off the Earth. Therefore more fuel is required, which means an even bigger rocket.

Rockets in History

China invented gunpowder, the first explosive material, in the ninth century. By the thirteenth century, it had exploited its potential to power incendiary rockets in time of war. In the following century, the Chinese navy was using multi-stage rockets, in which a second rocket was lit by the last flames of the first to carry the rocket further.

The marauding Mongolian army adopted the technology and spread it far and wide. A metal-cased rocket was developed in Mysore in southern India in the eighteenth century to fight the British East India Company. British inventor Sir William Congreve refined the design, and the Congreve Rocket, propelled by compacted gunpowder, was used to great effect during the Napoleonic Wars.

Inset right: A 1961 comparison of NASA's Redstone, Jupiter-C, and Mercury Redstone rockets.
Inset far right: NASA's 1965 comparative guide to the rockets used in its lunar program
Right: A Little Joe rocket, designed to test the Mercury's launch escape system, September 1959

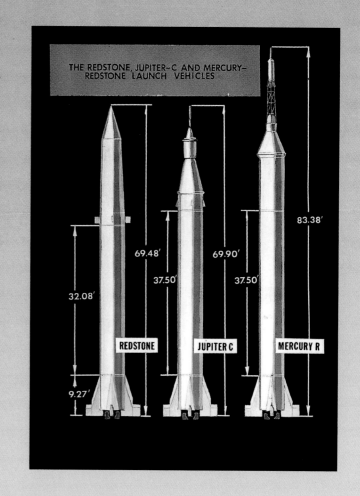

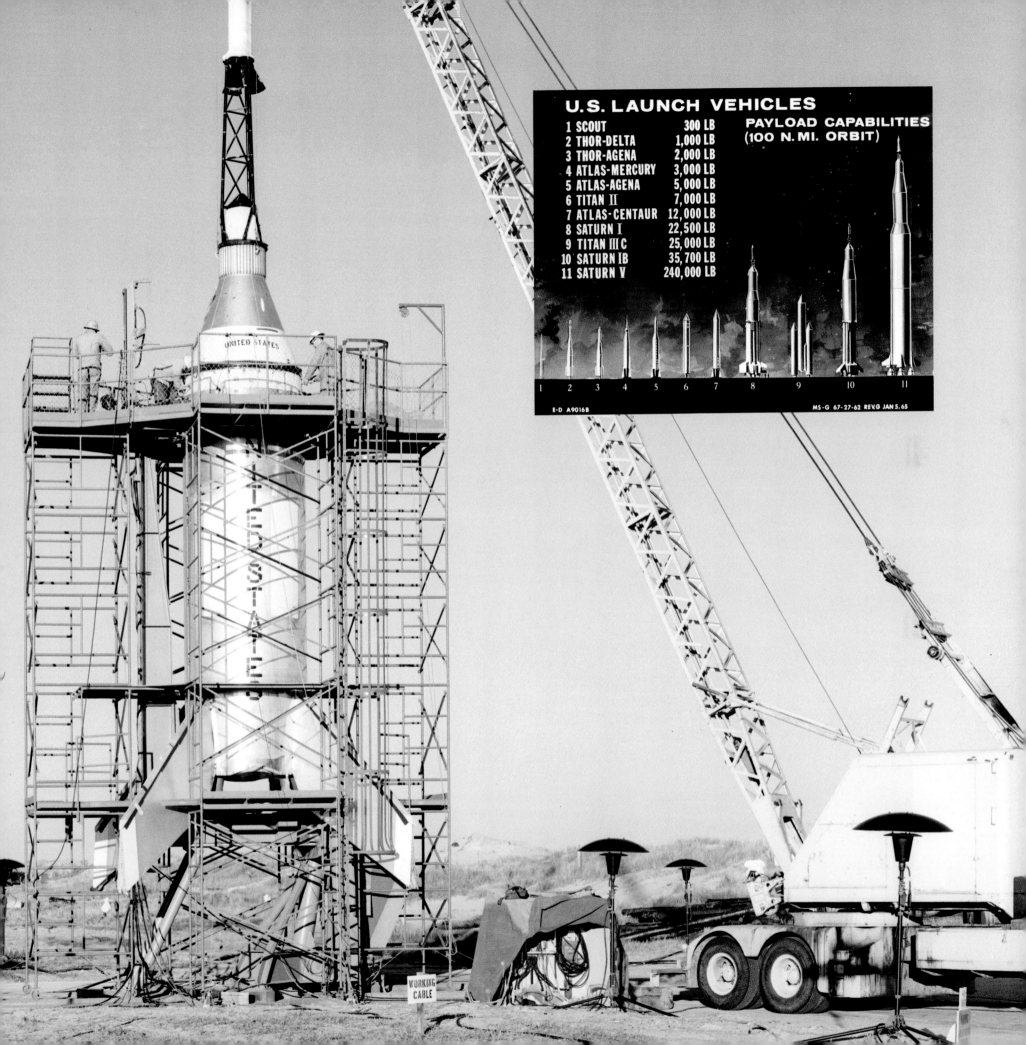

U.S. LAUNCH VEHICLES

PAYLOAD CAPABILITIES
(100 N. MI. ORBIT)

#	Vehicle	Payload
1	SCOUT	300 LB
2	THOR-DELTA	1,000 LB
3	THOR-AGENA	2,000 LB
4	ATLAS-MERCURY	3,000 LB
5	ATLAS-AGENA	5,000 LB
6	TITAN II	7,000 LB
7	ATLAS-CENTAUR	12,000 LB
8	SATURN I	22,500 LB
9	TITAN III C	25,000 LB
10	SATURN IB	35,700 LB
11	SATURN V	240,000 LB

E-D A9016B

MS-G 67-27-62 REV.G JAN 5, 65

UNITED STATES

WORKING CABLE

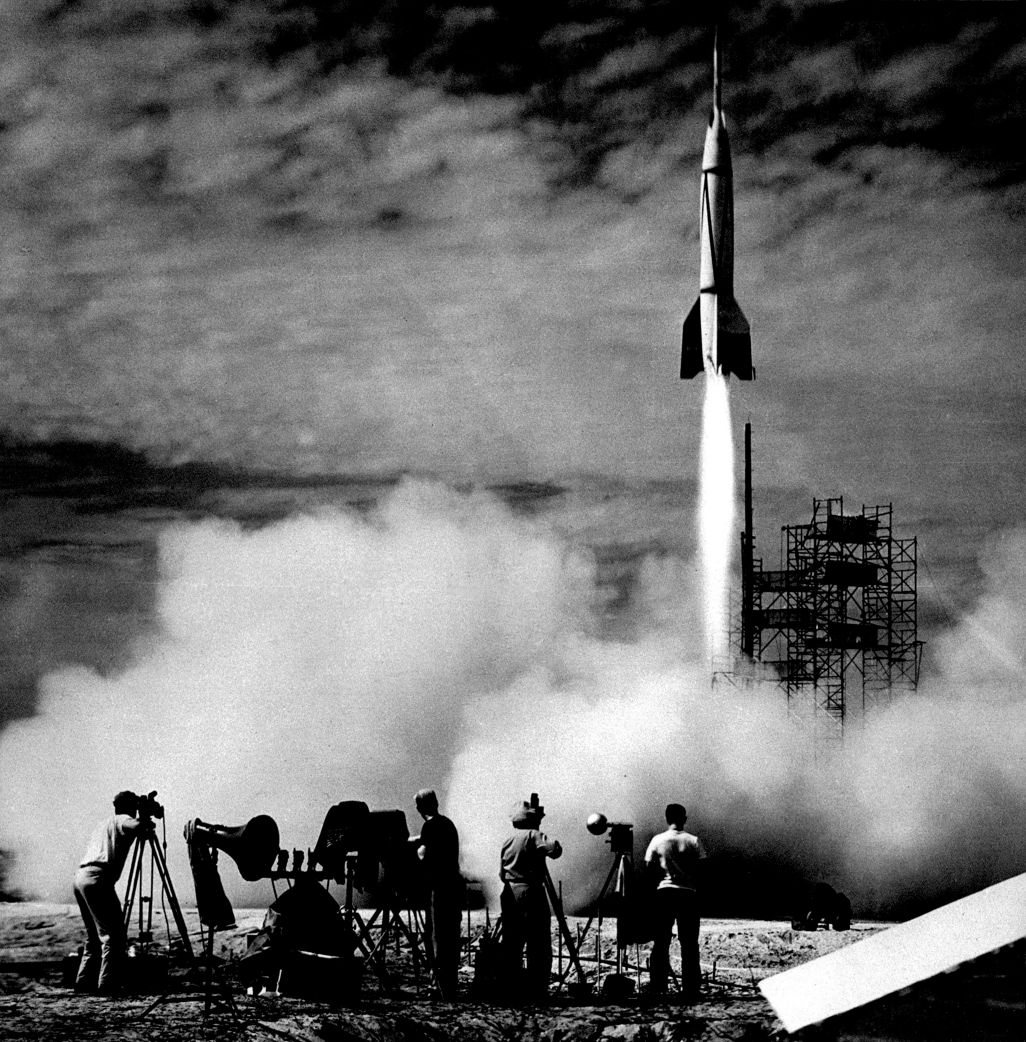

From Chinese fireworks to Congreve Rockets, the range of the device was extended from 100 m (328 ft) to 2,000 m (6,562 ft). In 1861, Scottish astronomer William Leitch was the first man to suggest using rockets to carry humans into space.

Twentieth-Century Rocket Power

Others, including the German Hermann Oberth and the Russian Konstantin Tsiolkovsky, developed the idea and the technology, but it fell to the American physicist Robert Goddard to launch the first rocket powered by a liquid propellant in 1926. By adding a nozzle beyond the combustion chamber, he also increased the power and efficiency of the rocket, and liquid-fuel rockets became part of the arsenal of artillery units in the Second World War.

It is a measure of Germany's success in this field during the war that, on its defeat, the US recruited Wernher von Braun, whose V2 rocket was a major development in design. Both the US and the USSR based their initial post-war rocket research on captured V1s and V2s.

With their capacity to fly high and far, rockets were developed by the military in the pursuit of superior intercontinental ballistic missiles (ICBMs). But they also served science in their use for atmospheric research. In the US, Chuck Yeager became the first man to fly at supersonic speed in a rocket-powered Bell X-1 aircraft. Rockets, it became clear, were the key to a successful space program.

Rocket Science

Rockets are powered by jet engines, the principle behind them being simple. Sir Isaac Newton's Third Law states that for every action, there must be an equal and opposite reaction. By thrusting air at great pressure backwards, a jet engine and the vehicle to which it is attached are thrust forwards.

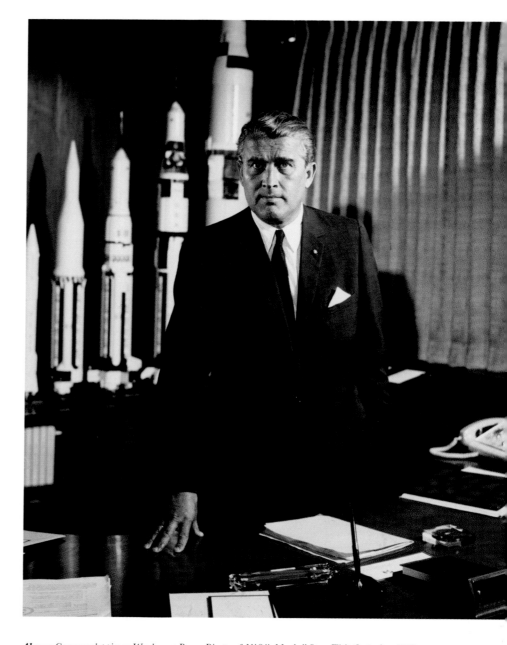

Above: German rocket pioneer Wernher von Braun, Director of NASA's Marshall Space Flight Center from 1960
Left: US test in 1946 of a captured German V2 rocket designed by Wernher von Braun

This principle has been known for nearly 2,000 years. In the mid-first century AD, Ancient Greek engineer Hero of Alexandria demonstrated it with a hollow copper sphere mounted on a horizontal axle. He filled it with water and set a fire under it; the resulting steam escaped from two small nozzles opposite each other on the sphere's 'equator', causing it to spin round at great speed. It was the first recorded steam engine and jet engine.

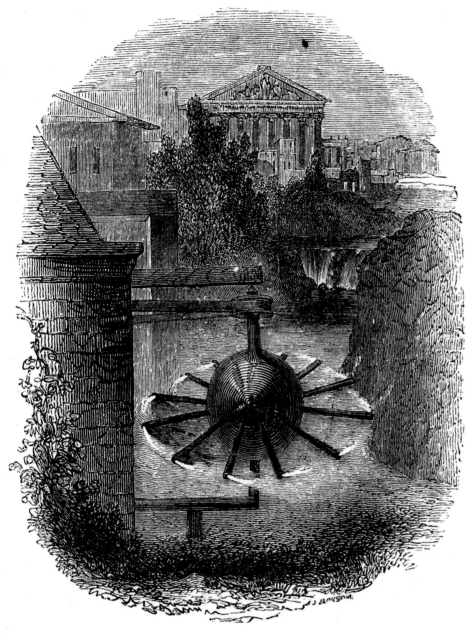

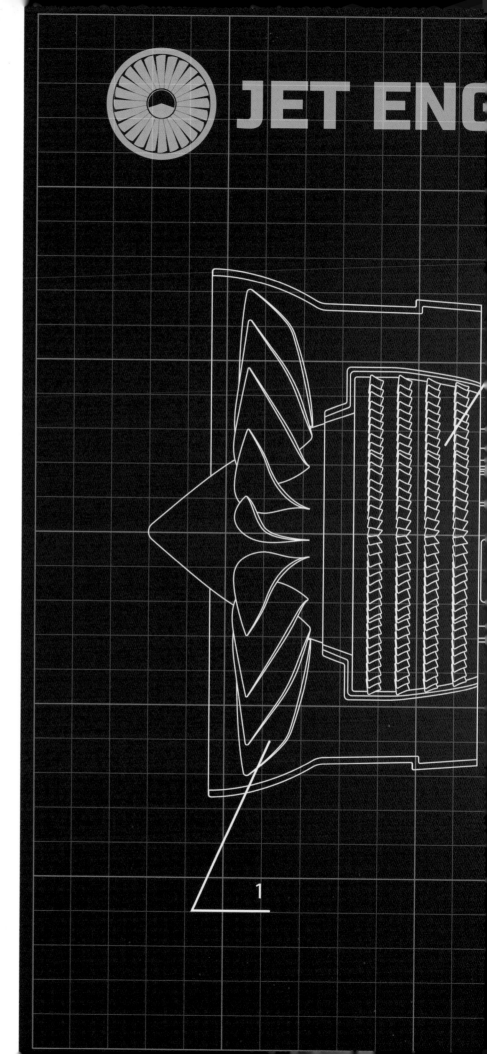

JET ENG

A jet engine conducts four stages – intake of air and fuel, compression, combustion and exhaust – in one long tube. All four stages contribute to the thrust that results, and the thrust is continuous. Although it consumes a lot more fuel as a result, the power produced is greater and more efficient. Fans, compressors and turbines within the tube increase the efficiency and power.

Above: *Reconstruction of the steam engine developed by Hero of Alexandria, demonstrating action and reaction*
Right: *Diagram of a jet engine*

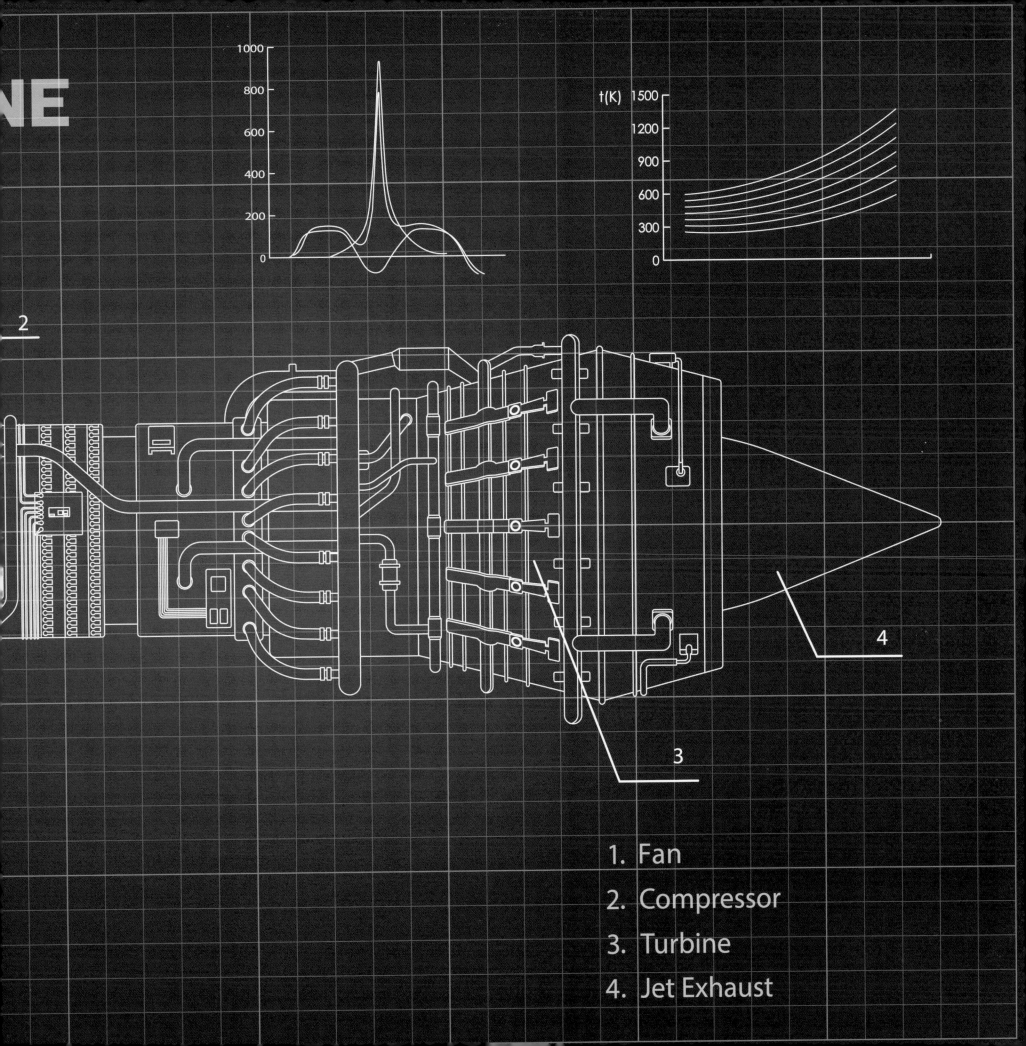

1. Fan

2. Compressor

3. Turbine

4. Jet Exhaust

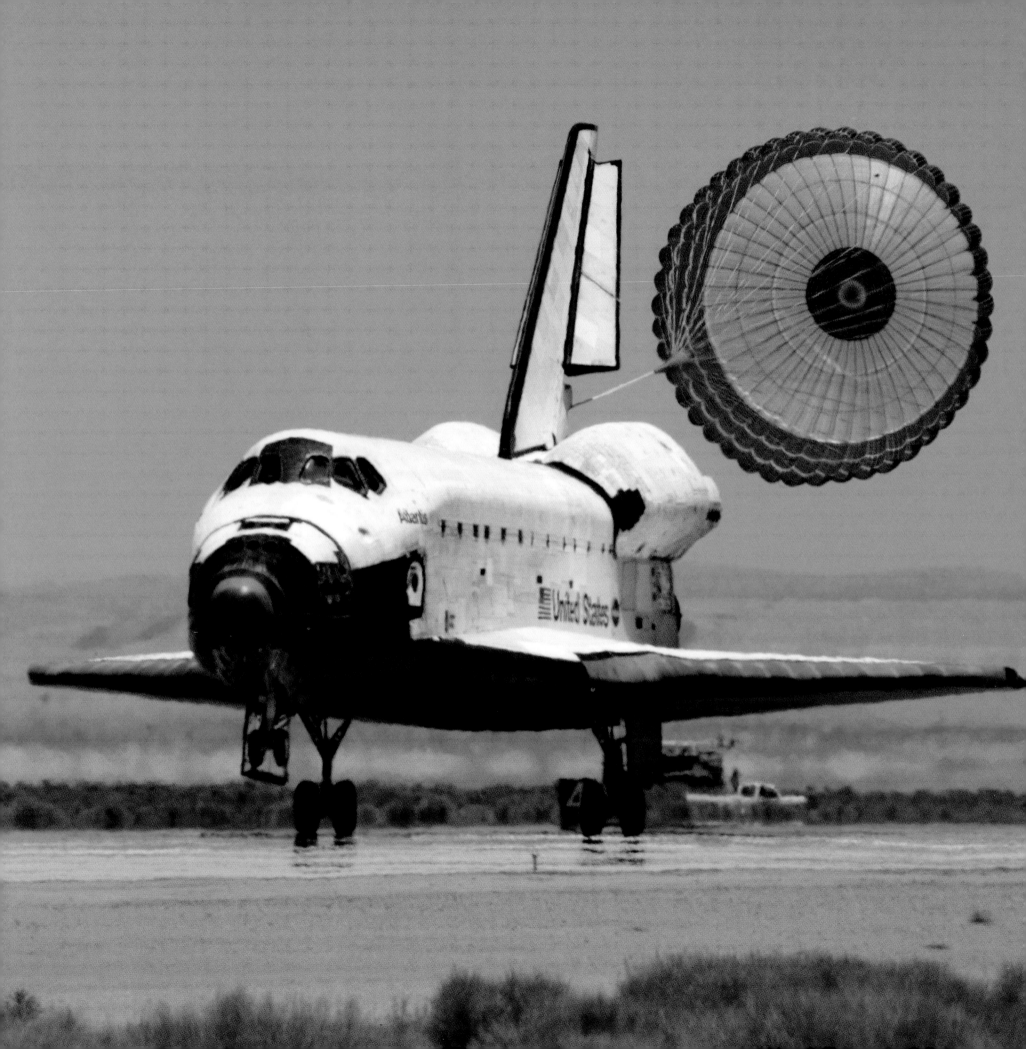

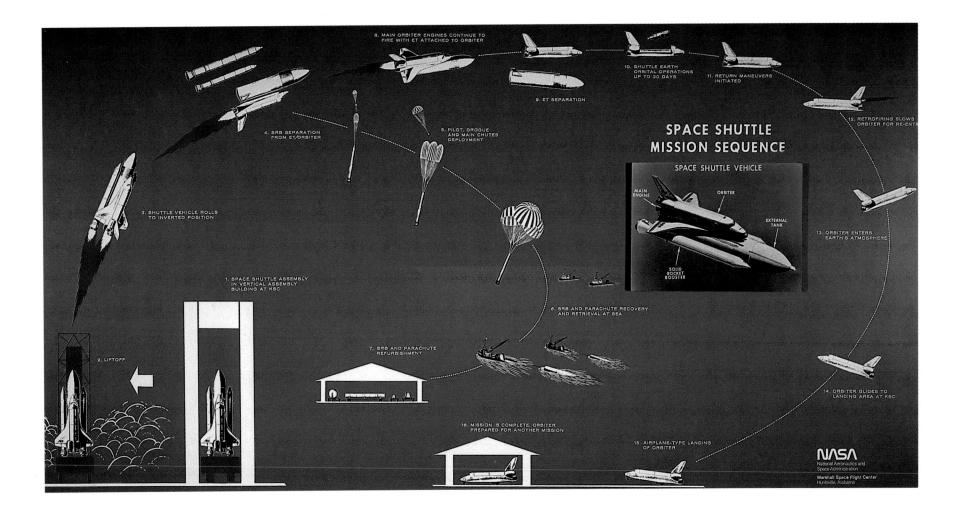

Within the image:

SPACE SHUTTLE MISSION SEQUENCE

SPACE SHUTTLE VEHICLE

MAIN ENGINE

ORBITER

EXTERNAL TANK

SOLID ROCKET BOOSTER

8. MAIN ORBITER ENGINES CONTINUE TO FIRE WITH ET ATTACHED TO ORBITER

10. SHUTTLE EARTH ORBITAL OPERATIONS UP TO 30 DAYS

11. RETURN MANEUVERS INITIATED

9. ET SEPARATION

4. SRB SEPARATION FROM ET/ORBITER

5. PILOT, DROGUE AND MAIN CHUTES DEPLOYMENT

12. RETROFIRING SLOWS ORBITER FOR RE-ENTRY

3. SHUTTLE VEHICLE ROLLS TO INVERTED POSITION

13. ORBITER ENTERS EARTH'S ATMOSPHERE

1. SPACE SHUTTLE ASSEMBLY IN VERTICAL ASSEMBLY BUILDING AT KSC

6. SRB AND PARACHUTE RECOVERY AND RETRIEVAL AT SEA

7. SRB AND PARACHUTE REFURBISHMENT

2. LIFTOFF

14. ORBITER GLIDES TO LANDING AREA AT KSC

16. MISSION IS COMPLETE, ORBITER PREPARED FOR ANOTHER MISSION

15. AIRPLANE-TYPE LANDING OF ORBITER

NASA
National Aeronautics and Space Administration
Marshall Space Flight Center
Huntsville, Alabama

What Goes Up Must Come Down

Rocket jets need vast amounts of liquid fuel to provide the energy to escape Earth's gravity. The same gravity causes problems for spacecraft returning to Earth. Travelling at supersonic speeds through the vacuum of space, they must slow down to the point at which parachutes or air brakes can safely be deployed. A retro-firing jet engine could do the job, but it would need almost as much fuel as it did at the launch.

Instead, returning spacecraft rely on the relative density of Earth's atmosphere compared to space to slow them down. It is the same principle as stone-skimming by a lake. As long as you spin the stone fast enough, it skims along the surface of the water until eventually the friction of the water slows it enough to sink. Entering the Earth's atmosphere at a flat enough angle has the same effect.

Belly Flops and Heat Shields

This atmospheric drag can tear an object apart. A meteor falling to Earth is likely to be broken up into much smaller meteoroids as it falls through the atmosphere. Many of the early V-2 rockets suffered the same fate. For larger objects such as ICBMs and space capsules, another factor affecting re-entry is the heat generated by aerodynamic resistance at such high

Above: Explanatory diagram of the Space Shuttle's mission sequence, issued by NASA in 1975
Left: Space Shuttle Atlantis returns to Earth from a mission to the International Space Station

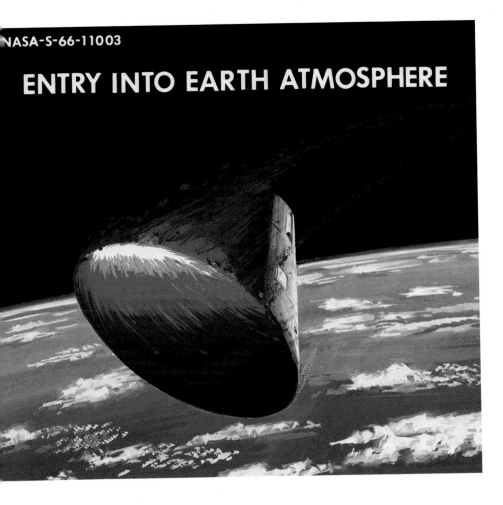

ENTRY INTO EARTH ATMOSPHERE

NASA-S-66-11003

speeds. The heat shield developed to combat this is important, even on the nose cones of missiles which have no need to slow down. On manned flights, any failure of the shield can be fatal.

Researchers in the early 1950s discovered that, surprisingly, blunt objects were less vulnerable to aerodynamic heat. The air in front of them is unable to flow around them at heat-inducing speeds and instead acts as a cushion. This is why space capsules from Gemini and Apollo re-entered blunt end first, and why the Space Shuttle belly flops down through the atmosphere.

Above: An artist's impression of the Apollo command module re-entering the Earth's atmosphere
Right: In 2018, a Soyuz spacecraft lands with astronauts returning after 168 days on the ISS

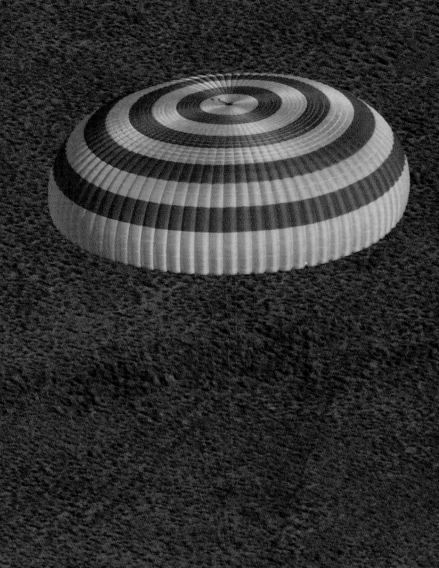

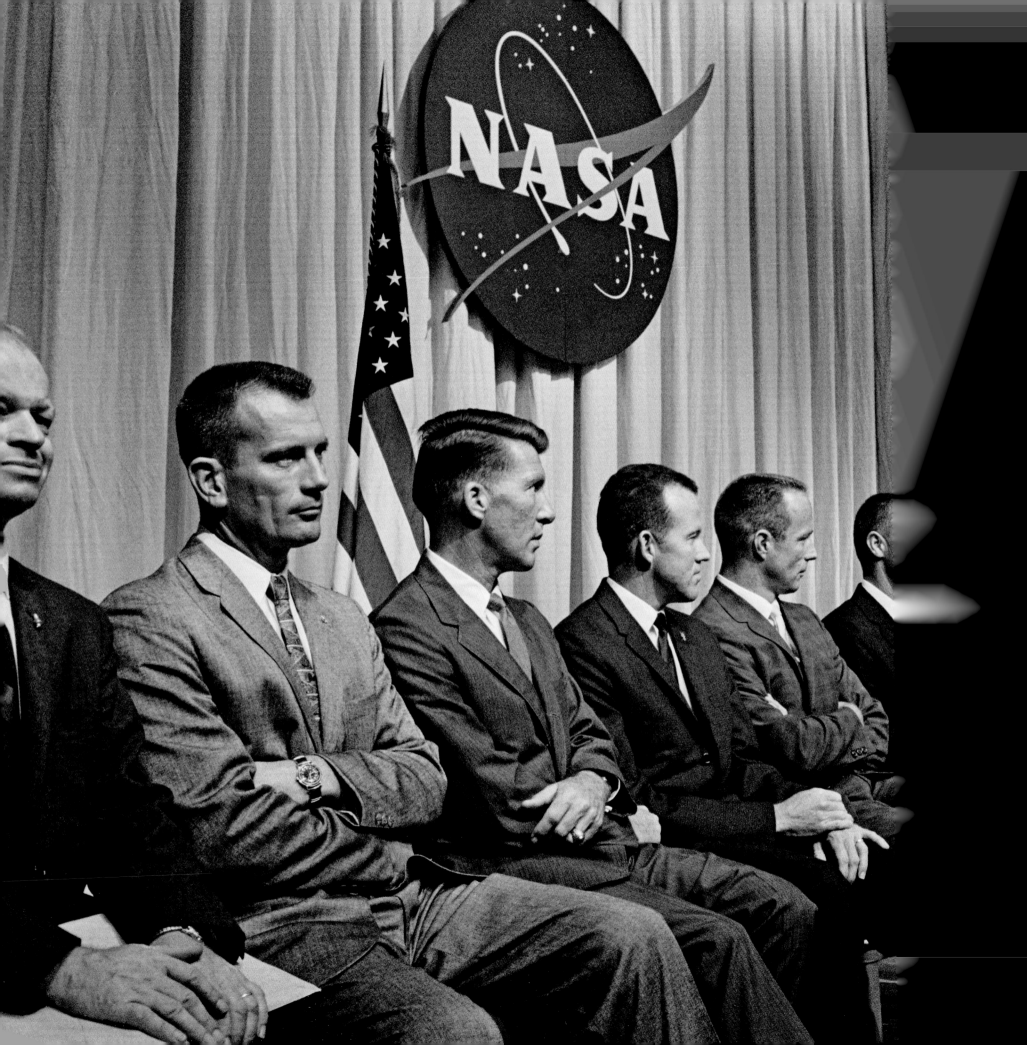

Spacecraft

Rockets, first developed for war in the thirteenth century and reinvented for warfare in the nineteenth century, were pressed into new service after the Second World War to carry ICBMs to their targets. When the successful launch of Sputnik 1 by a modified Russian ICBM R-7 rocket proved to be the starting gun for the Space Race, it was ironic that both sides were building on the same, German, technological innovations.

America and Russia took different approaches to the competition. For the US, NASA planned and guided the country's space strategy, and its Apollo program was overseen almost entirely by one man, Administrator James Webb. In the Soviet Union, Sergei Korolev was the lead designer and engineer, responsible for the early successes of Sputnik and Vostok, including the pioneering flight of Yuri Gagarin. However, despite living in a country under entirely central control, he had to balance the competing ambitions of several different state bureaux headed by rival designers.

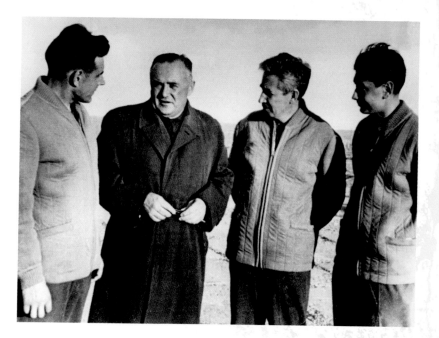

Above: *Space travel pioneer Sergei Korolev (in coat) with the crew of 1964 Soviet mission Voskhod*
Left: *NASA Director James Webb introduces the Mercury Seven, America's first astronauts, in 1959*

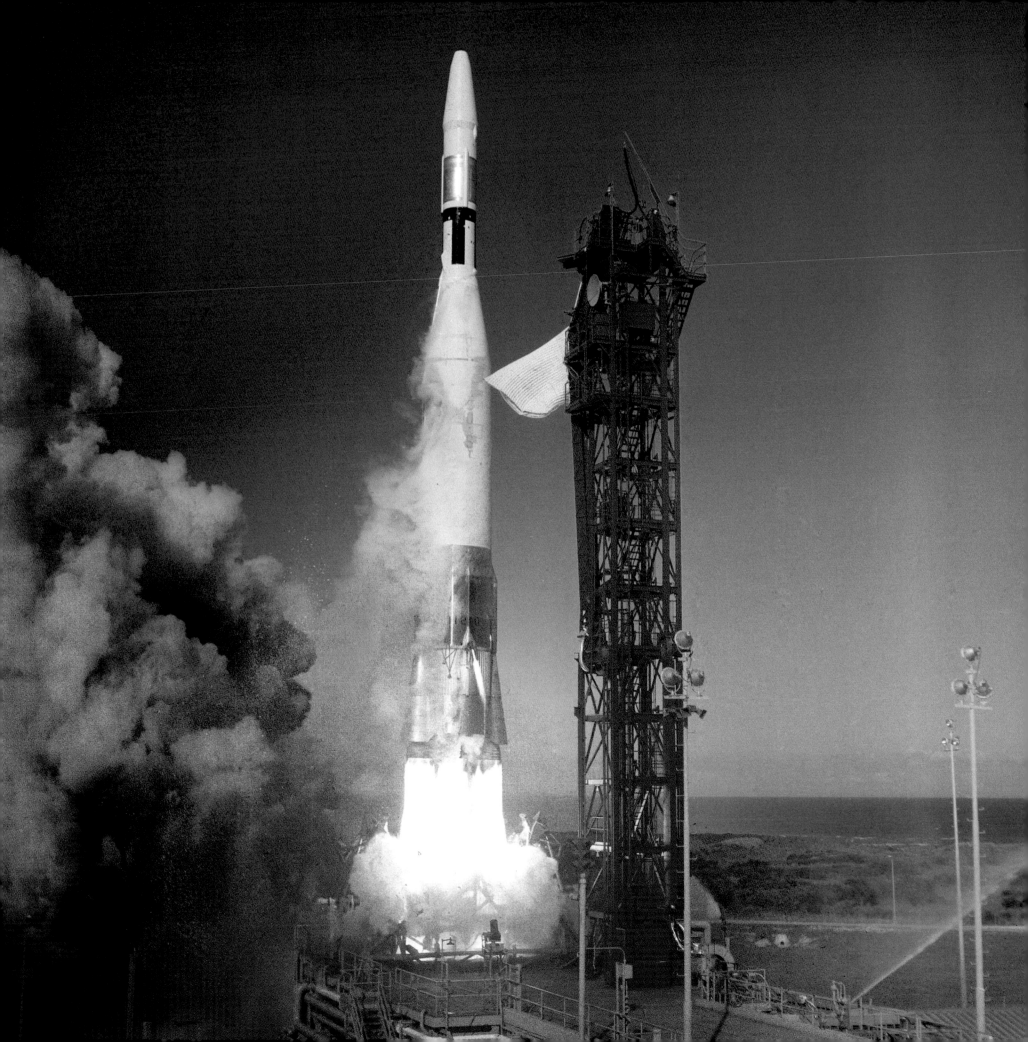

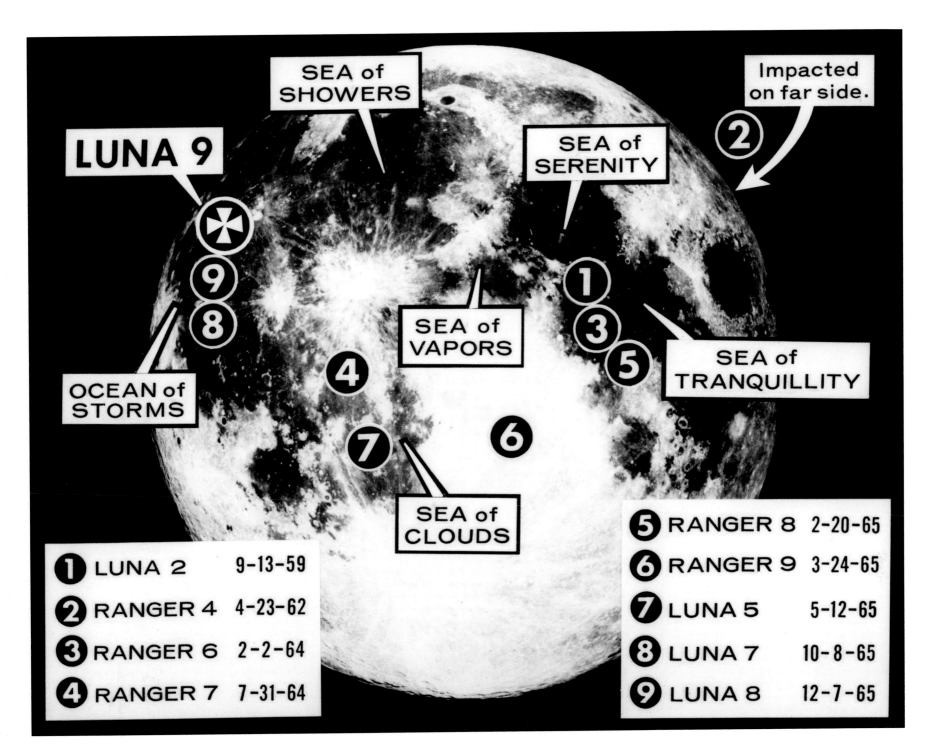

SEA of SHOWERS

Impacted on far side.

②

LUNA 9

SEA of SERENITY

✳

⑨

⑧

① ③ ⑤

SEA of VAPORS

SEA of TRANQUILLITY

④

OCEAN of STORMS

⑦ ⑥

SEA of CLOUDS

❶ LUNA 2	9-13-59
❷ RANGER 4	4-23-62
❸ RANGER 6	2-2-64
❹ RANGER 7	7-31-64

❺ RANGER 8	2-20-65
❻ RANGER 9	3-24-65
❼ LUNA 5	5-12-65
❽ LUNA 7	10-8-65
❾ LUNA 8	12-7-65

Above: Landing sites of early 1960s lunar probes from the USSR (Luna) and US (Ranger)
Left: Lift-off of an Atlas rocket carrying the Ranger 3 lunar probe in 1962

NASA's Race

In the United States, NASA planned a series of space programs designed to improve its knowledge and experience of space before committing an astronaut to fly to the moon. Its unmanned lunar probes were all launched by Atlas-Agena rockets derived from the US's Atlas missiles. Three of the nine Ranger launches and all five of the Lunar Orbiters were successful. Images captured by both series – the Ranger during descent, Lunar Orbiter from orbit – helped NASA to choose landing sites for the Apollo missions.

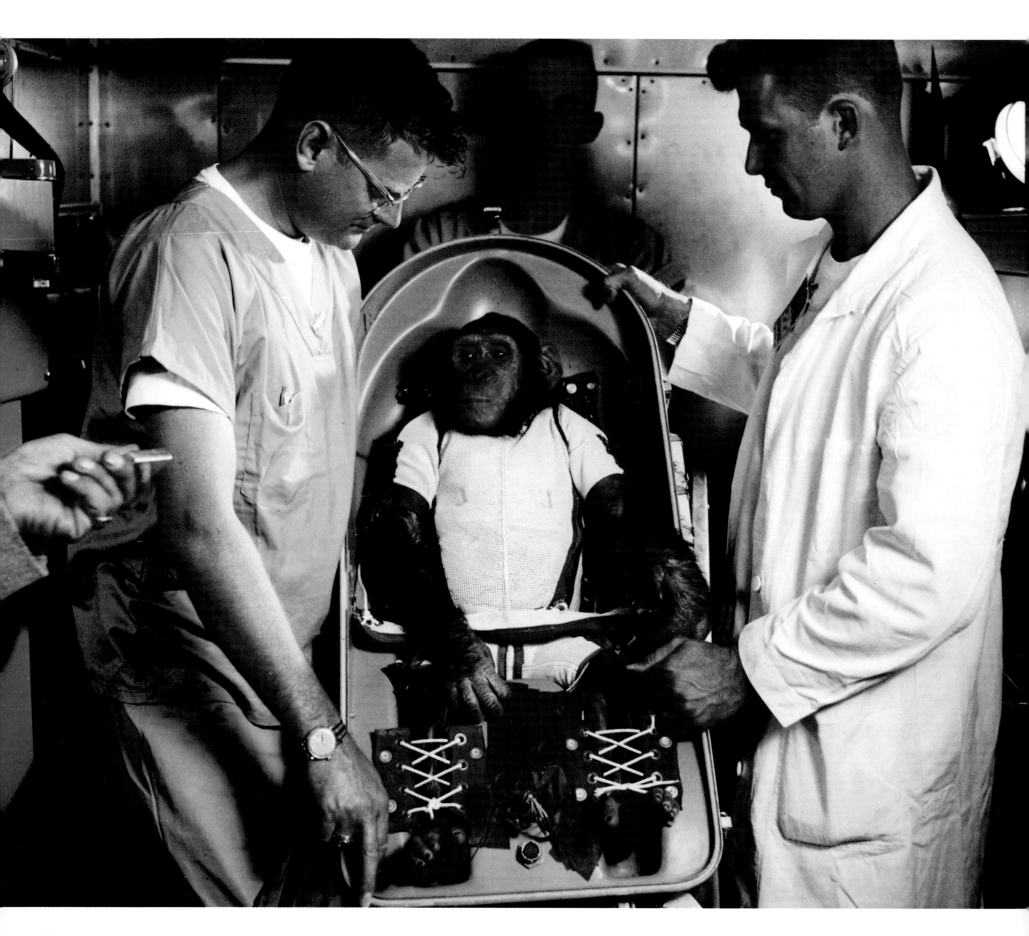

The successful Ranger flights were designed to crash into the Moon, a so-called hard landing. The USSR's Luna 9 was the first spacecraft to make a controlled descent, a soft landing, continuing to relay information back to Earth and proving that a moon vehicle would not sink into the surface dust. The US did not carry out soft landings until its Surveyor series of probes between 1966 and 1968. The Surveyors were launched on Atlas-Centaur rockets, and their guidance systems and landing mechanisms were crucial experiments in the progression to a manned lunar landing.

Monkeys and Men in Space

The US had yet to get a man into space. NASA was more cautious than the USSR in its approach. The program, codenamed Mercury, was in two stages – first, sub-orbital flights using adaptations of Redstone missiles, then orbital missions launched by Atlas derivatives. Each stage was planned in three steps – unmanned, then carrying an ape, and finally a human.

On 31 January 1961, Ham was the first chimpanzee in space, and on 5 May Alan Shepard was the first American, both in suborbital flight. Enos on 29 November and John Glenn on 20 February 1962 were their counterparts in the orbital stage. US astronauts traditionally name their own capsules. Shepard's was Freedom 7, Glenn's Friendship 7. The number 7 was used for all capsules in honour of the seven astronauts selected for the Mercury program from the US Army, Navy and Air Force.

Pushing the Envelope

The success of the Mercury program restored American pride and confidence in its ability to win the Space Race. Within weeks of Shepard's flight, President Kennedy announced the US's commitment to putting a

Left: Chimpanzee Ham operated levers on a 1961 Mercury test flight when cued by a flashing light
Right: Alan Shepard is picked up after splashdown, having become the first American in space

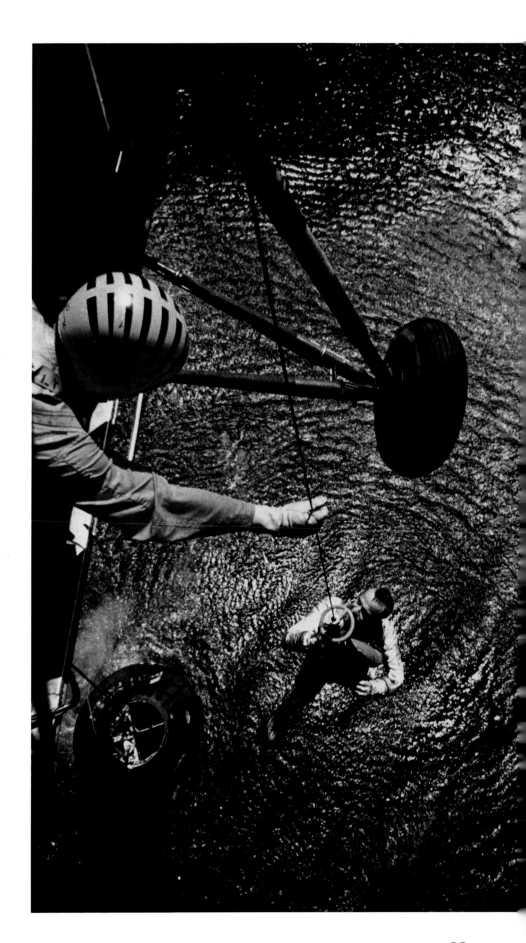

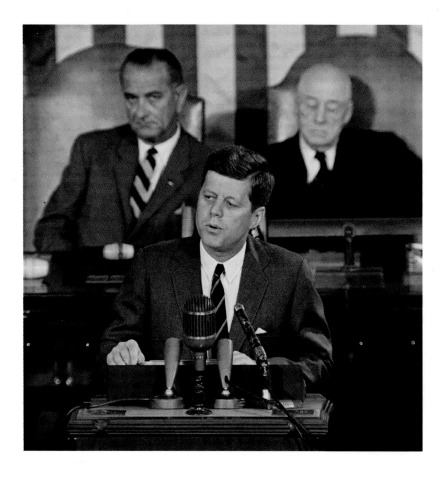

Above: Spurred by Soviet success in space, President Kennedy announces the Apollo program in May 1961

man on the Moon. Mercury was succeeded by Gemini, which conducted a series of flights with two-man crews. The Gemini capsules were all launched on Titan II rockets, which in their military capacity were successors to the Atlas ICBMs that powered the Mercury flights.

The purpose of the Gemini missions was to overcome the technical challenges of travel in space. Gemini capsules practised docking procedures with unmanned targets to test manoeuvrability, and Gemini crews remained in orbit for longer periods to establish whether astronauts could survive long enough in space to get to the Moon and back.

Right: A replica of a Vostok spacecraft at Russia's Konstantin Tsiolkovsky State Museum of the History of Cosmonautics, opened in 1967

The USSR's Race

The R-7, which carried Sputnik into orbit, was the basis for a whole family of Soviet space rockets: the Luna, which carried unmanned lunar probes into space; the Vostok, used for the first manned space flights and for launching weather and reconnaissance satellites; and the Voskhod, the first to take more than one cosmonaut into space and from which the first spacewalk was made. The Russian space program gave the same names to its rockets and to its spacecraft. So the Luna rocket delivered the Luna moon probes, a Vostok rocket carried a Vostok space capsule, and so on.

Chief Designer of Rocket-Space Systems Sergei Korolev dreamt of travel to Mars, and he wanted to make a manned Moon landing the important first stage for Russian space efforts. His superior, Deputy Premier Dmitri Ustinov, had played a key role in developing captured German rockets for Soviet ICBMs, and had military rather than lunar ambitions. His focus was on a planned military space station orbiting Earth, and he ordered Korolev to concentrate on Earth-orbit missions and on unmanned probes to other planets.

It was only by Korolev's intense lobbying and fully three years after the USA's commitment to lunar exploration that the USSR finally decided in 1964 to work towards a Moon landing, with Korolev in complete control. Despite this late start, the USSR intended to achieve one by 1968.

Soyuz Rises from the Ashes

Korolev began to work on two new rockets, the Soyuz (developing the R-7) and the massive N-1, which was intended to be the workhorse of the Moon-landing missions. However, soon after the establishment of the Soviet Moon program, the USSR suffered a series of blows to its morale and its capability. First, less than two years after his appointment as head, Korolev died in January 1966 after routine surgery, leaving others to pick up his work on Soyuz and N-1.

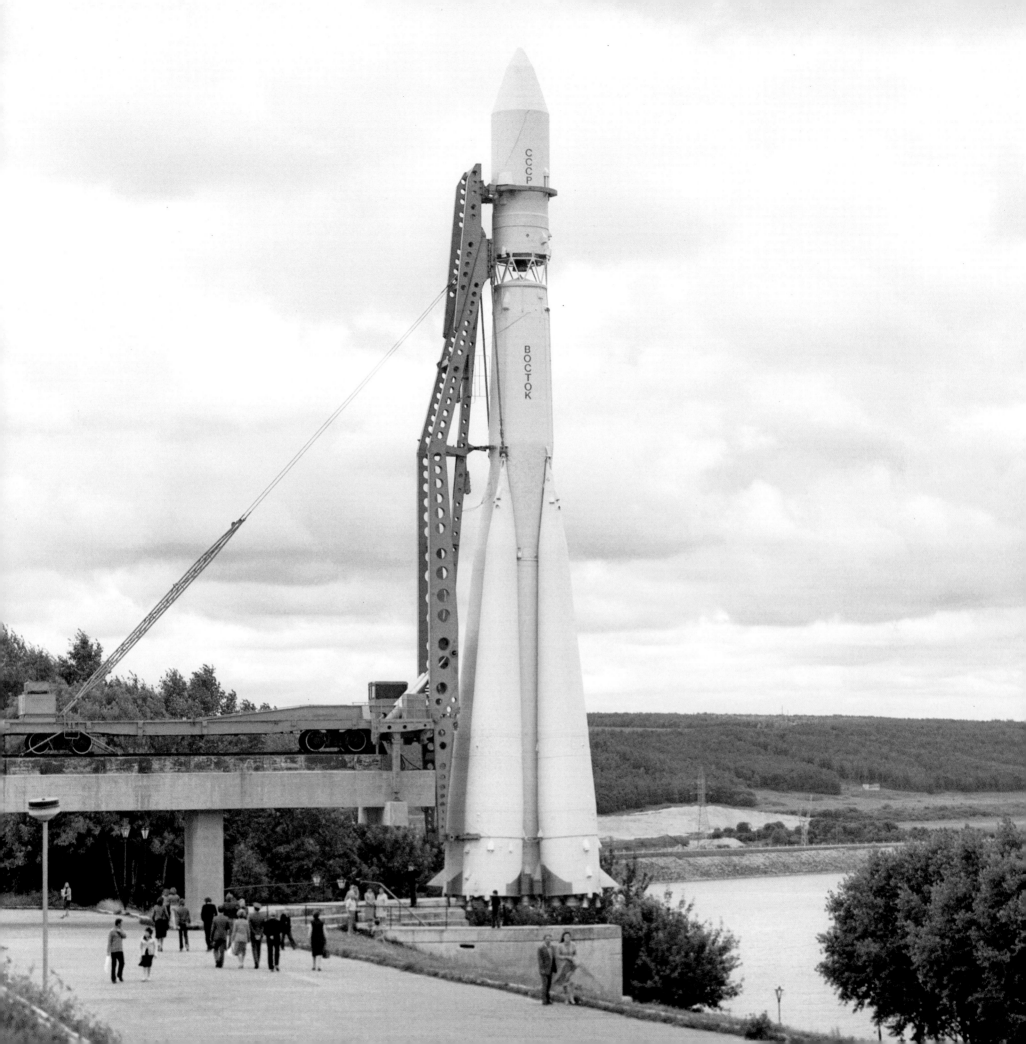

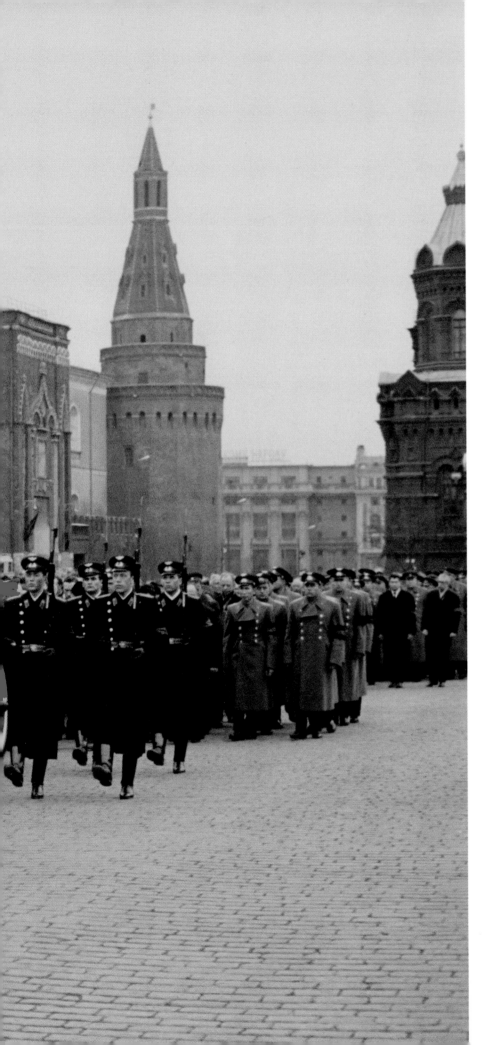

His replacement, Vasily Mishin, who lacked Korolev's brilliance, commitment and influence, was pushed into an early manned Soyuz flight before it had been thoroughly proved in unmanned tests. In April 1967, the Soyuz 1 capsule crashed to Earth and its cosmonaut, Vladimir Komorov (*see* pages 88–87), became the first space pilot to die during a flight.

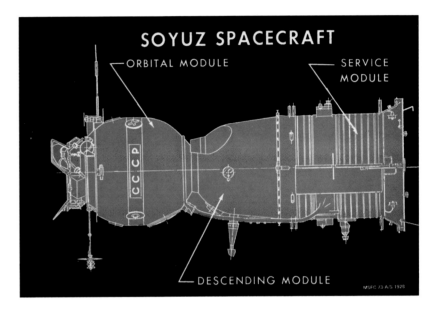

Above: *An illustration of the Soyuz spacecraft used in the Apollo-Soyuz Test Project in 1975 (see page 164)*
Left: *Yuri Gagarin's death and Red Square funeral procession in 1968 prompted mourning throughout the USSR*

In March the following year, the great Soviet space hero Yuri Gagarin, the first man in space, was killed when his MiG-15 jet fighter crashed during a routine training exercise, plunging the USSR into mourning. By the end of 1968, Apollo 8 had orbited the Moon, while a second manned Soyuz flight had failed in its mission to practise docking with an unmanned Soyuz capsule. With the Space Race all but lost, in desperation, the USSR attempted two unmanned launches of the underfunded and badly rushed N-1 in 1969. Both failed, and the second, on 5 July, exploded catastrophically, throwing debris over a six-mile radius. Sixteen days later, the Race was over. After two more failures of the N-1 in 1971 and 1972, further launches were put on hold in 1974 and formally abandoned in 1976. However, Korolev's Soyuz family of rockets still flies supplies to the International Space Station (ISS), more than 50 years after it was first developed. It is the most-used launch system in the history of space exploration.

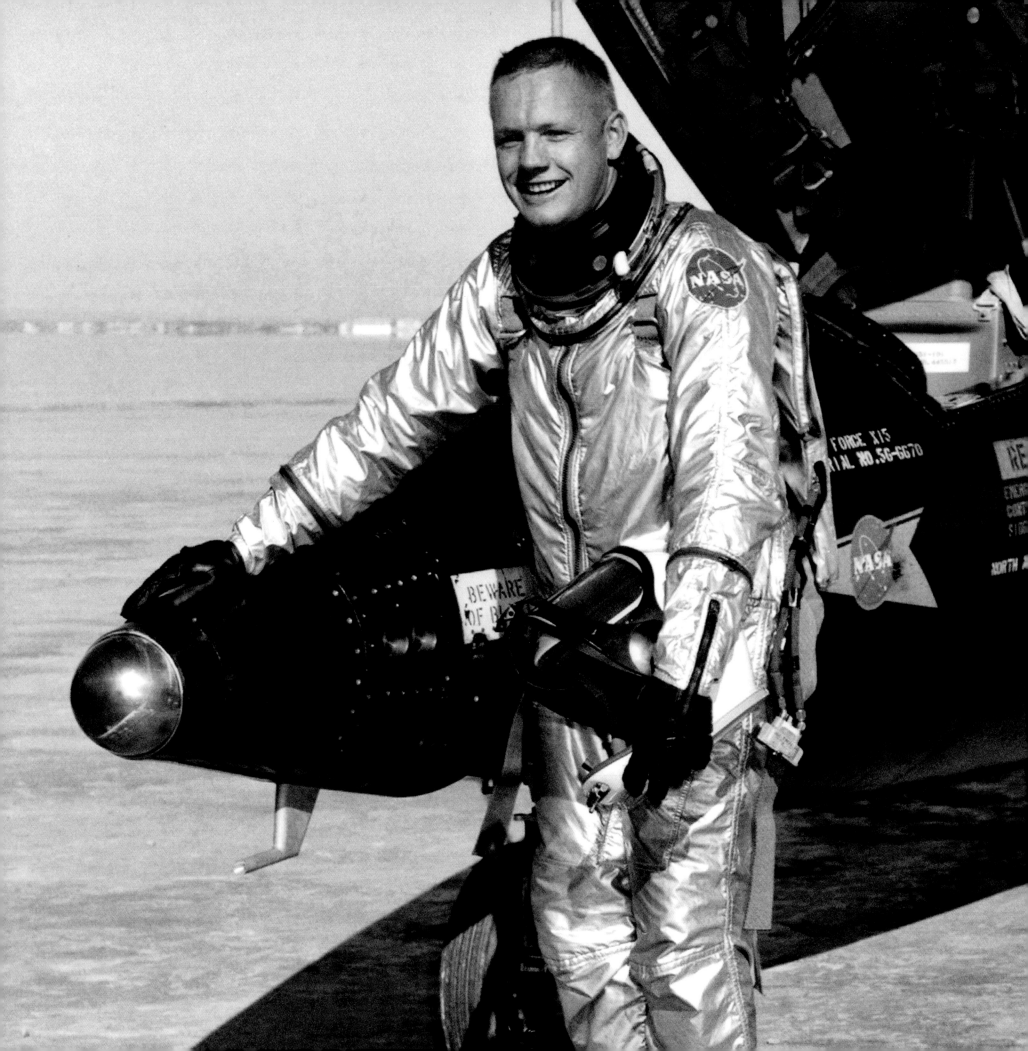

Human
Spaceflight

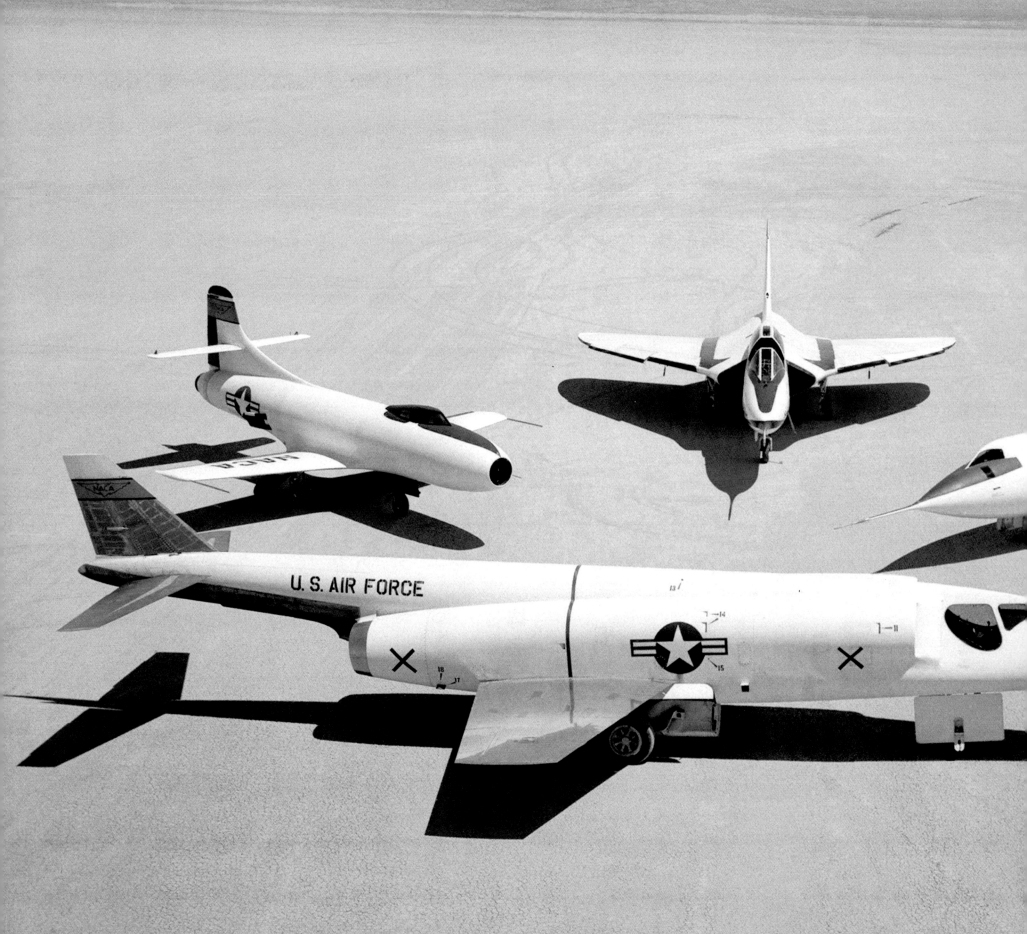

Project Mercury

It is one thing to design a machine capable of carrying human beings into space and back again, but it is quite another to be the human beings who undertake such a journey. Such people must have superhuman qualities, as author Tom Wolfe argued in his 1979 space history, *The Right Stuff*.

The book and subsequent film celebrate the early American pioneers of space flight. These ground-breakers were the first test pilots at Edwards Air Force Base in California and the seven men chosen for the United States' first program of manned space flight, Mercury. Soviet cosmonauts were certainly made of the same stuff, although in the atmosphere of the Cold War, news of their activities was carefully controlled and restricted by the USSR.

So Much At Stake

Russia's successful launch on 4 October 1957 of Sputnik 1, the world's first artificial satellite, caught America by surprise. By the time the US satellite Explorer 1 – launched on 31 January 1958 – had restored some American pride, Sputnik 2 had joined Sputnik 1 in orbit. The Space Race was now on and the opposing ideologies of Communism and capitalism fought for the prizes of propaganda and prestige which space exploration offered.

Explorer 1 was carried on a Juno 1 rocket, a modified Jupiter intermediate-range ballistic missile of the US Army. The US Navy's own rocket,

Previous page: Research pilot Neil Armstrong next to a hypersonic rocket-powered X-15 aircraft, 1960
Left: A group of Douglas airplanes, including (front) the X-3, an early attempt at supersonic flight

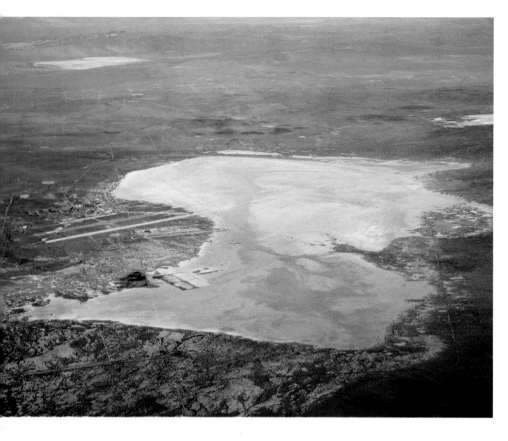

Above: Edwards Air Force Base, where Rogers Dry Lake makes an ideal landing strip

Vanguard, had exploded on take-off the previous December. In July 1958, following Explorer 1's success, President Eisenhower established NASA to co-ordinate the US space effort. NASA absorbed all of the nation's military space programs, including the MISS operation. Under NASA, this became Project Mercury.

Finding the Right Stuff

As the earlier air force name implied, Mercury's mission was to put an American in space, specifically in orbit around Earth, and to bring him back alive in his capsule. In the process, the Mercury flights were intended to discover how a human being functioned in the environment of space.

Right: A Jupiter-C missile during assembly. In 1958, a Jupiter-C launched America's first satellite, Explorer 1

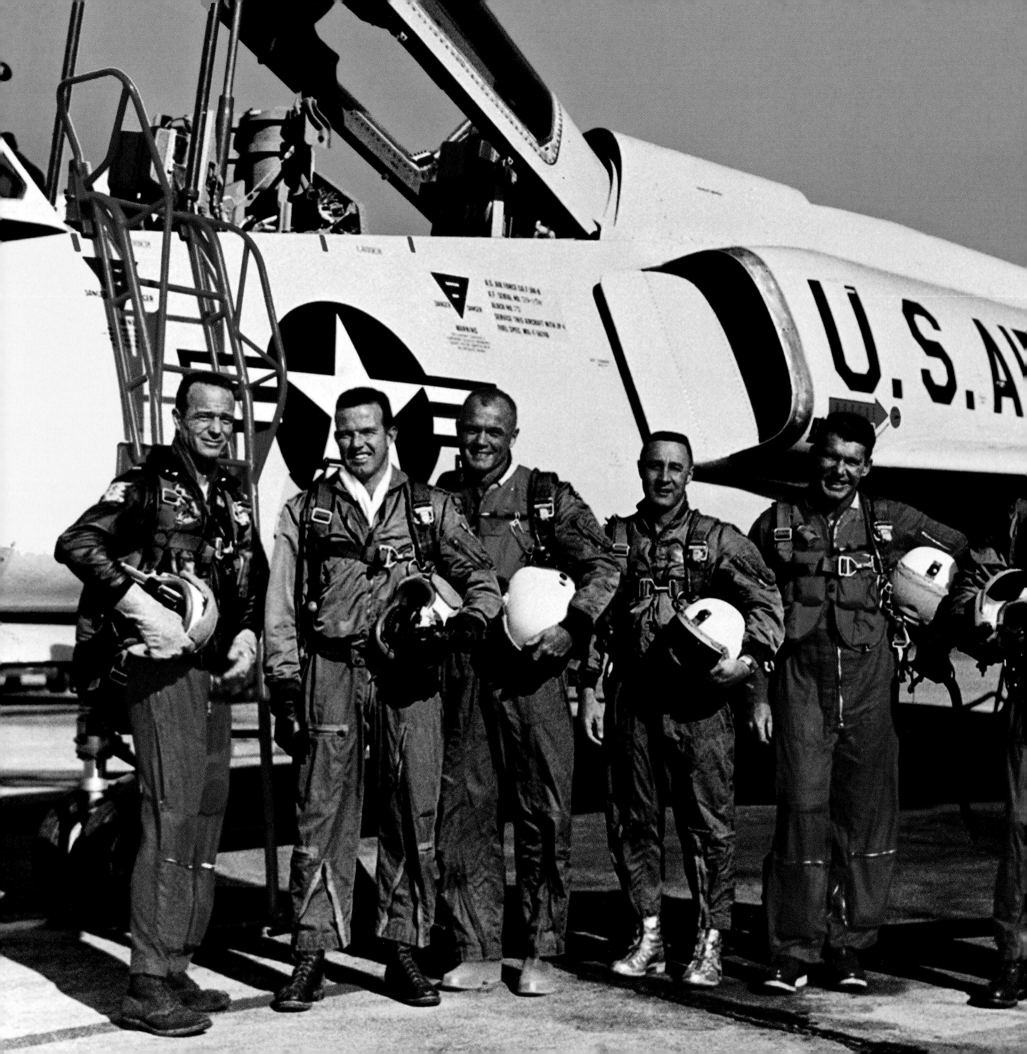

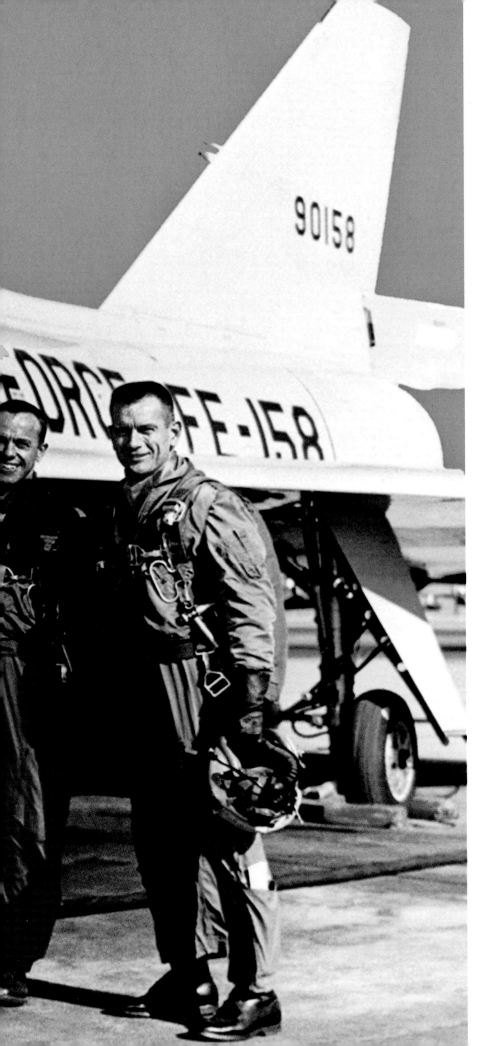

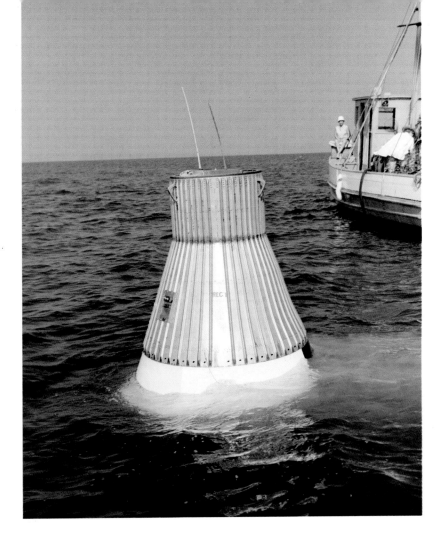

Above: A model of the Mercury capsule, designed to land in the ocean, undergoes flotation tests

NASA decided to recruit its first group of astronauts from the ranks of military test pilots, of which there were at the time 508 serving men, and no women. Through a series of other filters, such as height, age and education, 110 made it to interview, of which seven – celebrated today as the Mercury Seven – were finally accepted for training as America's first spacemen in April 1959.

No fewer than 17 unmanned flights were launched in the Mercury program before the first manned flight. While the astronauts trained, ground control tested the heat shield, controls and the abort and escape provisions of the Mercury capsule during flight. The first was a disappointing start to the program – while the rocket was still being prepared for launch, a faulty

Left: The Mercury Seven: l–r, Carpenter, Cooper, Glenn, Grissom, Schirra, Shepard and Slayton

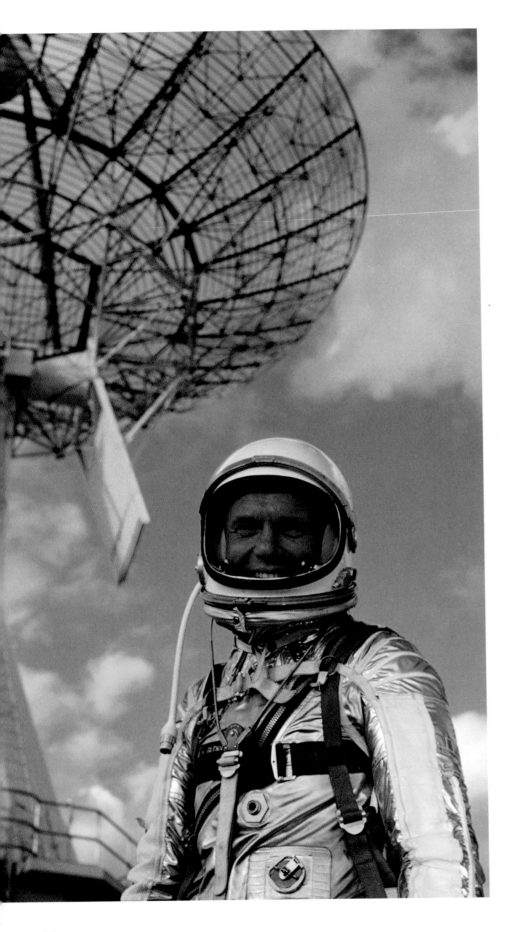

battery set off the abort system that was going to be tested during the flight. The rocket, called Little Joe 1, climbed a mere 610 m (2,000 ft) before crashing back to Earth.

Americans in Space at Last

Later test flights were more successful. Sam, the rhesus monkey, tried out the escape system in the upper atmosphere in December 1959 on board Little Joe 1B; and Ham, the chimpanzee, the life support systems of Mercury-Redstone 2 beyond the atmosphere in January 1961. Both survived.

After President Kennedy's declaration on 25 May that the USA would put a man on the Moon by the end of the decade, five more manned Mercury flights took place, progressing from suborbital leaps to full space orbits, each manned by a different member of the Mercury Seven.

Of the Seven, astronauts Gus Grissom, Scott Carpenter, Wally Schirra and Gordon Cooper all piloted a Mercury capsule. Only Donald 'Deke' Slayton, grounded by a heart condition, did not fly as part of the Mercury program. His time would come.

The Mercury program delivered on its mission, gaining invaluable experience of space flight for both the astronauts and the designers of their vehicles. Although the USSR still led the Space Race, Mercury proved to Americans that the US was in it to win it, restoring the nation's dented pride and winning public backing for costly space exploration. Glenn's orbital flight was commemorated on a postage stamp, the first of many issued by the US Postal Service in honour of the men and milestones of the US space program.

Left: Astronaut John Glenn at Cape Canaveral ahead of his groundbreaking Earth orbit
Right: The launch of Friendship 7, carrying John Glenn into orbit around the Earth, 20 February 1962

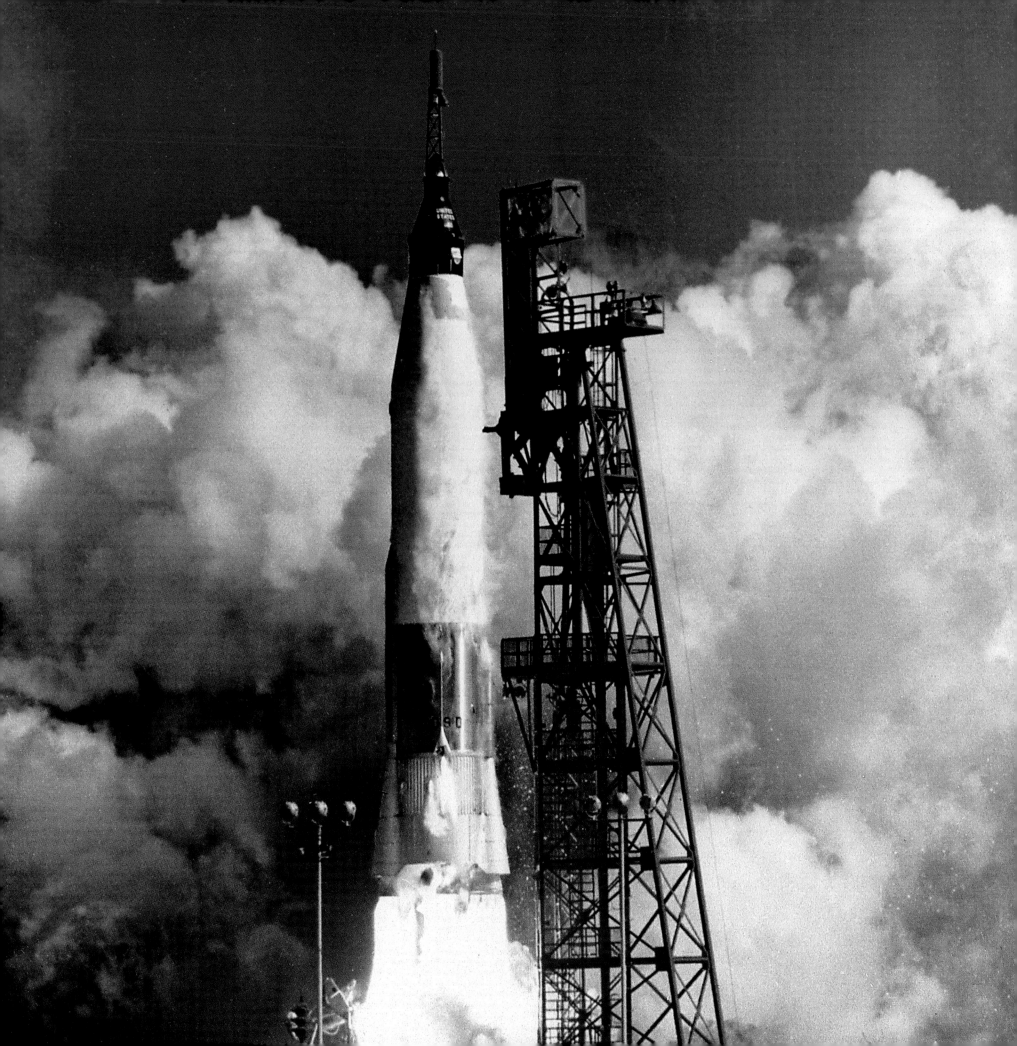

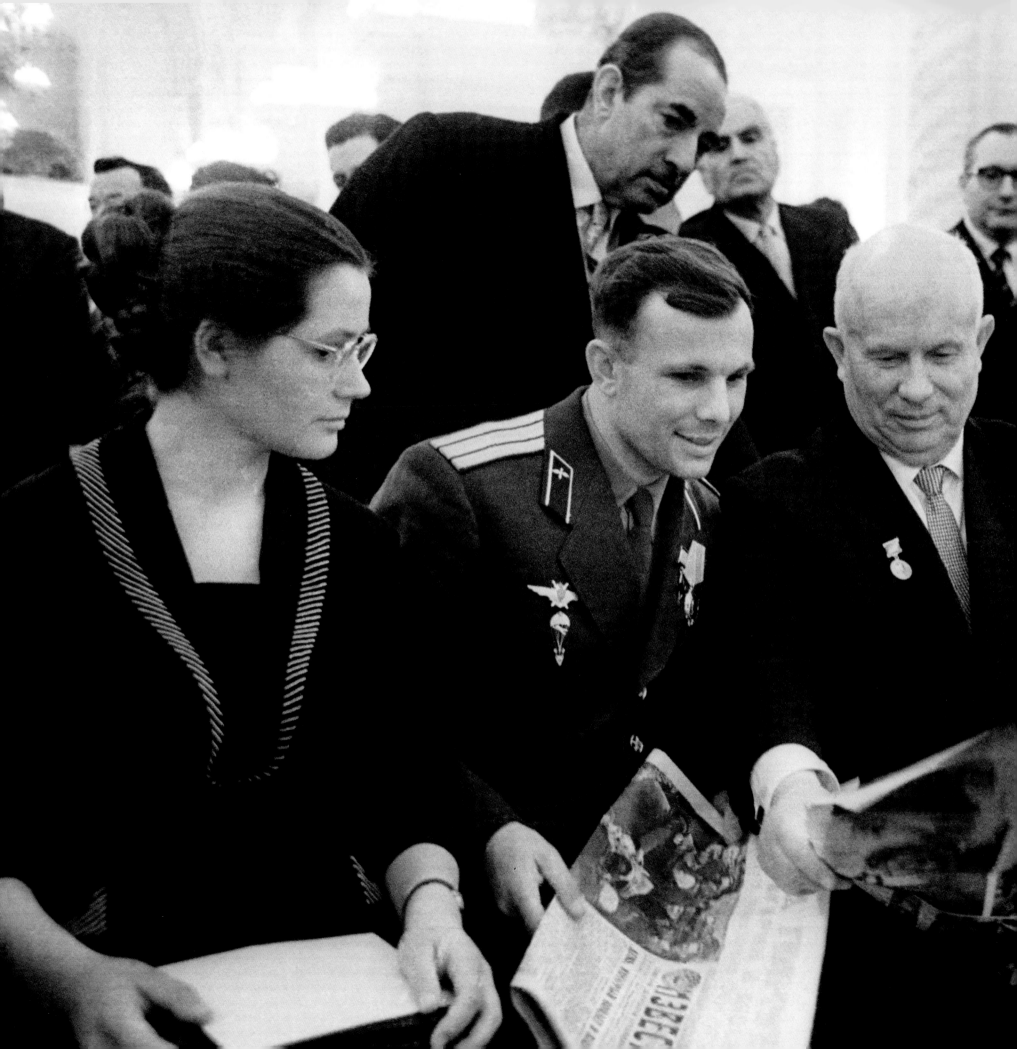

Back in the USSR

Would there have been a Space Race without a Cold War? Konstantin Tsiolkovsky, a pioneering early twentieth-century Russian rocket theorist, was the first to propose human space travel and to consider engineering solutions to many of its problems with a view to establishing colonies, not on the Moon but on Mars.

However, it was only after the US announced in July 1955 its intention to launch a satellite in 1957, designated International Geophysical Year, that the USSR began its own space program. Khrushchev responded positively

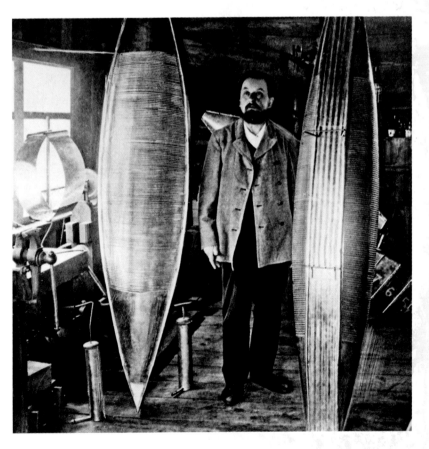

Above: *Russian space visionary Konstantin Tsiolkovsky pictured in 1913 with his experimental all-metal airships*
Left: *Khrushchev with cosmonaut Yuri Gagarin*

in January 1956 to Sergei Korolev's lobbying, recognizing that here was an opportunity to outdo the US and demonstrate Communism's superior technical and organizational potential. Khrushchev's primary interest, however, was in the development of the rockets as ICBMs.

Sputnik in Space

Sputnik 1 and Sputnik 2 both beat the US's first satellite into orbit. Russia had safely sent up and recovered two dogs in an atmospheric rocket in 1951, eight years before Sam's suborbital Mercury flight. Now Sputnik 2 also carried a dog, Laika, the first animal in space, three years ahead of Ham.

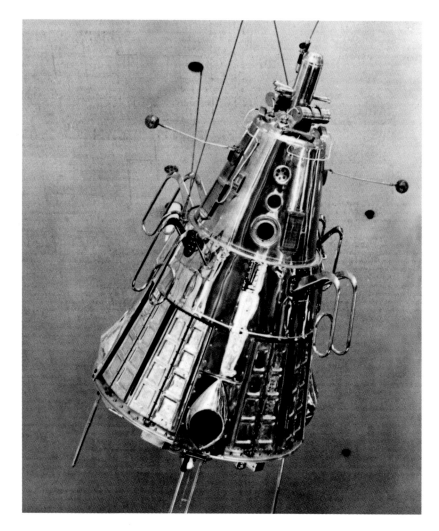

Above: *A model of satellite Sputnik 2 exhibited in East Berlin in 1959*
Right: *Laika, the Moscow stray who became the first dog in space on board Sputnik 2*

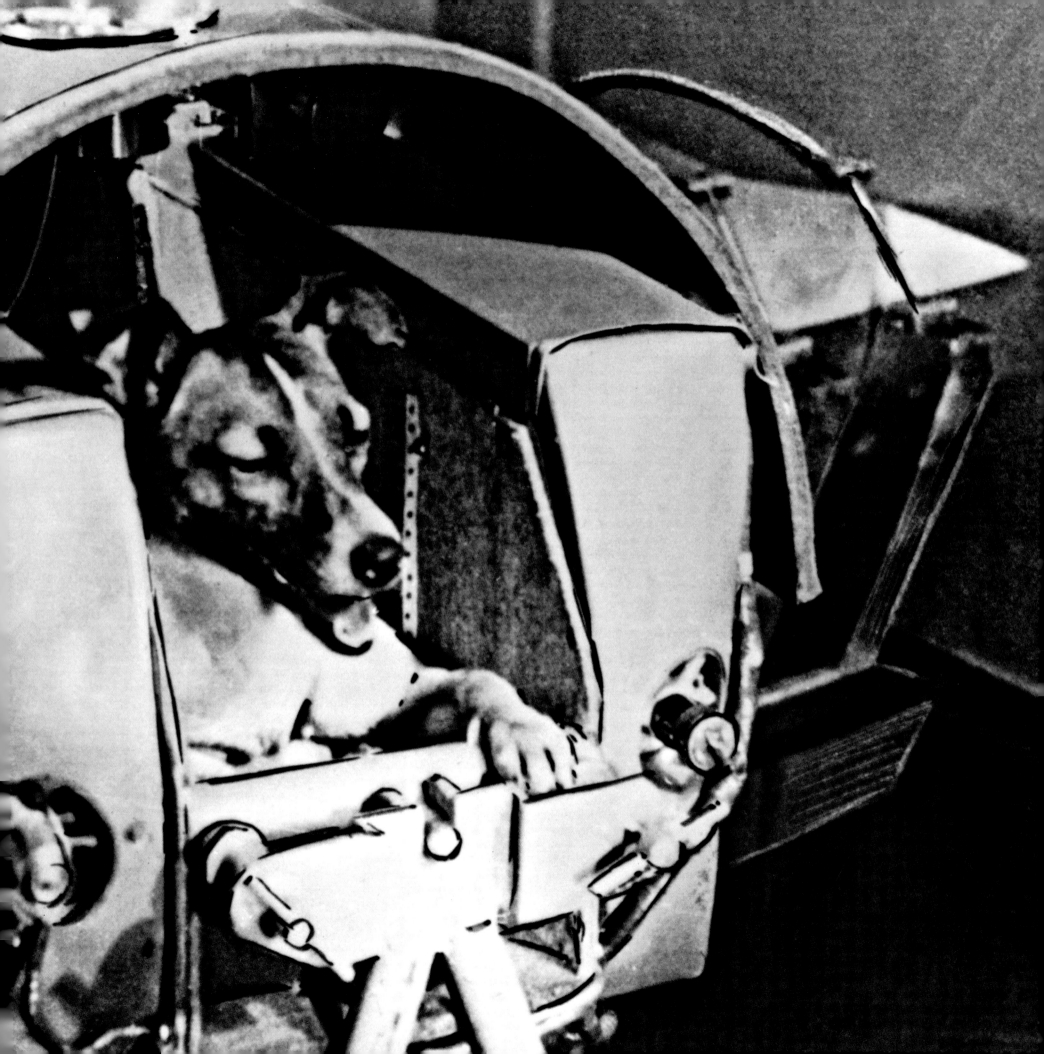

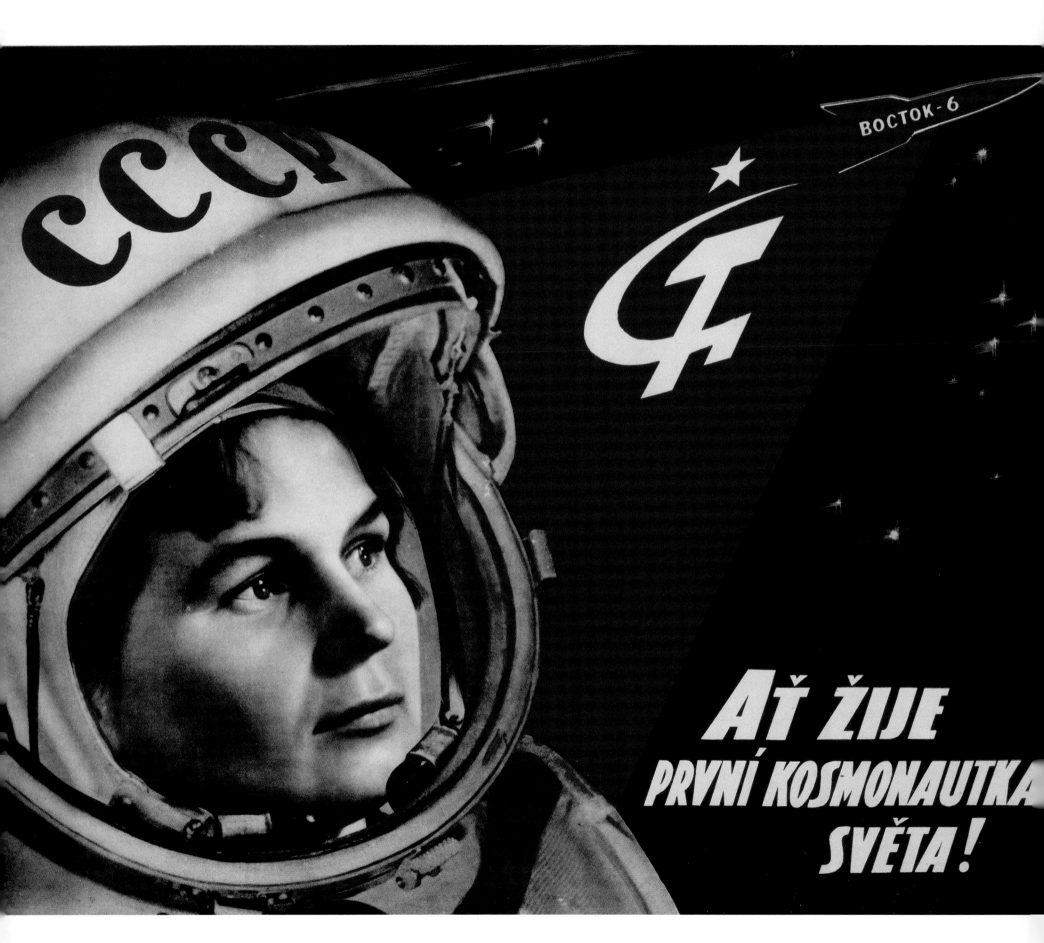

As a classified military program, the Soviet space effort was carried out in great secrecy. The identity of Korolev was kept undisclosed for fear of assassination attempts. Successful missions were announced only after they were known to have been successful, and accidents and failures were concealed. It was only under Gorbachev's policy of *Glasnost* – openness – that many details of the USSR's space program became known to the West in 1989.

Starting a full six months behind the US, Sputnik's arrival in orbit was a propaganda coup. The planned addition of the Zenit series of military satellites was now combined with the goal of getting a man in space and was called the Vostok program.

Vostok in the Void

Vostok's greatest achievement was its first manned flight under the command of Yuri Gagarin, a carpenter's son who joined the space program from the Soviet Air Force. Of the Sochi Six – the six men chosen for the USSR's first program of manned space flight – Gagarin stood out from his peers for his sharp mind and reflexes, and his willingness to push himself.

His flight transformed the human experience. For the first time in history, mankind was able to leave the planet on which we had evolved. But after the glory of changing for ever how we view our place in the Universe, it took Gagarin ten minutes to come down to Earth. When Vostok 1 re-entered Earth's atmosphere after his pioneering orbit, Gagarin had to leave the capsule in mid-descent and parachute the last 7 km (4.3 miles), because there was no provision on the capsule for a soft landing.

Gherman Titov, who would have been Gagarin's replacement on Vostok 1 in the event of illness, became – with Vostok 2 – the first man to spend more than 24 hours in space. Vostoks 3 and 4 flew simultaneously – another first – and Vostok 6 took the first woman into space (*see* page 28–31).

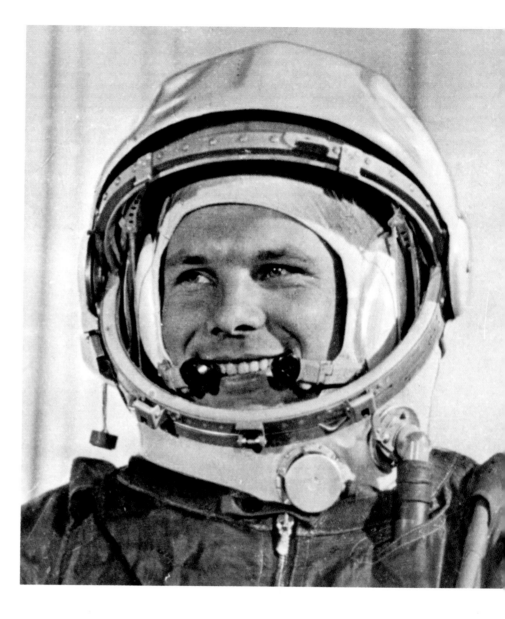

The Moon and Mars

Korolev was planning to send a manned mission to Mars in 1968, thus the early Vostok missions were aimed at solving interplanetary problems of travel. When Gagarin became the first man to orbit Earth, it was as part of an ambitious plan for self-sustaining long-distance spacecraft departing from large-scale staging posts circling our planet.

Above: A still of Yuri Gagarin from the 1961 Soviet documentary First Voyage to the Stars
Left: Soviet cosmonaut Valentina Tereshkova, the first woman in space, on Vostok 6 in 1963

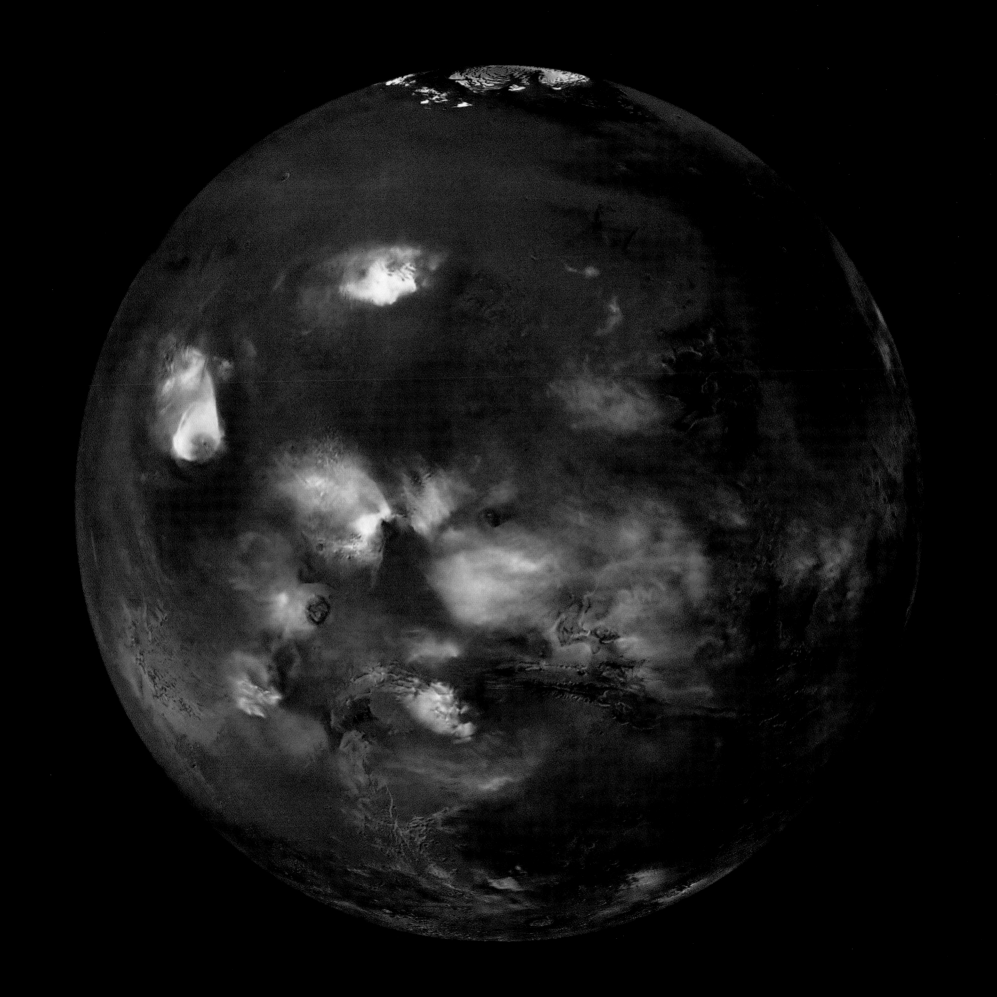

Russia's Luna program was the first to land a probe on the Moon and the first to take photographs of the dark side of the Moon, with Luna 3. But after President Kennedy promised the US public an American man on the Moon by 1969, it took Khrushchev three years to be convinced – by Korolev – that Russia should develop its own Moon-landing program.

Voskhod 1

The Voskhod program, successor to the Vostoks, was a direct challenge to NASA's Gemini program. Only two manned missions were flown out of six planned. However, the USSR's determination to win the PR battle with the US was at the expense of a more measured approach to manned flight.

The Voskhod program was almost entirely a propaganda exercise. It used leftover rockets and capsules from cancelled missions of the Vostok program with little in the way of technical innovation. In order to accommodate three cosmonauts in a capsule designed for one, the ejector seat was removed and the crew installed on a bench. The capsule had no abort rocket to carry the crew to safety in the event of a malfunction. Had the Voskhod rockets exploded on the launch pad, for example, there would have been no escape.

Voskhod 2

Although Voskhod 2 gave Alexei Leonov the honour of the first spacewalk, it nearly ended in disaster. The airlock consisted of an inflatable tunnel plated on to the side of the capsule. While Leonov was outside the capsule, his protective suit swelled up in the low-pressure environment of space and became so tightly inflated that he could not bend his limbs. Unable to complete any tasks, he found he could not even open the airlock hatch

Left: *A collage of photos taken by Mars Global Explorer in 1997 show that planet's weather*
Top right: *Voskhod 1 cosmonauts (l–r) Konstantin Feoktistov, Boris Yegorov and Vladimir Komarov after landing, October 1964*
Bottom right: *A radio station near Moscow receives transmissions from Voskhod 1, October 1964*

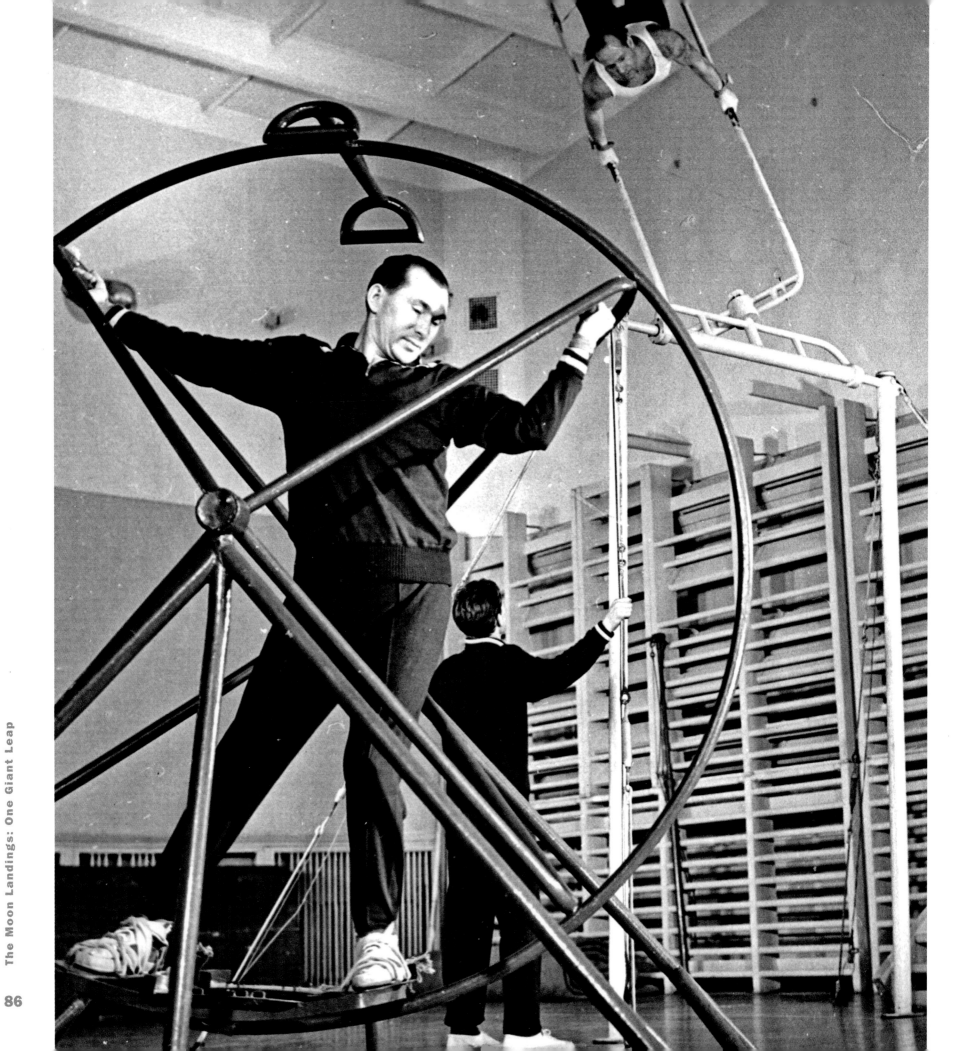

to re-enter the capsule until he had reduced the pressure in his suit to dangerously low levels. In his anxiety, he pitched headfirst into the airlock and found himself unable to turn around to close the hatch; and the delay in returning to the safe environment of the capsule resulted in a warping of the inner hatch and an imperfect seal.

Voskhod 2's return to Earth was no less hazardous. Leonov and his commander, Pavel Belyayev, were forced to orientate the capsule for re-entry manually because of the failure of an automatic system. It took an extra 46 seconds to return to their seats in the cramped conditions of the converted Vostok capsule. As a result, they overshot the planned landing site and came down instead in a dense, remote forest inhabited by bears and wolves.

A helicopter rescue was impossible because of the inhospitable terrain. After a cold, anxious night with pistols by their sides, they built, with the help of an advance ski-party of rescuers, a log cabin for their second night. On the third day, they skied to a waiting helicopter.

The Soyuz Program

The Voskhod missions were something of a technical stopgap following Khrushchev's decision to compete for the Moon. Korolev refined his plans for the Soyuz rocket, his latest variant of the R-7 ICBM, throughout 1964 and 1965. He intended the Soyuz spacecraft to be capable of docking with further rocket stages, which would have been placed in Earth's orbit in advance, increasing its range and reducing the payload of the rocket as it left its launch pad.

However, in 1964, Leonid Brezhnev toppled Khrushchev, Korolev's powerful ally in the Soviet space program, and there was considerable pressure to adapt Soyuz for military purposes. Korolev died aged only 59 in January 1966 and never saw his greatest design take flight. To date, Soyuz has flown

over 1,700 missions, having proved itself to be reliable, cheap and easy to build. During the 1980s, annual production reached over 60.

The USSR planned to conduct the first orbit of the Moon in 1967, and the first landing on it in 1968. After unmanned test flights, Soyuz 1 lifted off on 23 April 1967, with Vladimir Komarov, a veteran of the Voskhod 1 flight, on board. His mission was to rendezvous with Soyuz 2. Technical failures and bad weather forced the scrapping of the plan, and instead, Komarov began his re-entry into the atmosphere. Travelling at nearly 145 km (90 mph), the

Above: The world's first spacewalk: Alexei Leonov outside the capsule of Voskhod 2 in 1965
Left: The crew of Voskhod 2, cosmonauts Pavel Belyayev and Alexei Leonov, undergoing training in 1965

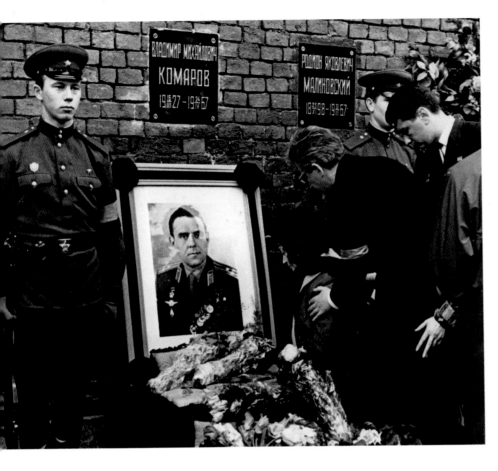

Above: Tributes to Soyuz 1 victim Vladimir Komarov by his wife and fellow cosmonauts in 1967

capsule's parachutes failed to open fully, and Soyuz 1 crashed to the ground, killing Komarov instantly. The retro rockets which should have slowed his descent only fired after the landing, completely destroying the capsule.

Both Apollo 11 and Apollo 15 left memorials on the Moon to Komarov, the first astronaut to die during a flight. His death, and the technical failures of Soyuz 1, caused an 18-month hiatus in the delivery of the Soyuz program, and effectively ended the Soviet race to the Moon. Soyuz 4 and Soyuz 5 docked and exchanged crews in orbit in January 1969, but a similar exercise in October that year with Soyuz 6, Soyuz 7 and Soyuz 8 was unsuccessful. By then, Apollo 11 had made lunar and human history.

Right: A Soyuz rocket launches successfully at the Baikonur Cosmodrome, Kazakhstan, in 2017

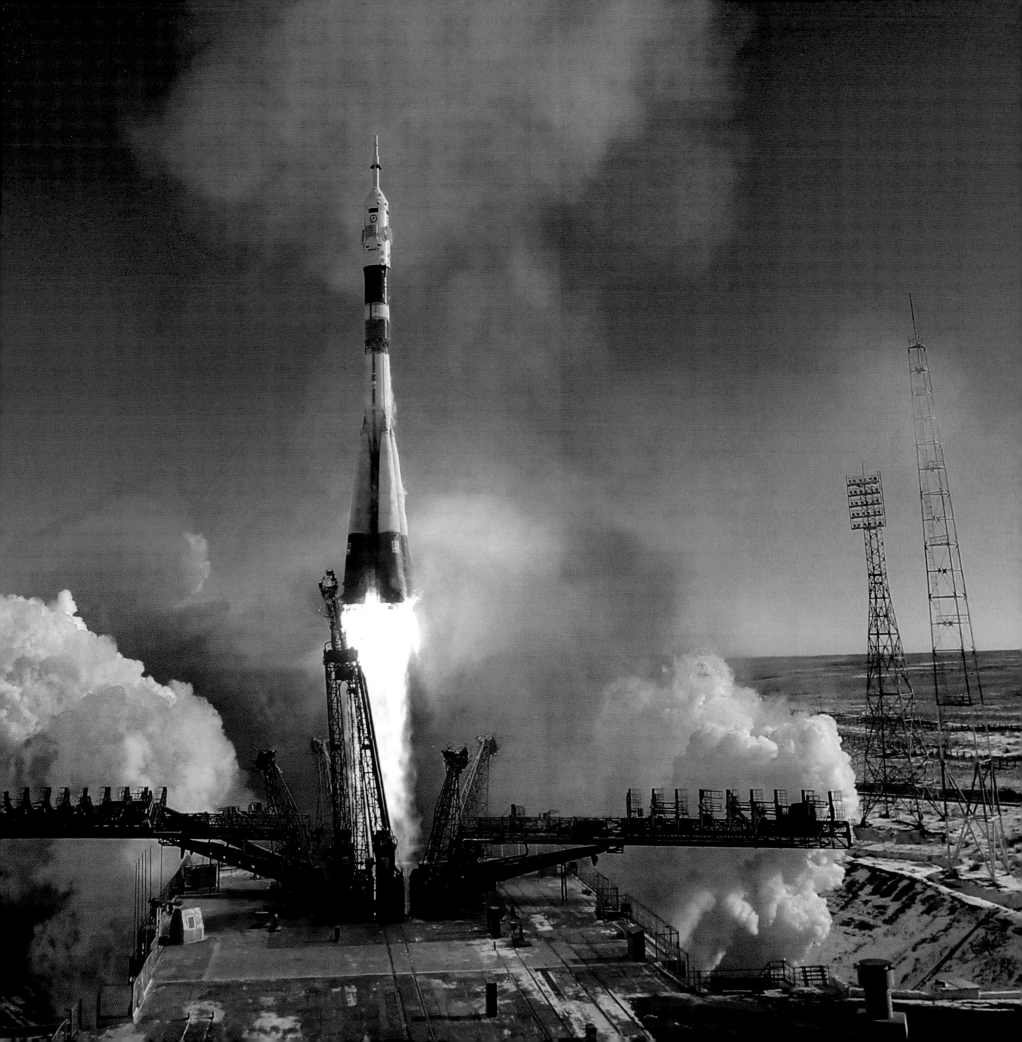

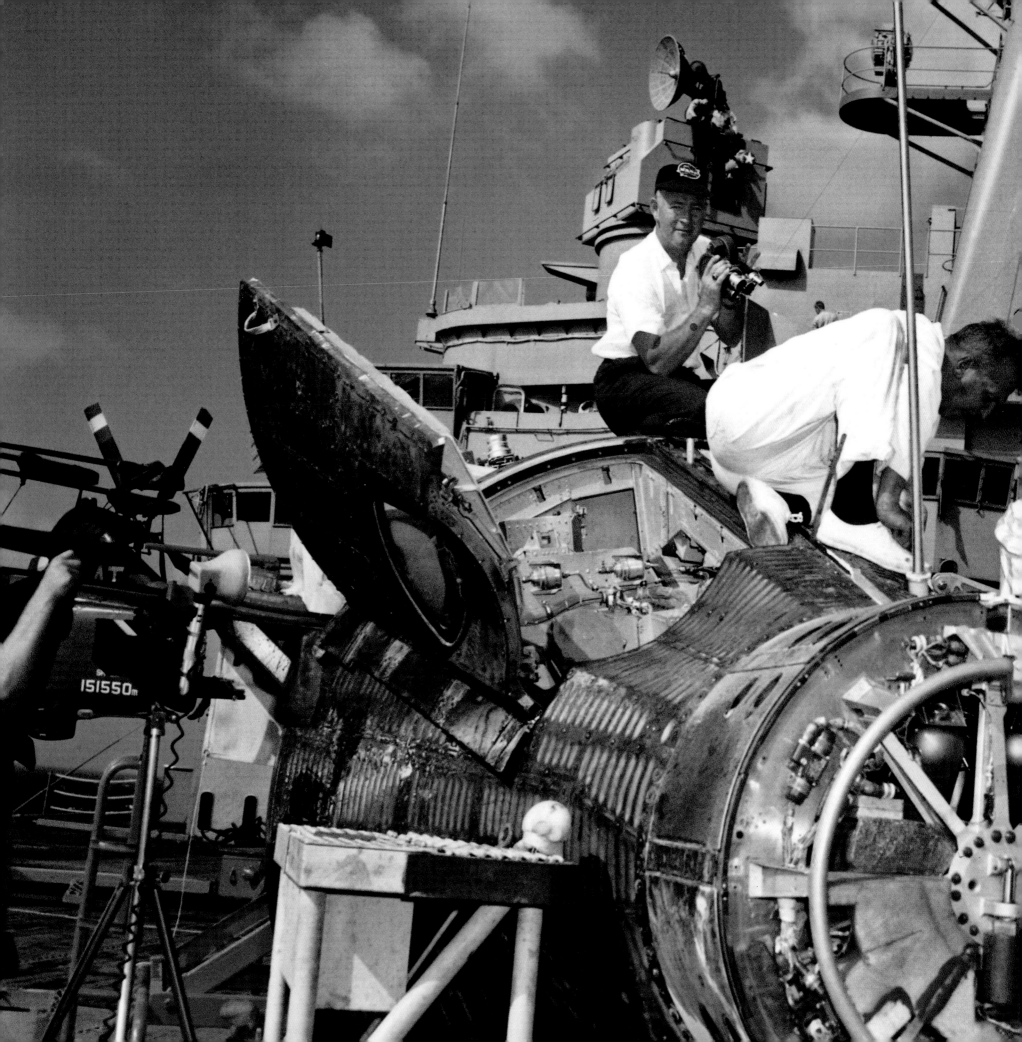

The Gemini Program

Gemini was a bridging project between Mercury, which got the US into space, and Apollo, whose aim was to put a man on the Moon. The capsule was simply an enlarged version of Mercury, whose fitness for purpose had been amply demonstrated, and its main considerations were to conduct docking missions between spacecraft, to field crews of more than one, to practise spacewalks and to extend the period astronauts spent in space. An eventual trip to the Moon would take at least eight days.

Of the original Mercury Seven, four astronauts went forward to Gemini and a substantial new cohort was recruited with an eye to the forthcoming Apollo program as well as the two-man flights of Gemini. They included

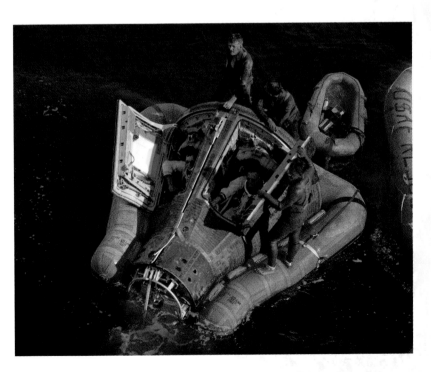

Above: *Neil Armstrong and David Scott in the Gemini VIII capsule after splashdown, 17 March 1966*
Left: *Aircraft carrier USS Wasp recovered the capsules of five Gemini missions in 1965 and 1966*

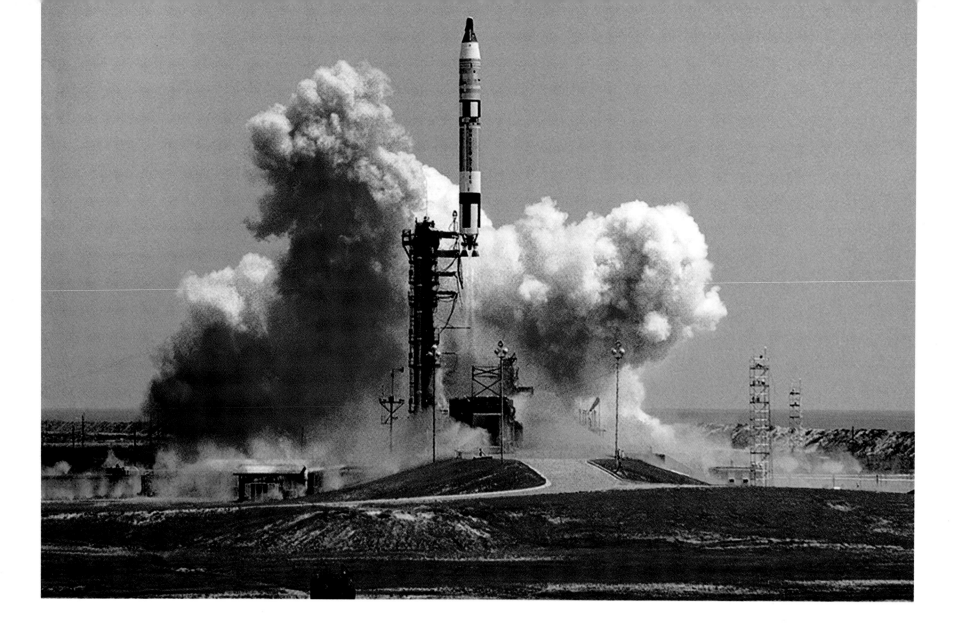

Jim Lovell, Michael Collins and Buzz Aldrin – and at last, Neil Armstrong, who, as a civilian test pilot, was ineligible for the Mercury Seven. Deke Slayton, who had missed out in Mercury because of a heart condition, was still out of action, but acted as Chief of the Astronaut Office.

Walking in Space

After two unmanned test flights of the Gemini capsule to test control systems and the effectiveness of the re-entry heat shield, 16 astronauts flew 10 Gemini missions between 1965 and 1966. This necessarily meant that some pilots flew twice, providing an opportunity to try out different combinations of pilots to assess their personal compatibility. The first three Gemini flights were designated by Arabic numerals – 1, 2 and 3. They followed a clear pattern of astronaut development, trying out new techniques and testing the limits of endurance. Gemini IV, the first to use Roman numbering, provided a big boost to US morale by staying up for over four days – approaching the five-day tally of Vostok 5 – and by staging the first American extra-vehicular activity (EVA). Ed White had the honour of opening the hatch and walking in space. He enjoyed the experience so much that he had to be ordered back into the capsule. Re-entering Gemini IV, he later claimed, was 'the saddest moment of my life'.

Above: Gemini IV takes off at Cape Kennedy, carrying Jim McDivitt and Ed White
Right: Ed White's spacewalk from Gemini IV on 3 June 1965, the first by an American

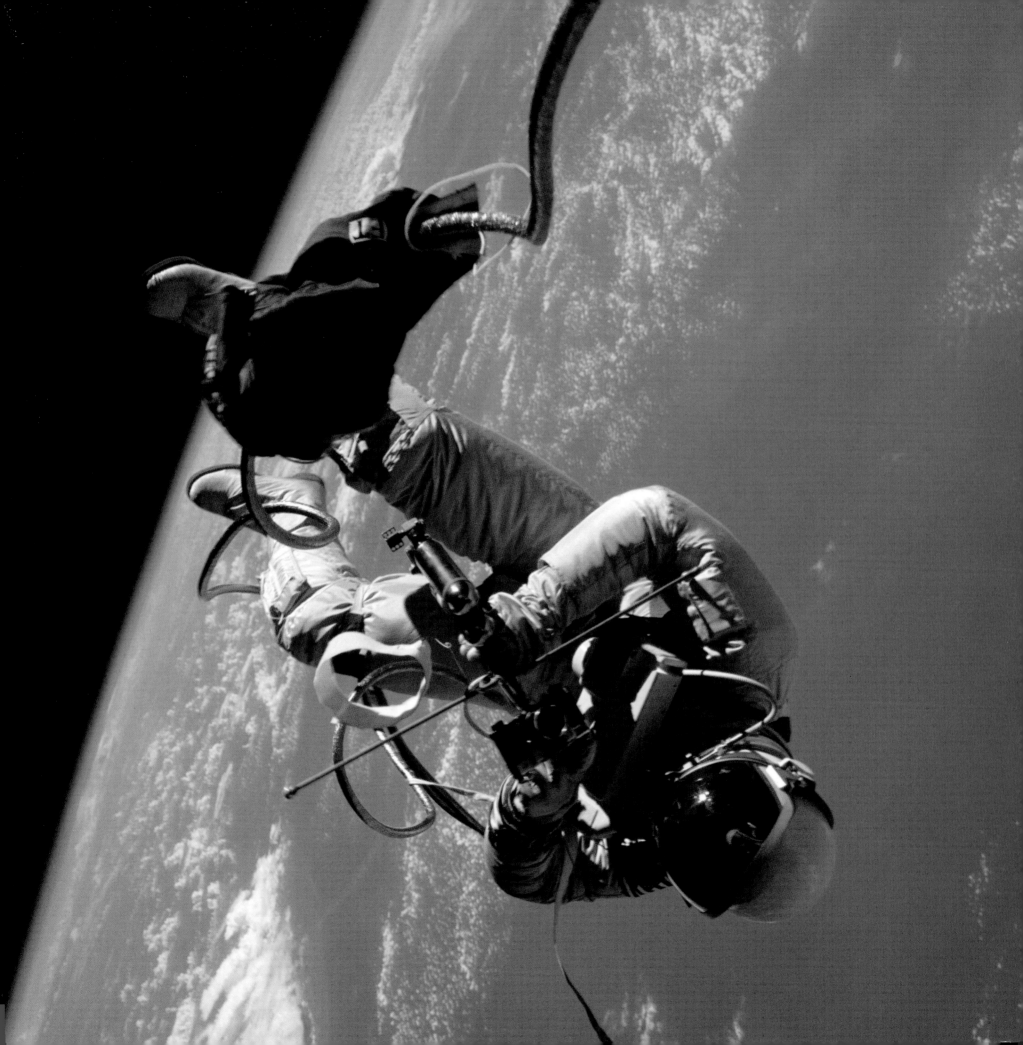

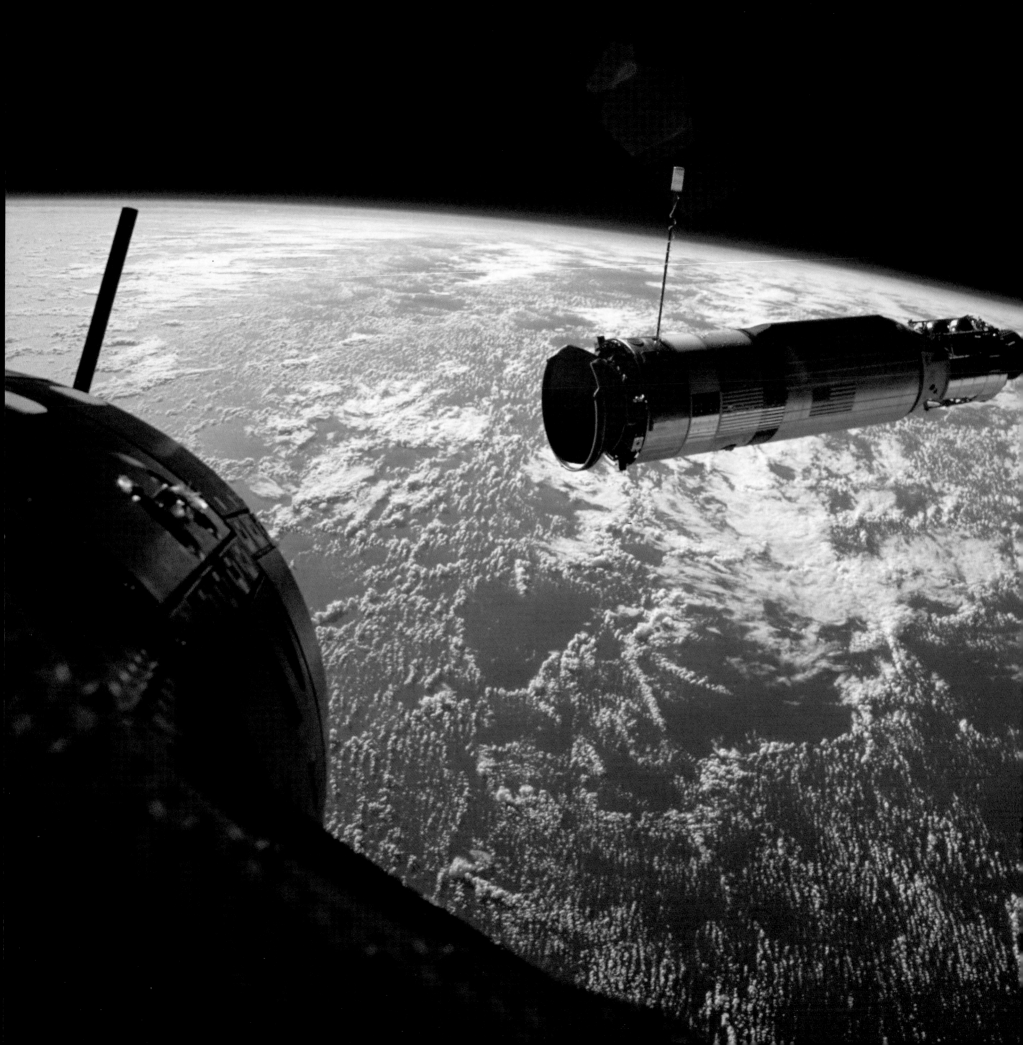

Gemini V remained in space for a week. Gemini VII, carrying Frank Borman and Jim Lovell, for nearly two. During that time, Gemini VII rendezvoused with Gemini VI-A. The two vessels did not dock, but in the vastness of space, they remained side-by-side for five hours, between 274 m (300 yd) and a nerve-racking 30 cm (12 in) apart. It was considerably closer than comparable rendezvous by Vostok flights, and it seemed that after a disappointing start, the US was finally drawing level in the Space Race.

Docking Practice

The remaining Gemini flights refined the astronauts' ability to function during the EVA, which was proving exhausting and physically stressful – although NASA space suits certainly permitted freer movement than the one worn by Leonov. Learning from the experience of spacewalks from Gemini IX-A, X and XI, Buzz Aldrin worked outside Gemini XII for a record-breaking five-

Above: A Gemini astronaut practises linking with another spacecraft in a NASA Docking Simulator, 1962
Left: The Agena Target Docking Vehicle photographed from Gemini X, 18 July 1966

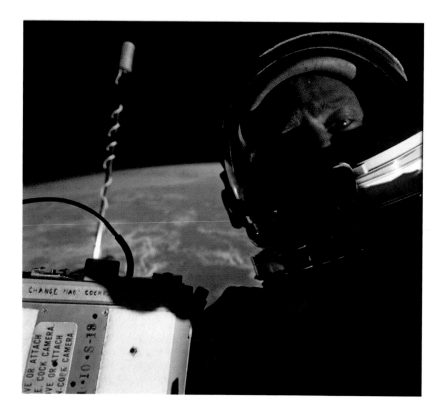

Above: Buzz Aldrin photographed with the pilot's hatch of the the Gemini XII capsule open, 12 November 1966

and-a-half hours, thanks in part to improved breathing techniques before and during the EVA. It was his first space flight, but not his last.

Geminis VIII-XII also rehearsed docking procedures with unmanned Adena target vehicles. Armstrong was the commander of Gemini VIII, which malfunctioned during docking, sending the linked spaceships into a violent spin, turning nearly a full circle every second. Armstrong's quick thinking and complete understanding of his vehicle stabilized the capsule after separating from the target, but the manoeuvre had used up 70 per cent of the spacecraft's re-entry fuel. The mission was immediately aborted and without further mishap, Armstrong and his co-pilot David Scott splashed down in the Pacific Ocean east of Okinawa, Japan. It was the first of only two critical in-flight failures for the NASA Moon program.

Right: An unmanned docking target only 35.5 feet from the Gemini IX capsule, 7 June 1966

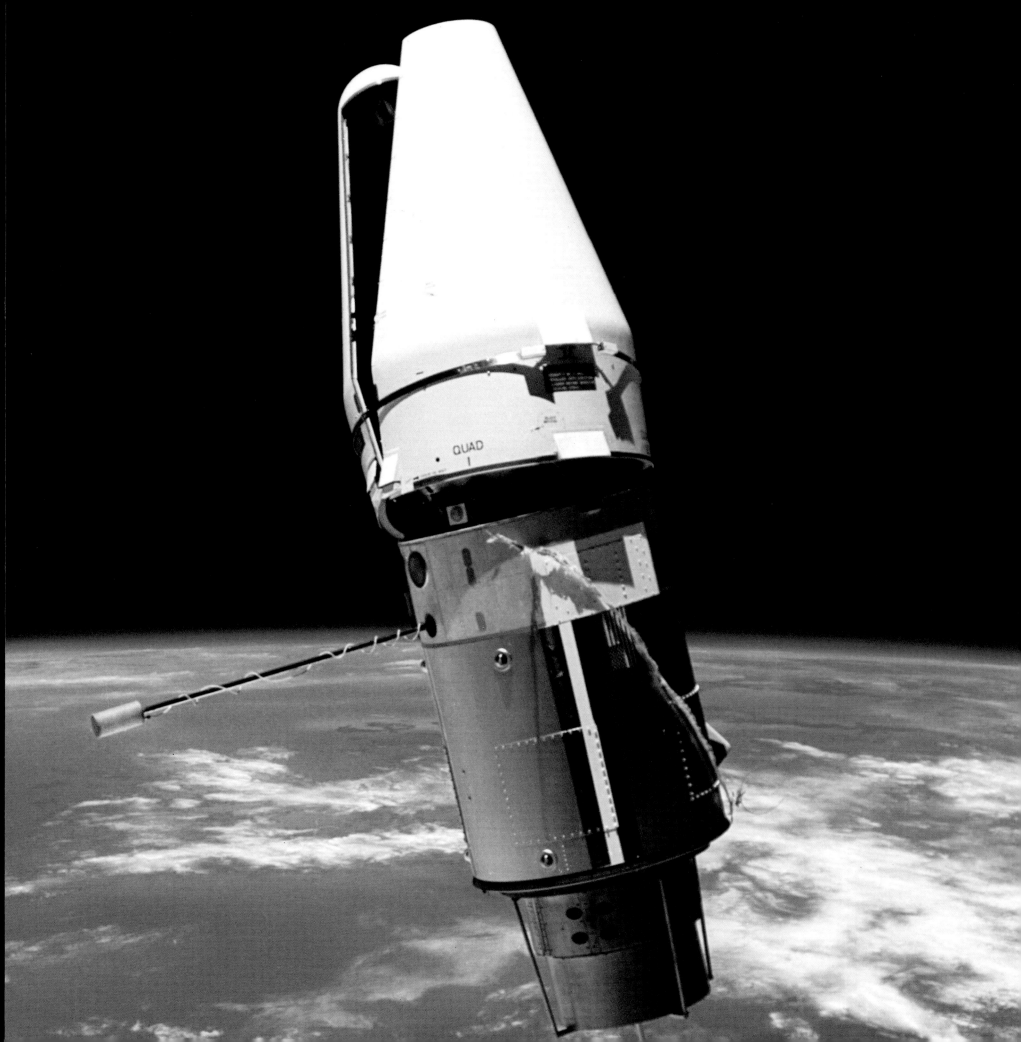

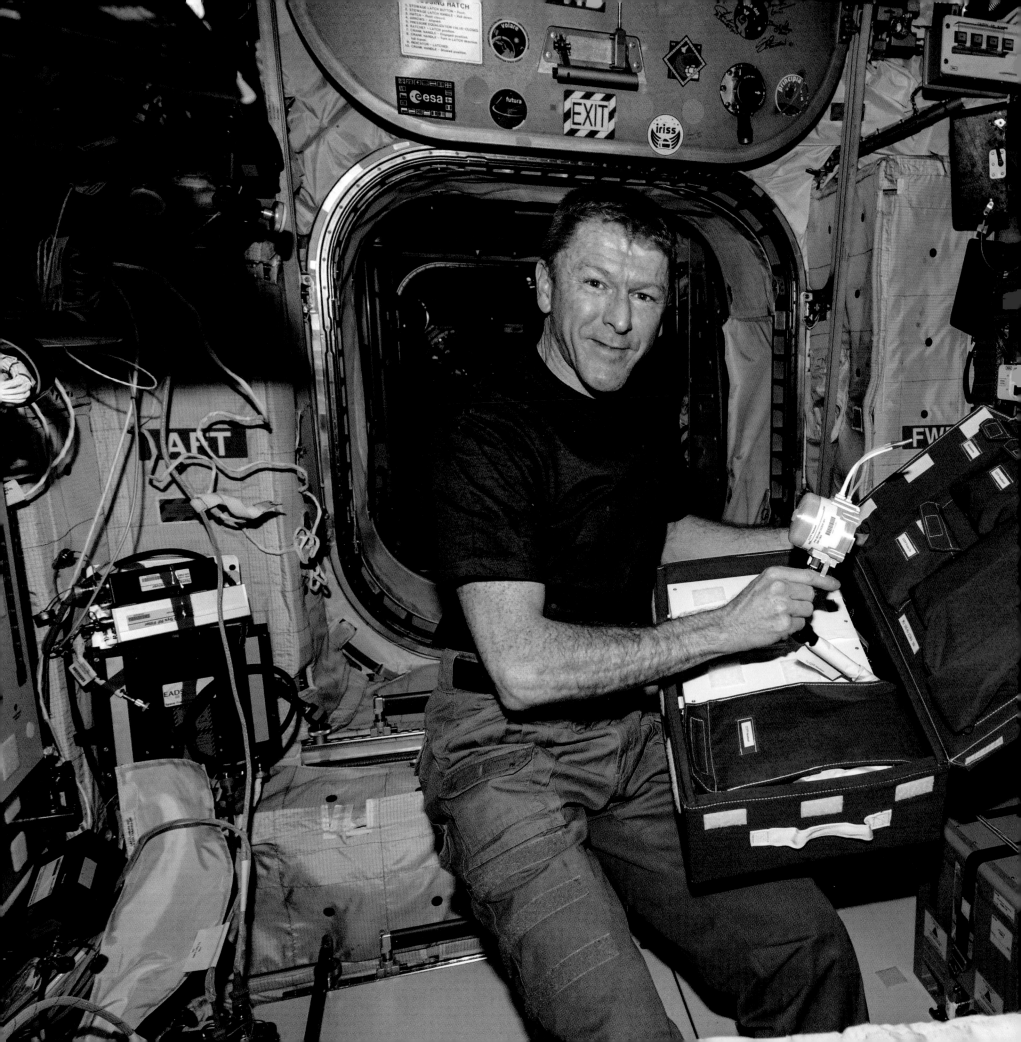

The Right Stuff

As Armstrong discovered in Gemini VIII, space can be a dangerous place. To become an astronaut, it is not enough to be an explorer and an adventurer; you must be an engineer, a computer programmer, an endurance athlete, the best pilot in your class, the most co-operative member of your team, and the public face of the Space Race.

It is a tough brief, but there are no shortage of candidates. The Mercury Seven were chosen from over 500 eligible men, and more recently, British astronaut Tim Peake was one of 8,000 applicants. The Mercury selection process was made harder by the fact that not even those making the selection really knew what conditions the astronauts were going to experience. They were the first of the few.

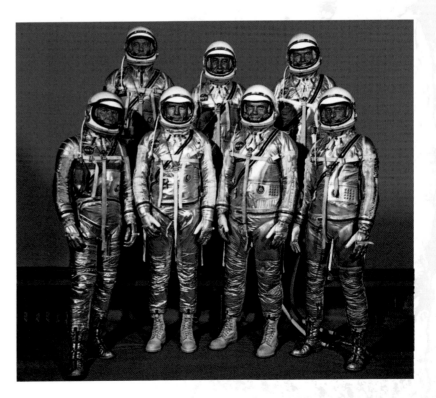

Above: Not enough space shoes: some of the Mercury Seven wore silver-painted work boots for this photocall
Left: ESA astronaut Tim Peake on the ISS, where he spent 6 months in 2015–16

Becoming an Astronaut

One of the primary requirements of an astronaut in 1958 was that he did not take up too much space in the tight confines of the Mercury capsule. There was a height limit of 180 cm (5 ft 11 in) and a maximum weight of 82 kg (181 lbs). No one over the age of 40 was considered and, to cope with the mental challenges of the task ahead, every candidate had to have at least a Bachelor's degree.

A review of the applicants' military records helped NASA reduce the original 508 to 110 from the US Marines, Navy and Air Force. Thirty-two men were shortlisted and put through rigorous tests of personality, mental prowess and physical endurance. They were exposed to extreme heat, icy water, isolating sensory deprivation, intense vibrations and G-forces equivalent to those they would experience during launch. They had to conduct tasks under disorientating conditions, such as tilting floors and distracting noises, and submit themselves to comprehensive and intrusive medical tests and health checks.

In the USSR, 20 pilots went through a similar selection and training process to select the final Sochi Six. Physical size was an issue for Russian cosmonauts too. Gagarin was only 158 cm (5 ft 2 in).

The seven original American astronauts presented to the American public for the first time on 9 April 1959 were, in alphabetical order, Scott Carpenter, Gordon Cooper, John Glenn, Gus Grissom, Wally Schirra, Alan Shepard and Deke Slayton. They became instant national heroes to an American public excited about space travel and stung by Sputnik.

Left: *Gus Grissom spins in an inertia facility to simulate the disorientation of a space emergency*
Right: *Buzz Aldrin practises in a water tank which simulates the weightless environment of space, 1966*

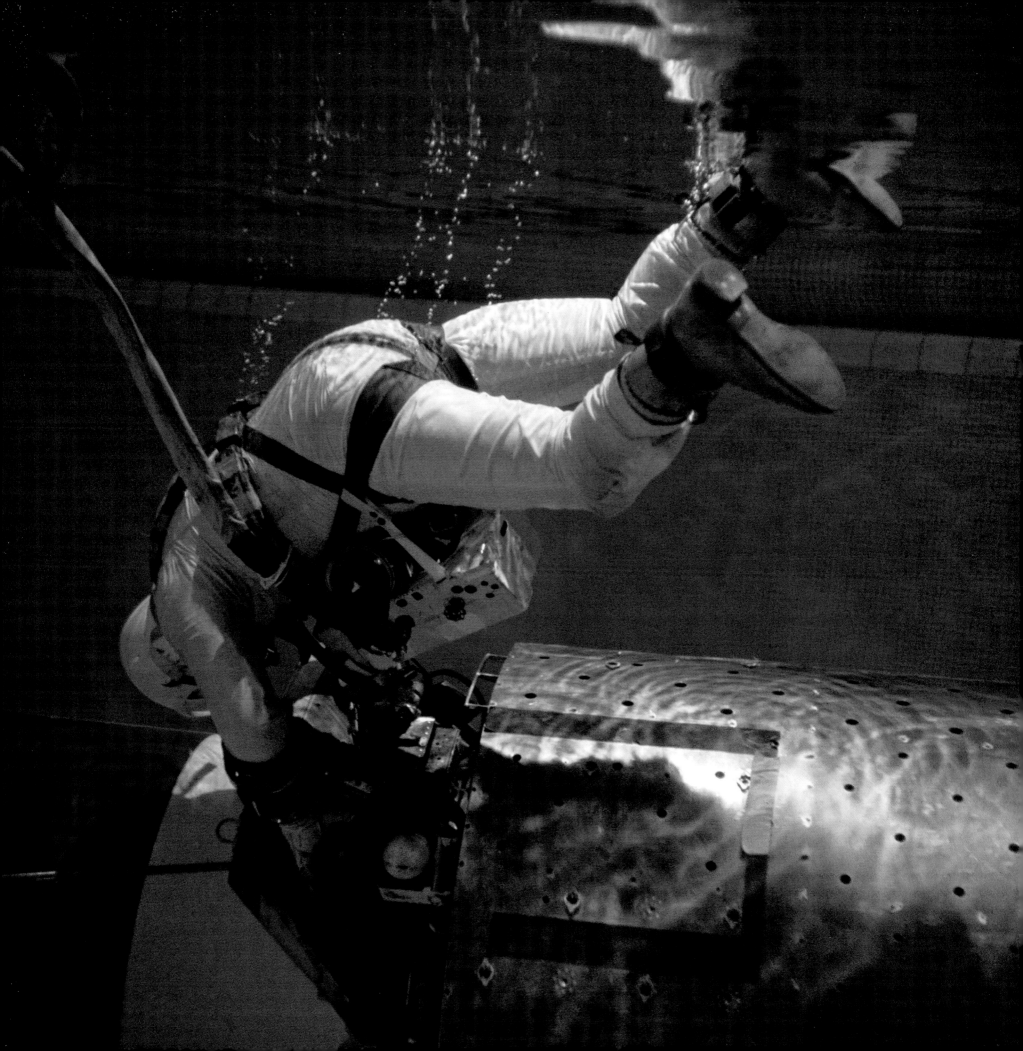

Life on Board

The first requirement of a spacecraft is that it should fly to and from its destination. Particularly in the early days of space flight, the pilot's comfort was a distant second consideration.

In the Mercury capsule the pilot was strapped into a fibreglass seat moulded to his body, surrounded by controls within touching distance. He wore an inflatable suit to protect him from the low pressure of his environment, and sensors in intimate areas to relay his health condition back to Earth. To regulate his bodily functions, he ate carefully formulated food pellets and drank water. Waste was absorbed in diapers.

The first space flights were short exercises, but as missions lengthened, so did the need for sleep. On Earth, our sleep is regulated by circadian rhythms and the cycle of day and night. In orbit, it takes about 100 minutes to circle the Earth and the Sun can rise as many as 15 times in a 24-hour cycle. Disruptions to earthly patterns of sleep and wakefulness can lead to tiredness, stress and mistakes.

Titov was the first person to sleep in space, on Vostok 2, and Gordon Cooper the first American, on Mercury 9. In a weightless environment, there is no up or down, and therefore no need to lie down to sleep. You can sleep anywhere; but you do need to secure yourself to prevent your body from floating. On the ISS, astronauts routinely sleep in sleeping bags tethered to the walls.

Input and Output

Because it is designed for long-term occupancy, the ISS devotes more attention to the comfort of its crew than single-mission capsules could afford. There is room to move around, to exercise, and even cabins for sleep and privacy.

Above: A water gun was used to rehydrate Gemini food rations, including beef sandwiches and strawberry cereal

The space toilet is, like its earthly counterpart, a separate room. There, to overcome the particular risks of weightlessness during its use, astronauts' bodily functions are assisted by an extractor fan, a little like a vacuum cleaner. Urine is purified and recycled as drinking water. Technology has come a long way from the super-absorbent diapers of the first space pioneers.

How they go to the toilet in space is one of the questions most frequently asked of astronauts. What astronauts eat is also a source of endless fascination. Powdered or cubed assemblies of flavoured nutritional material were the unappetizing fare on early missions – difficult to rehydrate and to enjoy. Some food came in pastes in tubes, like toothpaste. But escaping crumbs or pellets could float away and pose a risk to sensitive equipment on board.

Left: John Glenn helps Gus Grissom into his Mercury capsule, Liberty Bell Seven, 21 July 1961

Above: An astronaut's personal quarters on the ISS – their sleeping bag is tethered on the right
Right: The International Space Station, photographed from the Space Shuttle Discovery, 2001

Apollo missions were the first to be able to use hot water to rehydrate. Skylab, the first US space station, had a refrigerator and could store frozen food, which began to resemble more familiar dishes on Earth. On the ISS, fresh food can now be stored and, in the climate of international co-operation which exists there, dishes from many culinary cultures are available – it is seen as a matter of pride for people from various nationalities to share their own cuisine with others. Spicy dishes are popular in an environment where the sense of taste can be dulled.

Creature comforts have greatly improved since the 1960s. As the Gemini missions came to an end, NASA's astronauts could be far more confident about their equipment and their human abilities to survive and work in space. However, the challenge of landing on the Moon was more pressing and distracting than the longing for a decent meal or a functioning toilet. The Apollo program was about to begin.

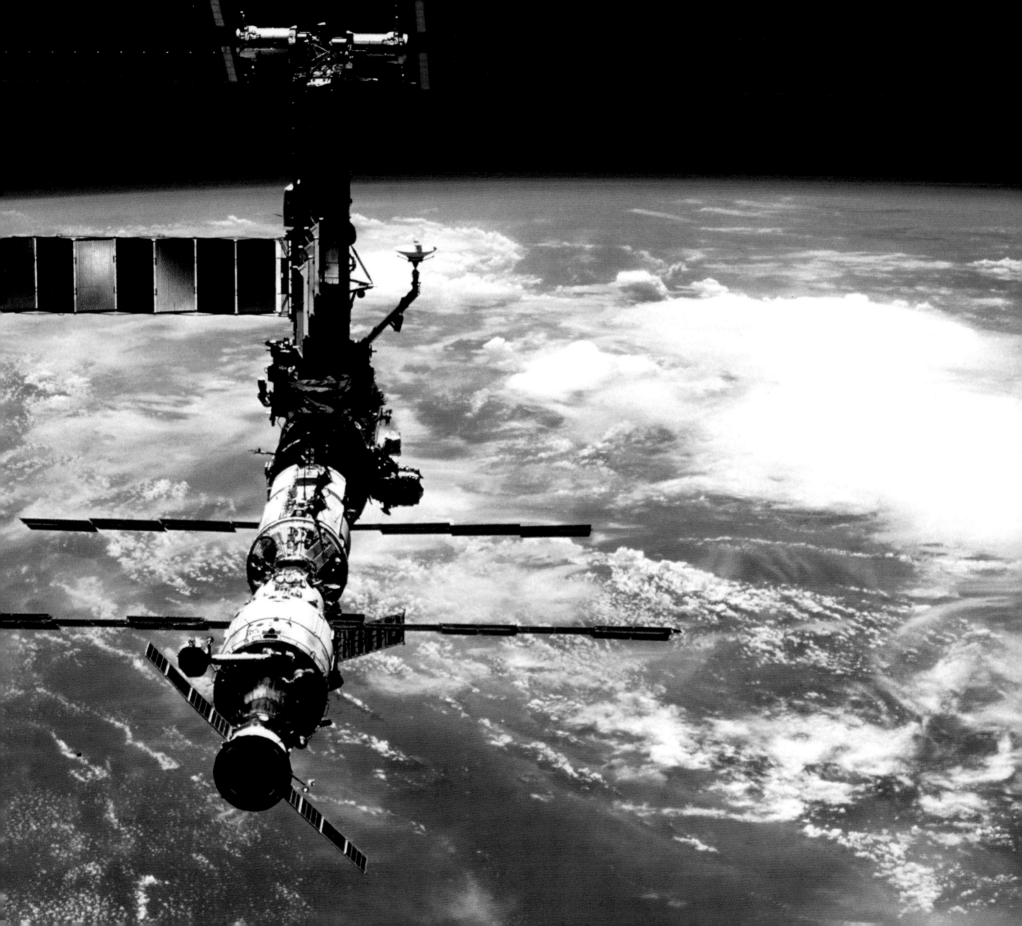

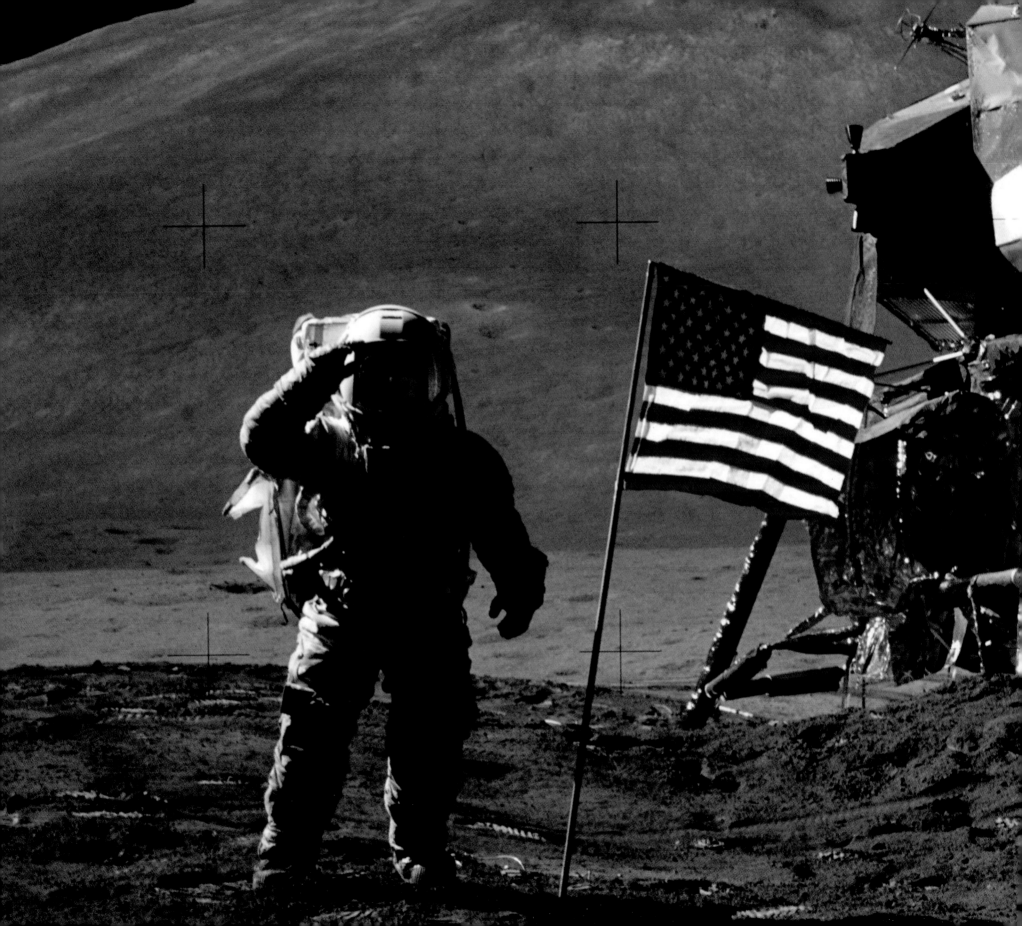

The Apollo
Missions

The Apollo Series

After the successful completion of the Mercury and Gemini programs, NASA was confident that it had gathered enough knowledge and experience of space flight to proceed with the Apollo program, whose aim was nothing short of landing an American astronaut on the Moon and bringing him back safely to Earth.

Apollo flew 17 manned missions between 1968 and 1972, exceeding its aims but encompassing tragedy and drama on the way. It paved the way for the Skylab project and after its Moon missions were completed, it played its part in the Apollo-Soyuz Project, a milestone in relations between the two former competitors in the Space Race.

Launching the Program

Although it appeared to be a response to President Kennedy's 1961 pledge, the Apollo Project was actually established under President Eisenhower during an election year, 1960. There was considerable political pressure within the US to throw everything at an urgent program of investment and research, with a view to catching up on the USSR's lead in the race.

Even after Yuri Gagarin's historic flight, Kennedy remained non-committal to the US space program until he had asked Vice President Johnson to report on its potential. Johnson told him that there was more that NASA could do, but that he was confident that the US could be first to put a man on the Moon.

Previous page: Astronaut Jim Irwin salutes the flag during the Apollo 15 mission, July 30 1971
Left: President Eisenhower arriving for the dedication of the Marshall Space Flight Center in 1960

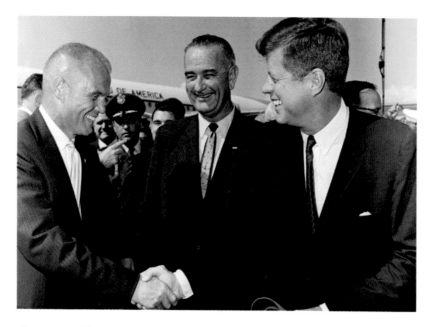

Above: President Kennedy congratulates astronaut John Glenn on his historic three orbits of the Earth

Kennedy's time frame, only eight years in which to develop the technology required for such a mission, raised eyebrows both inside and outside NASA. As the Soviet effort continued to outpace the US, many doubted the feasibility of such a tight schedule.

Kennedy considered abandoning the Space Race altogether and making the mission to the Moon a joint USA-USSR venture, in order to avoid duplicating research efforts. The President had found himself able to do business with Khrushchev during the Cuban Missile Crisis, but when Khrushchev was undermined and in 1964 replaced by Leonid Brezhnev, the Cold War and the Space Race resumed with renewed intensity.

Apollo 1

All the Apollo missions were launched on Saturn rockets. A great many trial flights of the Saturn I and Saturn IB were conducted between 1961 and 1967, testing their load capacity, the structural integrity of the Apollo modules, the launch abort systems and the effectiveness of the heat shield.

Right: Apollo 1 astronauts Chaffee, White and Grissom rehearse flight drills in the command capsule simulator

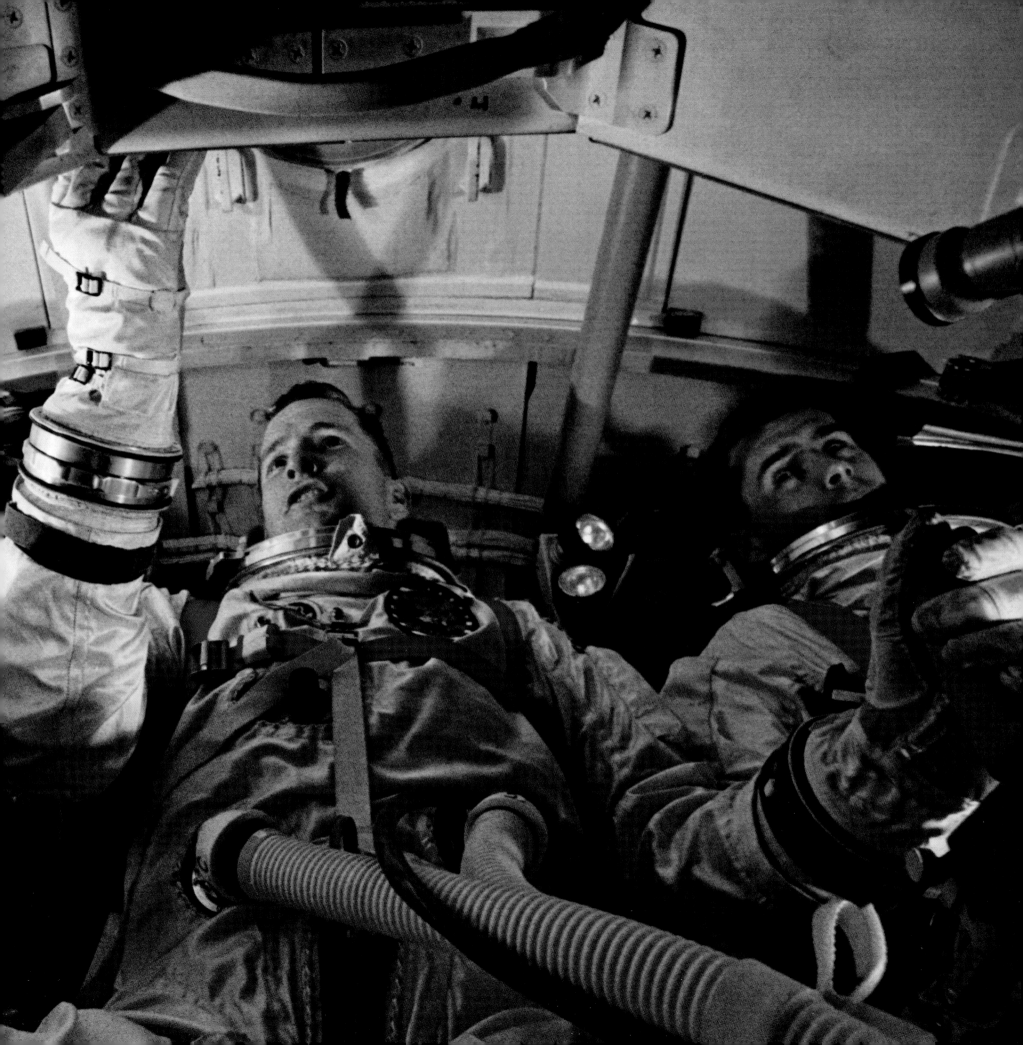

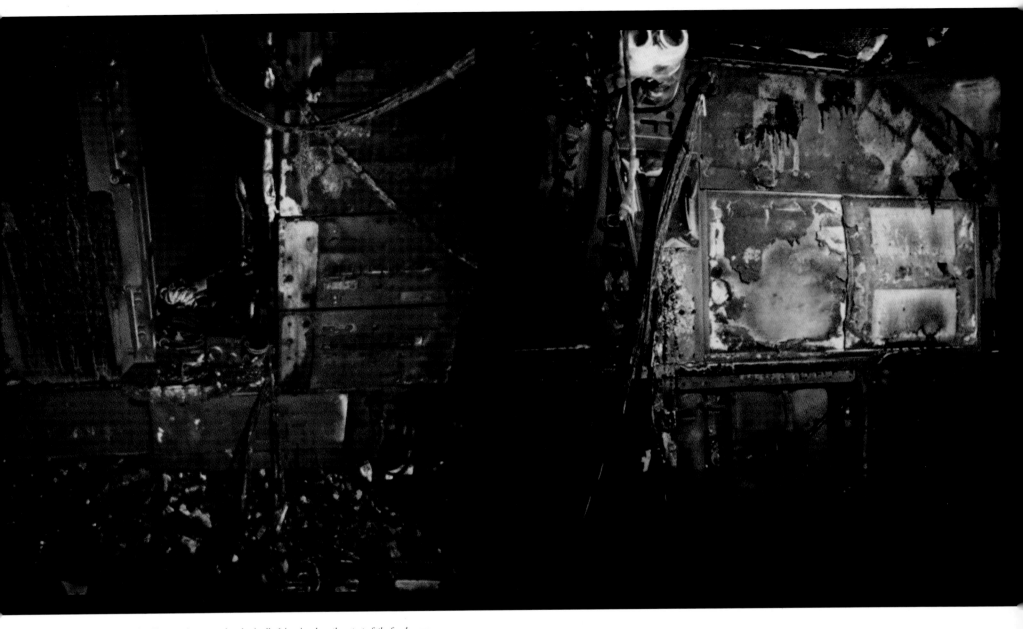

Above & right: Photographs presented to the Apollo 1 inquiry show the extent of the fire damage

Test flight AS-204, the first manned flight in the series of trials, was scheduled for 21 February 1967, with a three-man crew. Gus Grissom was a veteran of the Mercury program, the second American in space following Alan Shepard's flight. He also commanded Gemini III. Ed White, also selected for AS-204, had flown on Gemini. On both Gemini flights, Roger Chaffee, a freshman in the 1963 intake of astronauts, was CAPCOM (capsule communicator), the officer who communicated directly with the astronauts from Mission Control. By tradition, only fellow astronauts communicate directly with the flight crew during a mission, because only they can really understand what the crew is experiencing.

As a crew, therefore, Grissom, White and Chaffee already had a close bond before being teamed up for AS-204. On 27 January, the three men posed for a photograph in front of their launch vehicle before ascending to the command module for a launch rehearsal, which was to be conducted under launch conditions, the capsule being pressurized with an oxygen-rich atmosphere.

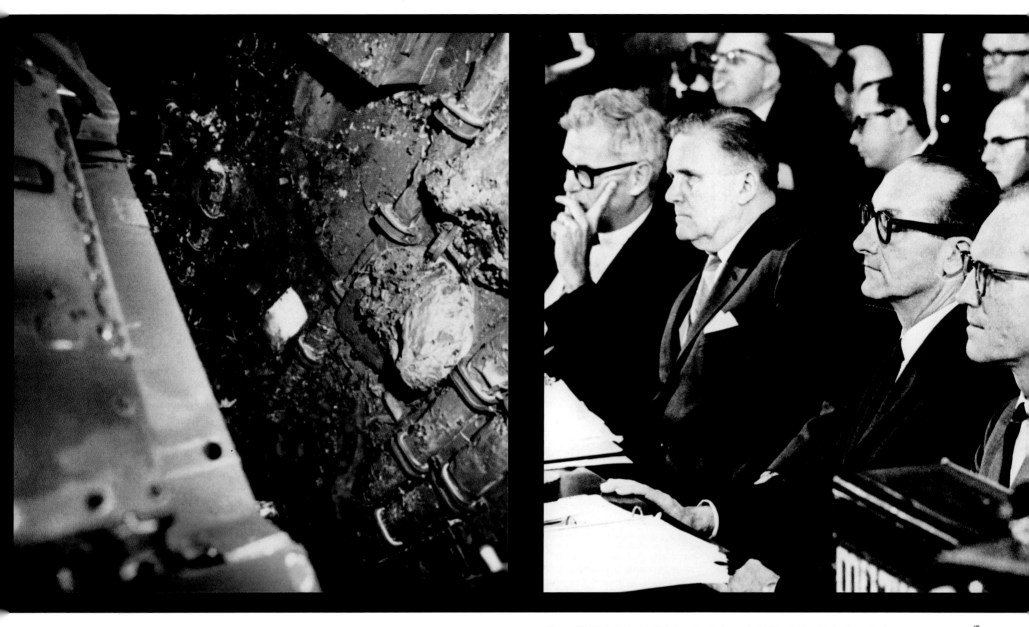

Above: NASA administration chiefs listen intently during the Apollo 1 Accident Review Board hearings in the Senate

The crew had been in the module for five-and-a-half hours, resolving a number of pre-test problems, when a voltage surge caused a spark in the electrical systems. A fire began, fuelled by the high level of oxygen and further fed by the nylon fittings of the cramped cabin. Because the pressure was higher inside the cabin than outside, the module's hatch could not be opened, and because the Saturn was empty of fuel, the safety procedures for the test were low-key.

All three crew members died in the fire. AS-204 was redesignated Apollo 1 in their honour. Besides the terrible loss to the men's families and their colleagues, it was an inauspicious start to the manned Apollo program.

Manned flights were suspended for 18 months, but unmanned tests of the Saturn rockets continued and modifications were made to the Apollo command module design in the light of the accident. The three Saturn IB test flights which had taken place before the fire were now unofficially renamed Apollo 1A, 2 and 3.

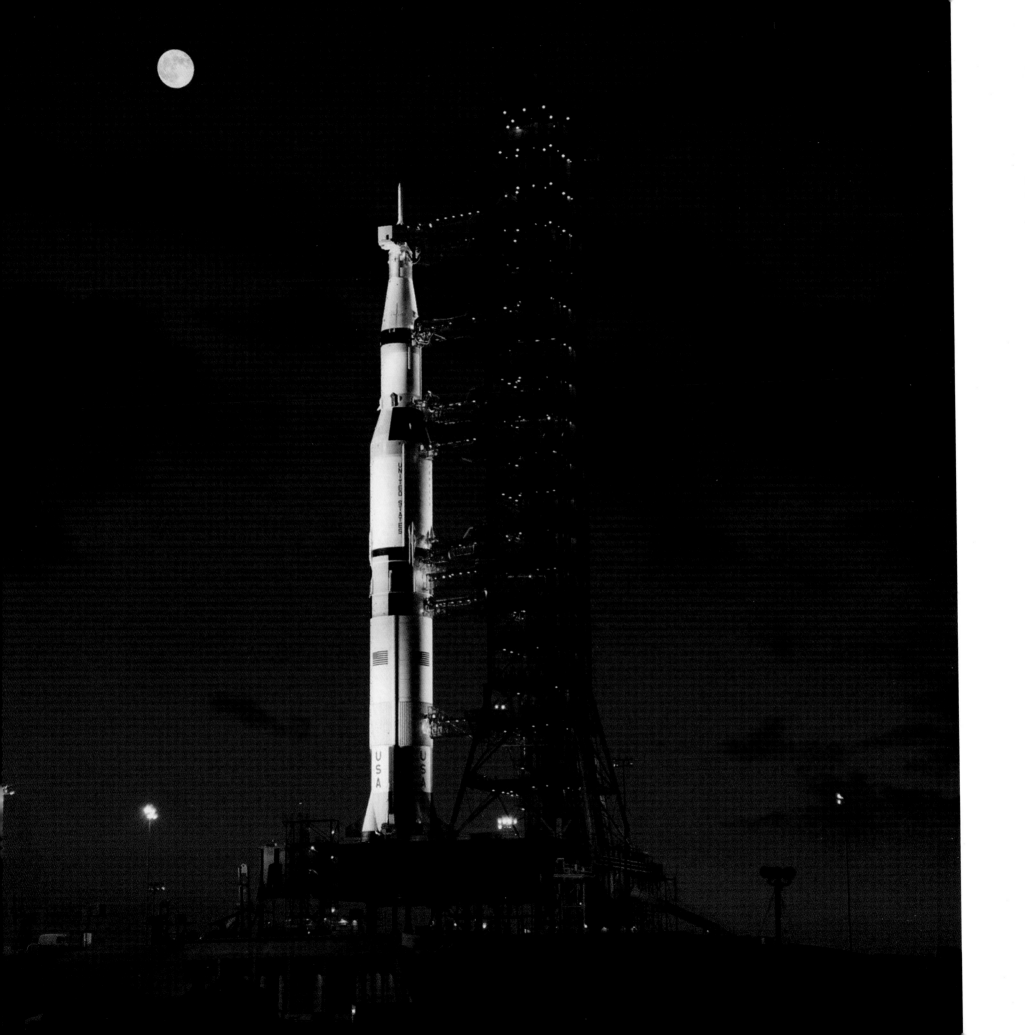

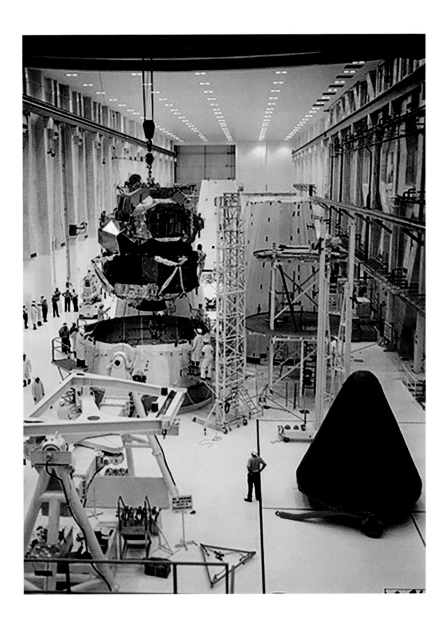

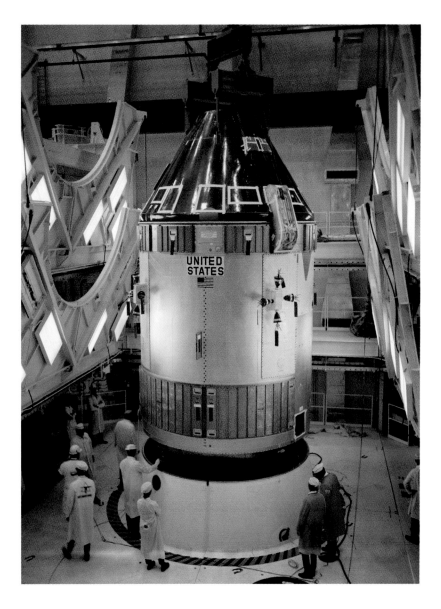

Countdown to Lunar Launch

Apollo 4 was the first test of the Saturn V, which successfully proved that its rocket stages and heat shield were working as designed. Apollo 5, also unmanned, used a Saturn IB to carry the lunar landing module into space and test its engines in the weightless environment.

Apollo 6 was a second test of Saturn V. Its guidance systems were able to overcome problems caused by vibration during the launch into Earth's orbit. NASA declared Saturn V fit for manned flights.

A further unmanned test was cancelled and, instead, Apollo 7, using the older Saturn IB, became the first manned flight of the program, testing the crew's ability to operate the Apollo command module during nearly eleven days of orbit around the Earth. Wally Schirra, Donn F. Eisele and Walter Cunningham, who had formed the second backup crew for the ill-fated Apollo 1, successfully completed this crucial Apollo 7 mission.

Above left: The first Lunar Module being loaded for Apollo 5's mission to practise docking in space
Above right: Apollo 7's Command and Service Module is suspended above its Lunar Module section during assembly
Left: Full Moon before dawn on 9 November 1967, launch day for the unmanned Apollo 4

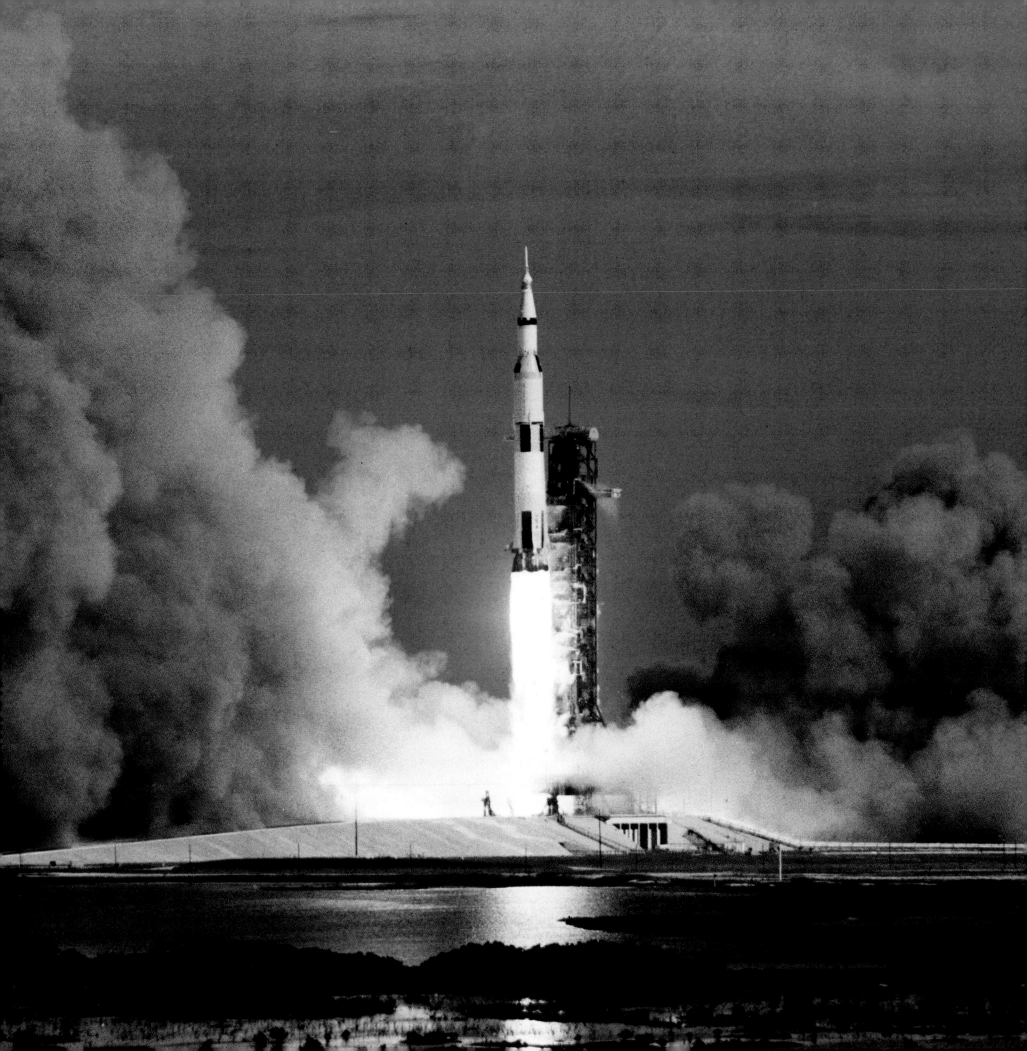

Journey to the Moon

Apollo 7 was the last piece of the puzzle: astronauts, ground staff and vehicles had all proved themselves in trials. The stage was set for Apollo 8, and on 21 December 1968, it took off from the Kennedy Space Center in Florida on the world's first manned flight to the Moon.

Above: *At Kennedy Space Center, Jim Lovell's family watch him lift off on board Apollo 8*
Left: *Apollo 8 blasts off on its way to the first manned orbit of the Moon*

Although Apollo 8's mission was not a lunar landing, its flight was in many ways a more momentous event. It was the first ever flight to go further into space than a low Earth orbit. The USSR had never achieved this, and for the first time the US was definitively ahead in the Space Race.

Travelling further away from Earth than anyone had ever done, the crew of Apollo 8 were the first men in history to see the whole world at once. On Christmas Eve 1968, they gave a television broadcast, sending back live images of Earth from space and reading the opening verses of the Bible,

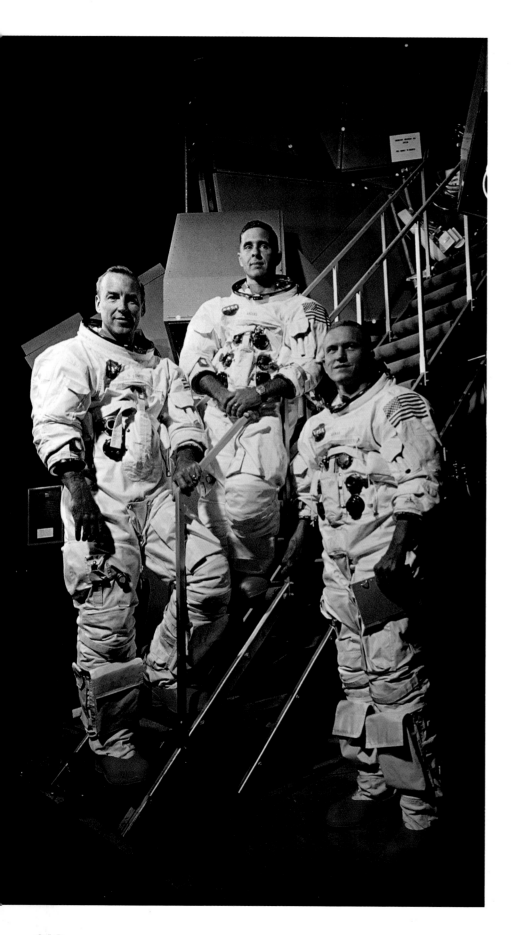

which describe the creation of the world. It attracted what at the time was the largest TV audience ever recorded. Frank Borman, commander of the flight, closed with the words, 'Good night, good luck, a Merry Christmas – and God bless all of you, all of you on the good Earth.'

The crew was made up of Borman, making his second spaceflight; Jim Lovell, on his third flight following tours on Gemini VII and Gemini XII; and William Anders on his one and only space mission. It took them 68 hours, nearly three days, to reach the Moon, which they orbited ten times. Not only were they the first people to see our home planet in its entirety; they were the first to set eyes on the dark side of the Moon, which had only been photographed previously by remote unmanned probes.

A New Perspective

The practical purpose of the Apollo 8 mission was reconnaissance of the Moon's surface with a view to a future landing. But the event of greatest impact was its first ever view of Earthrise, the moment when the Earth appears above the Moon's horizon, just as the Moon appears to do from our earthbound point of view.

Bill Anders saw it first and took a photograph which, it may fairly be claimed, changed the very world which he was photographing. It literally and metaphorically changed our view of ourselves and our planet – no longer the centre of the universe but one of many objects in it, all rising, falling, orbiting, spinning. It remains a humbling yet magnificent image.

When Apollo 8 splashed down safely in the North Pacific on 27 December, it was at the end of a troubled year in the US. Martin Luther King and Robert Kennedy had been assassinated, and society was divided by the

Left: The Apollo 8 crew – Jim Lovell, Bill Anders and Frank Borman – beside the mission simulator
Right: Earthrise over the lunar horizon, seen as Apollo 8 emerged from behind the Moon

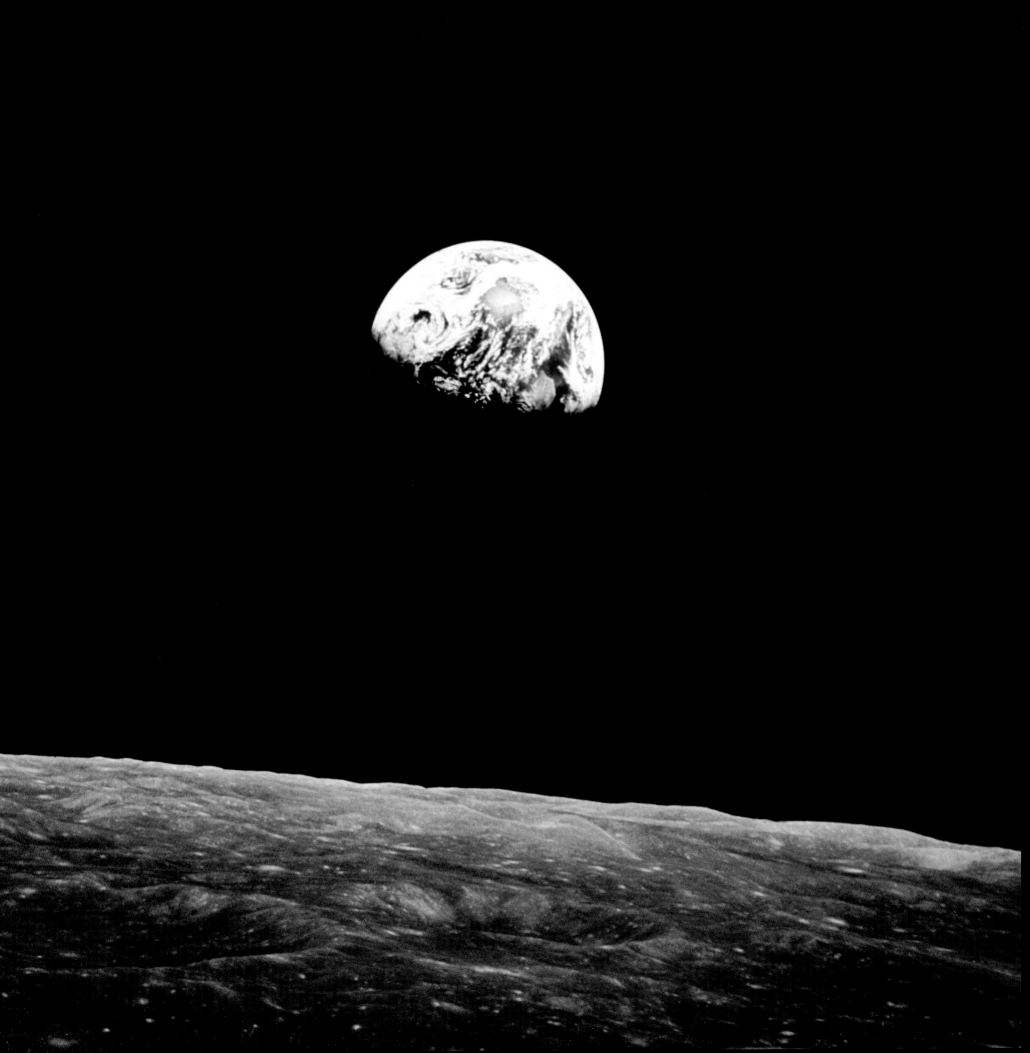

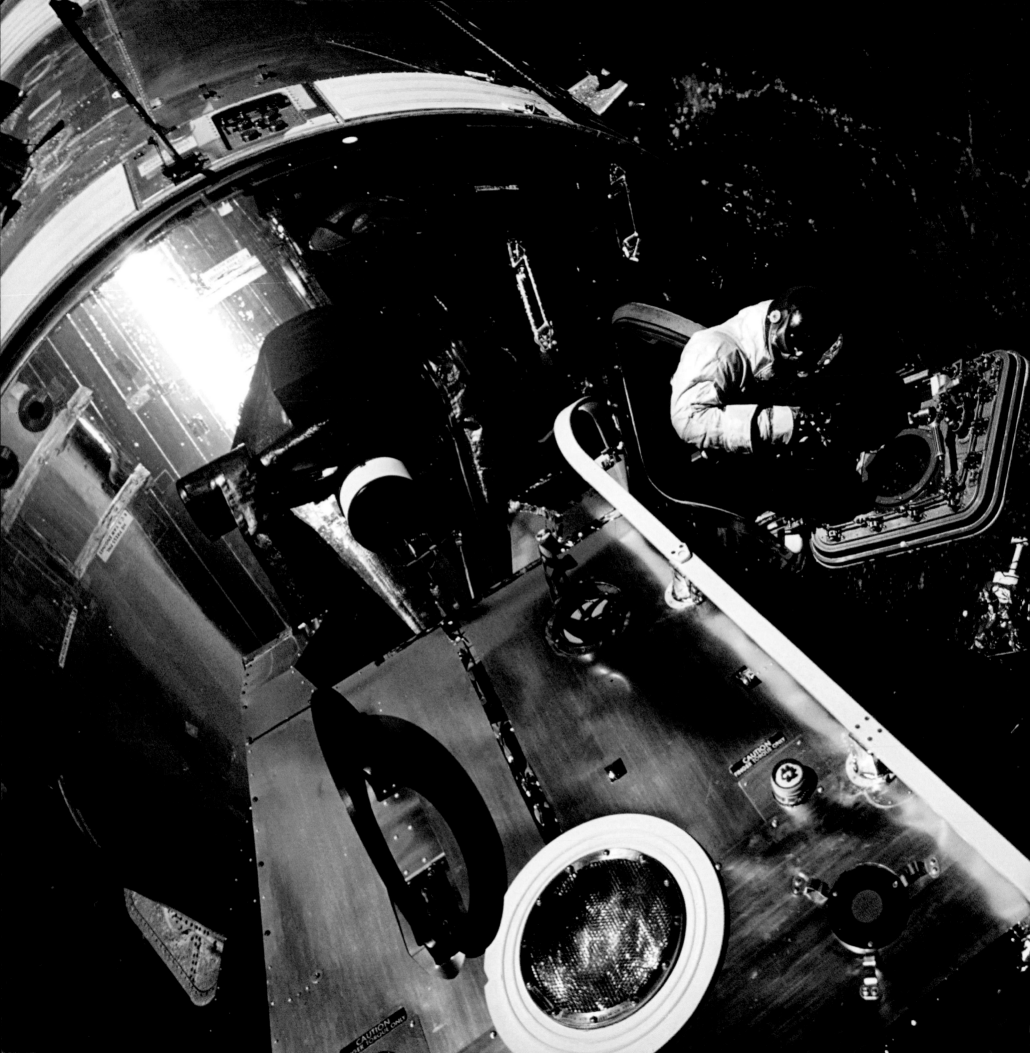

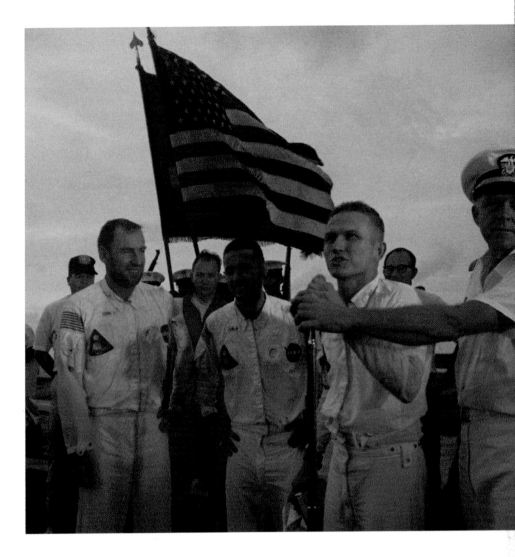

Above: Apollo 8's crew, the first men to orbit the Moon, speak of the experience
Left: Earth looms behind Apollo 9's CSM, docked with its LM, as David Scott begins EVA

Peace Movement and by Black Power. Race became an issue in Britain too, framed by politician Enoch Powell's inflammatory 'Rivers of Blood' speech. Apollo 8's new perspective on the world provided a healing balm and a sense of the good things of which humanity was capable.

Preparing for the Big One

Two further Apollo missions were flown in the spring of 1969. In March, Apollo 9, with the crew of James McDivitt, David Scott and Russell Schweickart, spent ten days in orbit around Earth testing the

manoeuvrability of the lunar landing module. It was the first time all the technical elements of the future Moon landing were flown together – the Saturn V rocket, the command and service module and the lunar module.

Everything worked perfectly, including the new Apollo space suits, which for the first time had their own life support systems instead of being tethered to the command module by an umbilical cord. The lunar landing module was taken more than 161 km (100 miles) away from the command module and back, in a controlled flight which ended with a successful re-docking – the first one by two manned US vehicles.

Apollo 10 was the final trial run, a dress rehearsal in theatrical terms for the main event. Its experienced crew had all flown in space before, and in May 1969, they flew to the Moon. There, astronaut John Young remained in the command module while his colleagues Gene Cernan and Tom Stafford piloted the lunar landing module in a descent orbit, gradually losing height until they were less than 14.5 km (9 miles) above the surface of the Moon.

At that height, they surveyed the Sea of Tranquillity, one of the proposed landing sites for Apollo 11. How tempting it must have been for the crew to continue with a powered descent, but instead, they fired the ascent rockets and returned to the command module. So near and yet so far.

Despite a pilot error which sent the lunar landing module into a near-fatal spin, Apollo 10 returned home safely. Now the only untested part of the US program to put a man on the Moon was the part that could not be practised or simulated – the landing itself.

Right: Apollo 10's CSM photographed from its LM in bright overhead sunlight after separation in orbit

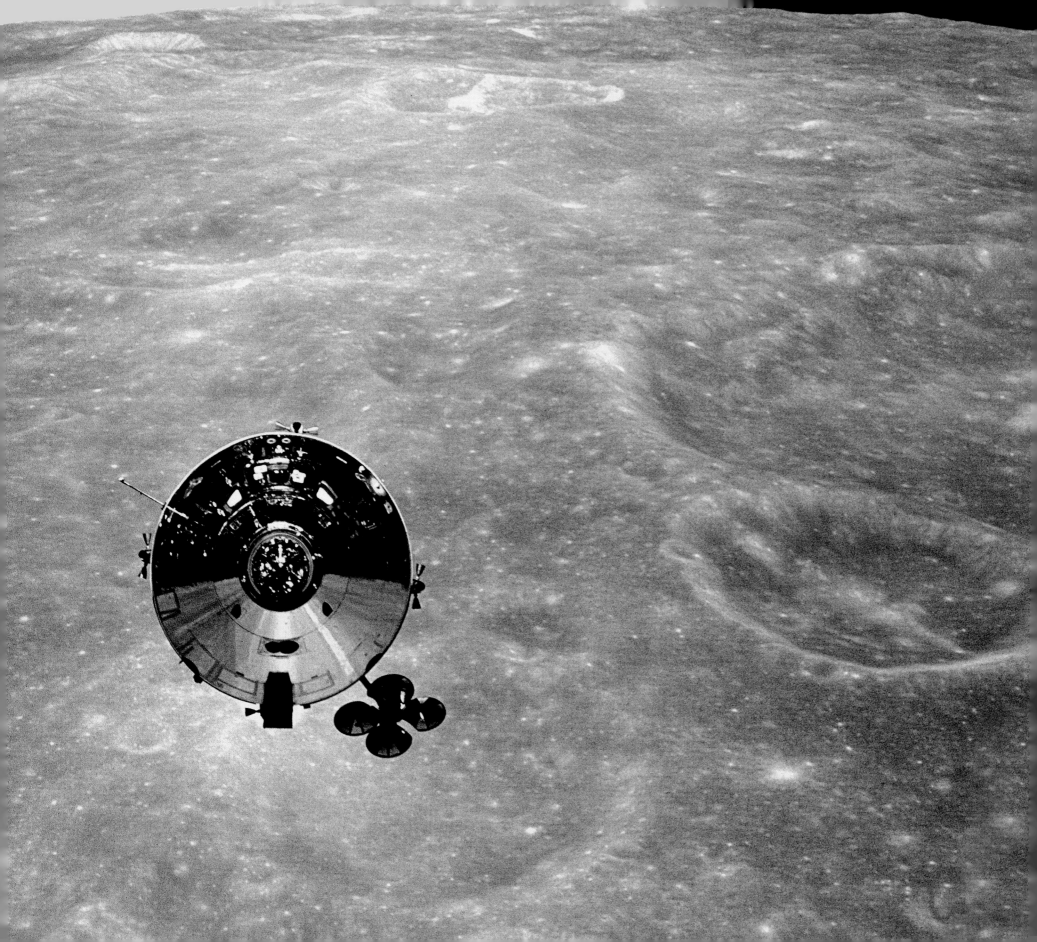

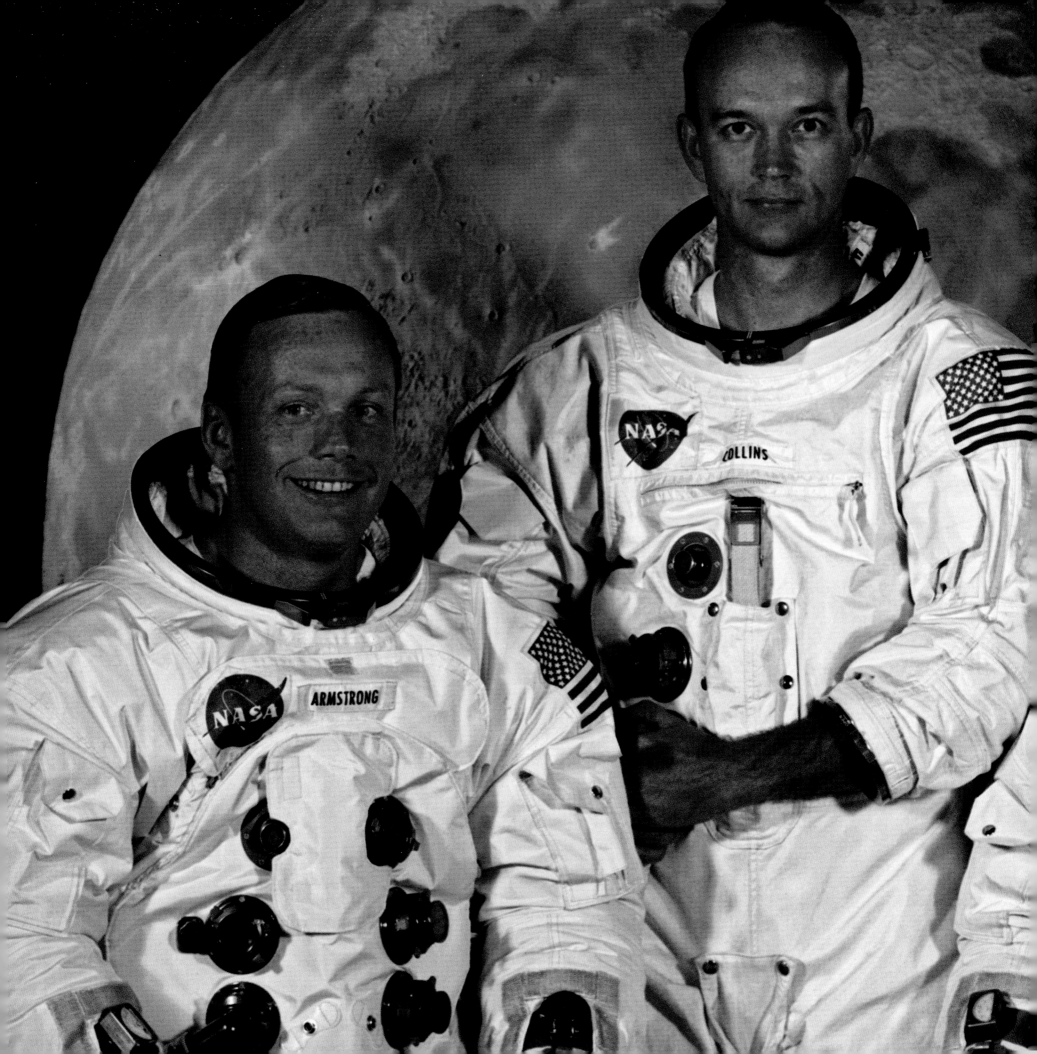

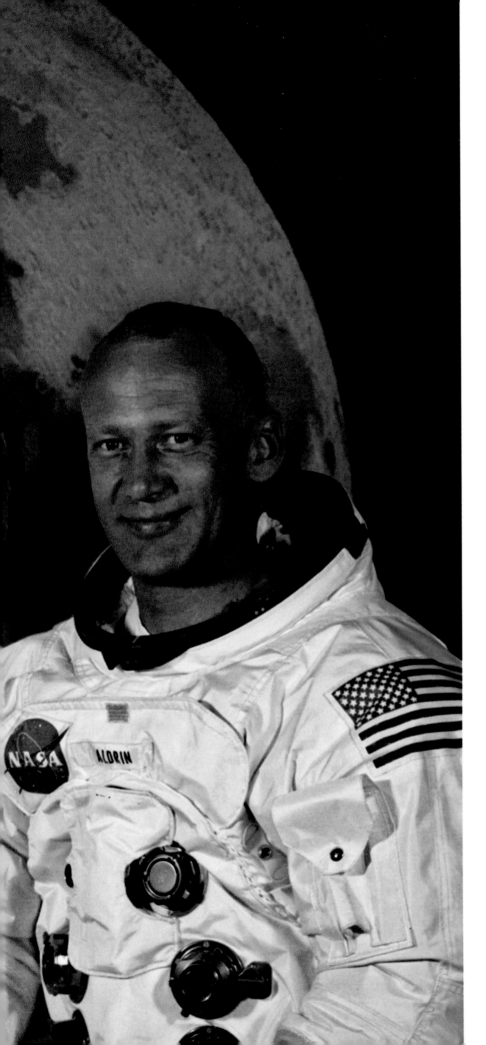

Landing on the Moon

NASA's step-by-step approach to the space program was unhurried in its careful resolution of each stage of the design process. Despite the tight schedule, NASA was now in a confident position to make good on President Kennedy's 1961 pledge to the world.

Launch Day

The launch was a very public affair, broadcast live in 33 countries, and in the US alone, the audience was estimated at 25,000,000. One million Americans came to see it for themselves, watching lift-off from stands and roadsides around the Kennedy Space Center. Dignitaries from the US forces and politics, including Vice President Spiro Agnew, and 3,500 representatives of the world's press were present. President Nixon watched the launch on television from the White House in the company of astronaut Frank Borman, commander of both Gemini VII and the landmark Apollo 8 mission. On the morning of 16 July 1969, there were no more rehearsals. This was it.

At around 07:00 local time, astronauts Neil Armstrong, Buzz Aldrin and Michael Collins took their places in the command module of Apollo 11. All three were undertaking their second space missions. By then, the fuel had been loaded, but the launch was not scheduled for another three hours — a long time to be strapped into a confined space above 3,589,030 litres (947,529 gallons) of kerosene and liquid oxygen. Their colleague, astronaut Fred Haise, remained with them for an hour until it was time to close the hatch and pressurize the capsule. Haise was one of 10 CAPCOMs for Apollo 11.

Left: The crew of Apollo 11: (l–r) Neil Armstrong, Michael Collins and Buzz Aldrin

Above: Lady Bird Johnson (in polkadots) and LBJ among spectators at the launch of Apollo 11
Right: The Kennedy Space Center team watch the Apollo 11 lift-off from the Launch Control Center

Meanwhile, in the launch control room, more than 450 technicians were making final checks of all systems before giving the 'Go!' to Clifford Charlesworth, one of four flight directors responsible for different stages of Apollo 11's flight. Only when all systems were 'Go!' could the automated countdown sequence be initiated, three minutes and twenty seconds before launch.

Destination Moon

Lift-off occurred at 09:32 local time. The power of the Saturn V rocket as it overcame Earth's gravity subjected the crew to rising G-forces, reaching a peak of 3.9 g after three minutes. After 12 minutes, it was 161 km (100

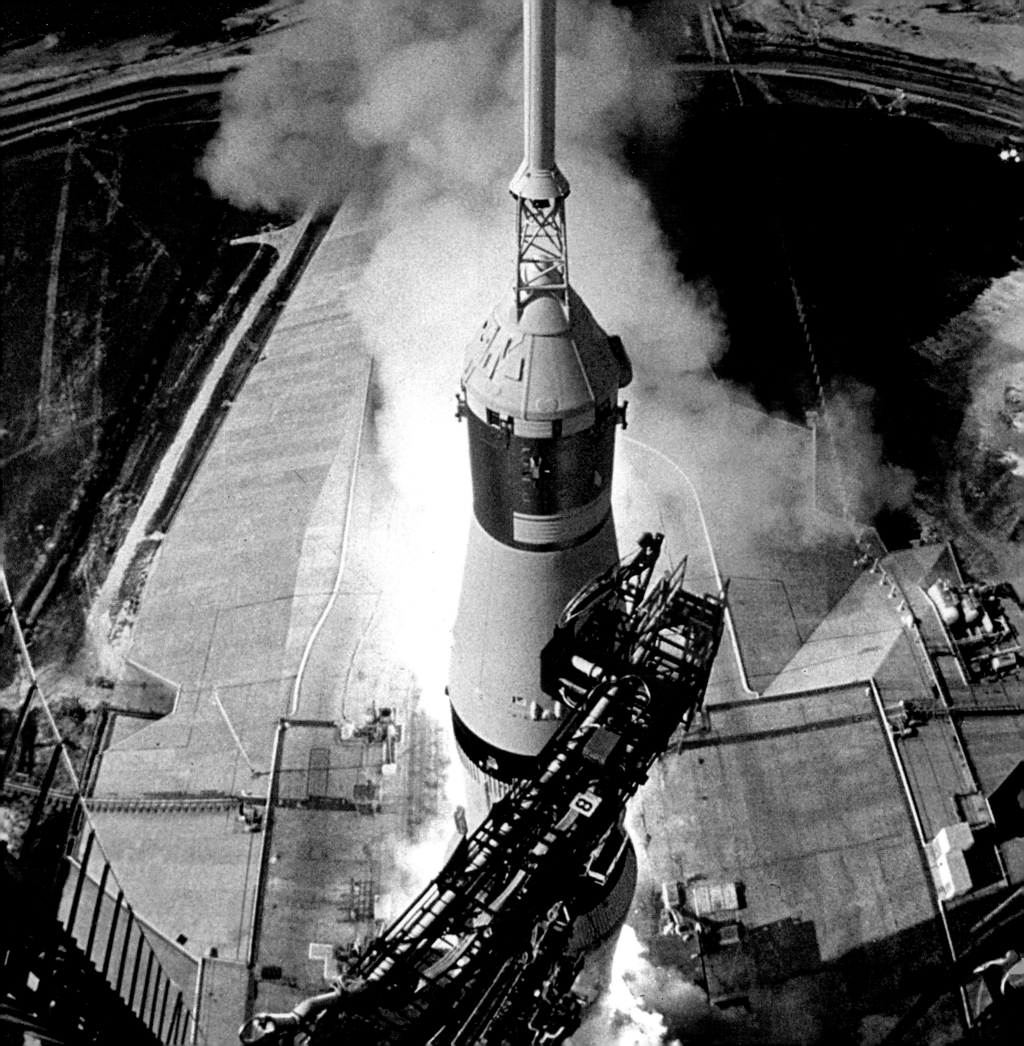

miles) high and in Earth's orbit. Apollo 11 circled the planet one-and-a-half times before striking out towards the Moon, driven by the third and final stage of the Saturn vehicle.

Stored in the third stage was the lunar landing module, codenamed Eagle, and after 30 minutes, when the stage had burnt out, the command and service module, codenamed Columbia, separated from the stage and turned through 180 degrees in order to dock with the lunar landing module and pull it clear.

Columbia was an early name for the North American continent. Columbiad [sic] was also the name which Jules Verne gave the cannon which sent his protagonists to the Moon in *Journey to the Moon*. NASA astronauts were allowed by convention to name their own mission craft. But when the Apollo 10 crew called theirs Snoopy and Charlie Brown after characters from the *Peanuts* cartoon strip, it was gently suggested that crews take future naming more seriously.

Crews were also encouraged to design the badge for their mission, and Apollo 11's insignia featured an American eagle landing on the Moon with an olive branch of peace in its talons. The crew of Apollo 11 chose not to add their names to the badge as earlier missions had done, believing that they were travelling on behalf of all mankind.

The astronauts were permitted another personal touch, their Personal Preference Kit (PPK). The PPK contained any objects of sentiment which each astronaut wanted to accompany him on his journey. Armstrong's PPK contained a small piece of wood from one of the twin propellers of the Wright Brothers' first successful aeroplane, and a small piece of cloth from one of its wings – mementos of one historic flight in the payload of another.

Lunar Descent

With Columbia and Eagle securely docked, Apollo 11 continued on its journey and entered lunar orbit on 19 July, a little over three days after leaving Earth. There, it made final preparations and passed repeatedly over the chosen landing site in the Sea of Tranquillity (*see* page 130), a relatively flat and crater-free lava flow identified by earlier probes. As you look at the

Left: *Lift-off of Apollo 11 at the start of its journey to the Moon*
Above: *Apollo 11's official emblem: an eagle with an olive branch lands on the Moon*

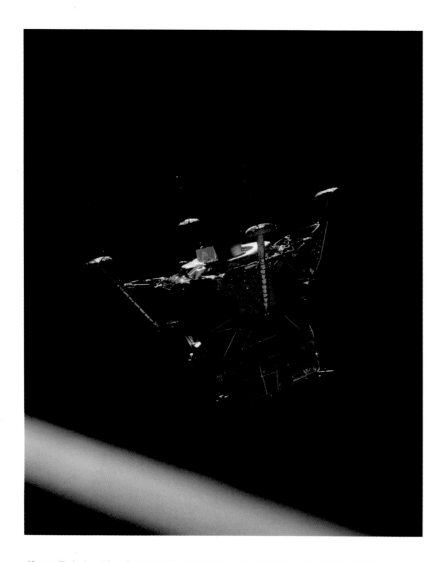

Above: Eagle viewed from Columbia before the LM's descent to the Moon's surface, 20 July 1969

Above: Apollo 10's LM descends to within 50,000 feet of the lunar surface (artist's impression)
Right: Michael Collins pilots the Apollo 11 Command Module in orbit around the Moon

full moon, the Sea of Tranquillity is the middle sea of a row of three dark areas in the upper right-hand quarter, between the Sea of Serenity to the north-west and the Sea of Fertility to the south-east.

The timing of the final descent to the surface was critical, dictated by trajectory angles and sunlight conditions. Nineteen hours later, Armstrong and Aldrin crawled through the hatch into Eagle and undertook five hours of pre-descent checks. On 20 July, at 17:44 UTC (Universal Time, 13:44 in Florida), just over four days after blasting off, Columbia and Eagle parted company.

Lunar Landing

Collins, remaining in the command module, inspected Eagle for damage and confirmed that the landing gear was in place; and just as Snoopy had done from Charlie Brown during Apollo 10, Eagle began its descent orbit. At the point, 13 km (8 miles) above the surface, where Snoopy had returned to Charlie Brown, Eagle fired its descent rockets and began its final approach.

1.6 km (1 mile) above the Moon, Eagle's computer began sounding alarms. It emerged that the computer was unable to process all the data it was

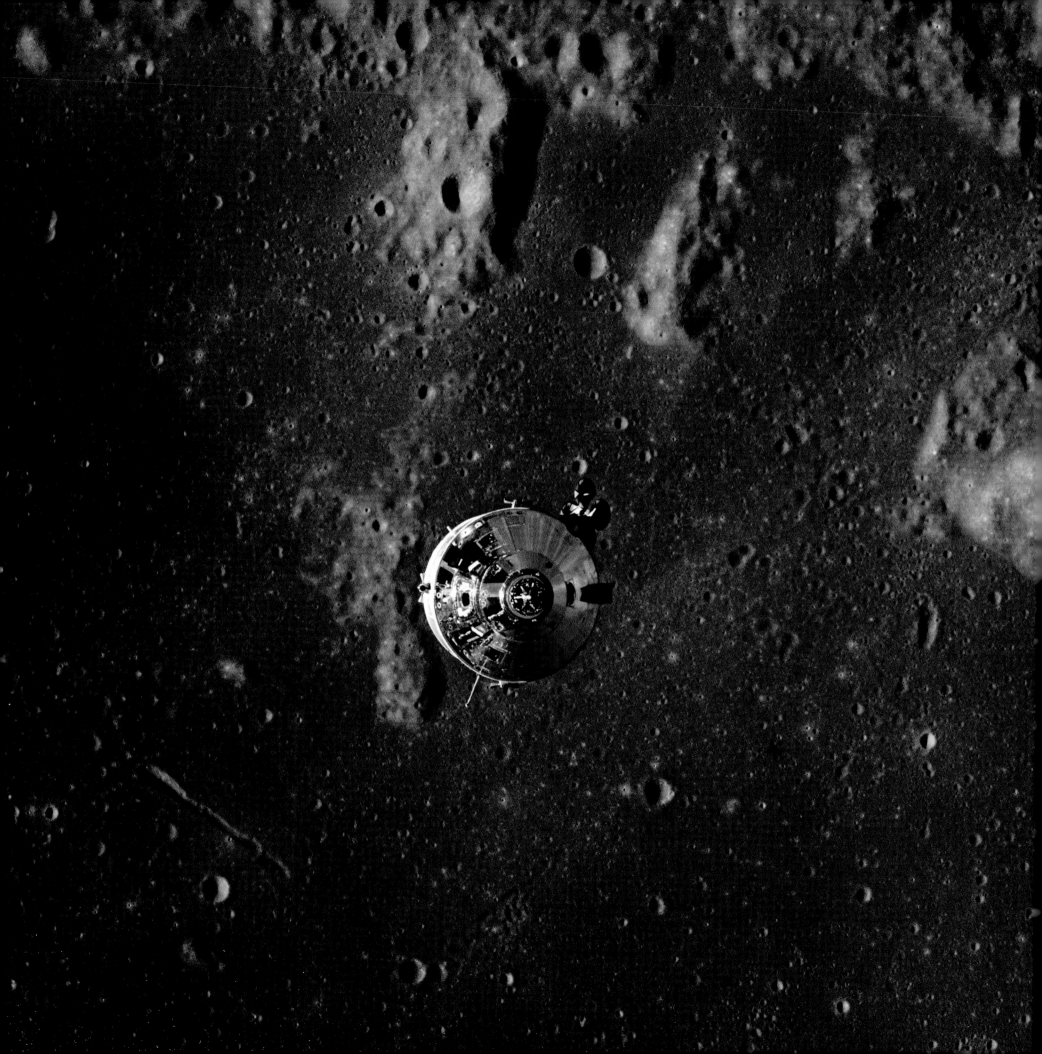

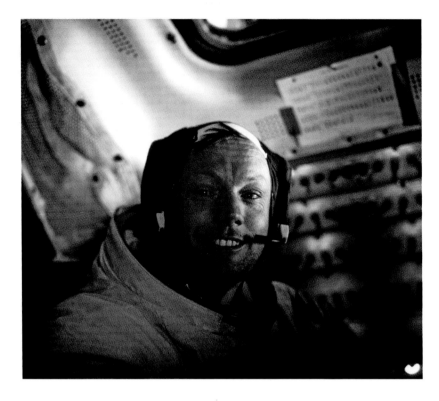

Above: Neil Armstrong, back aboard the Eagle after taking the first human steps on the Moon
Left: NASA staff monitor monitor the Apollo 11 EVA from the Mission Control Center in Houston, Texas

receiving and the alarms were to announce that it was prioritizing some tasks over others.

It had become clear during the descent orbit that Eagle was travelling faster than expected and would overshoot its landing site. The computer now chose a new site, but Armstrong looked out and could see that it was littered with boulders. He took control of Eagle and piloted it the rest of the way himself, while Aldrin called out instructions as navigator. With only 25 seconds of fuel left in the descent rockets, Eagle touched down at 20:17 UTC.

Properly completing all post-landing checks first, Armstrong eventually reported to duty CAPCOM Charles Duke with the immortal words, 'Houston, Tranquillity Base here. The Eagle has landed.' Duke replied, 'Roger, Tranquillity, we copy you on the ground. You got a bunch of guys about to turn blue. We're breathing again. Thanks a lot.'

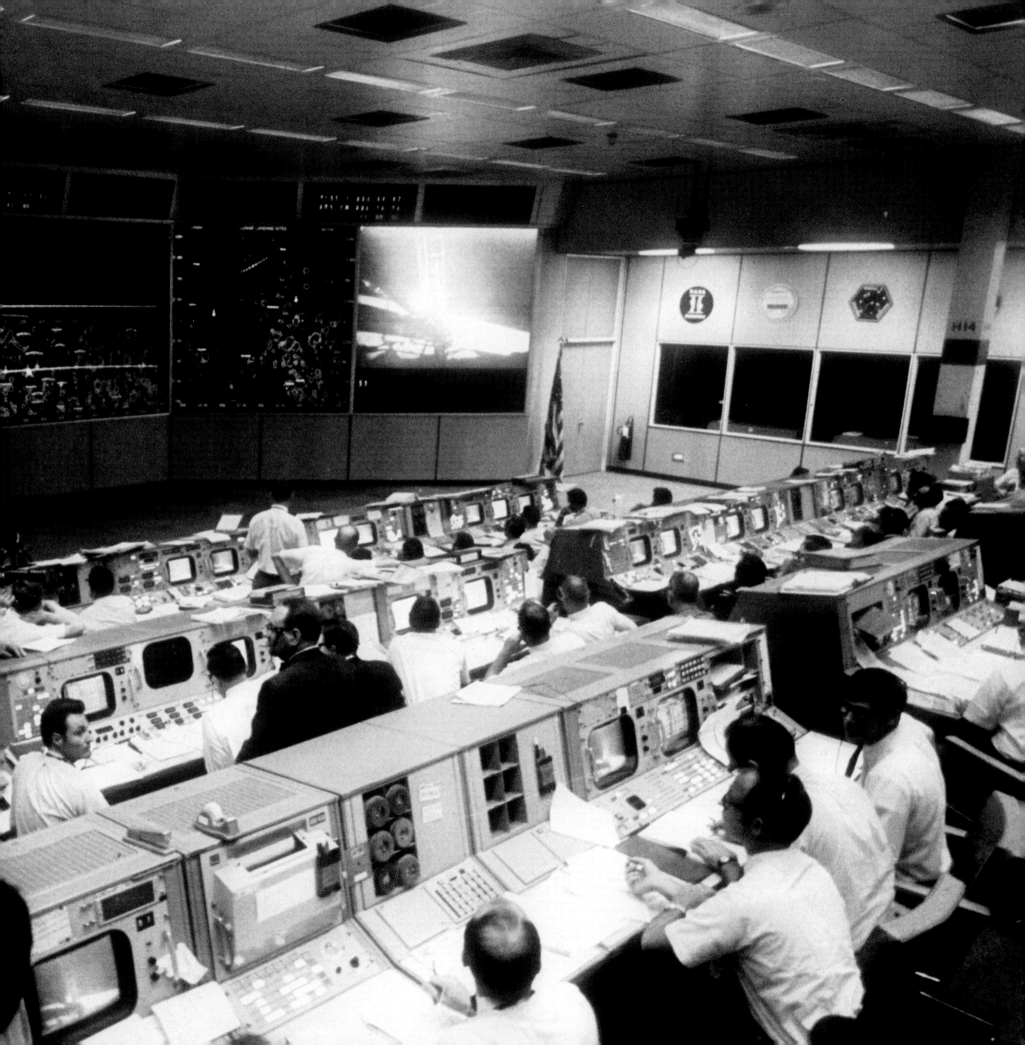

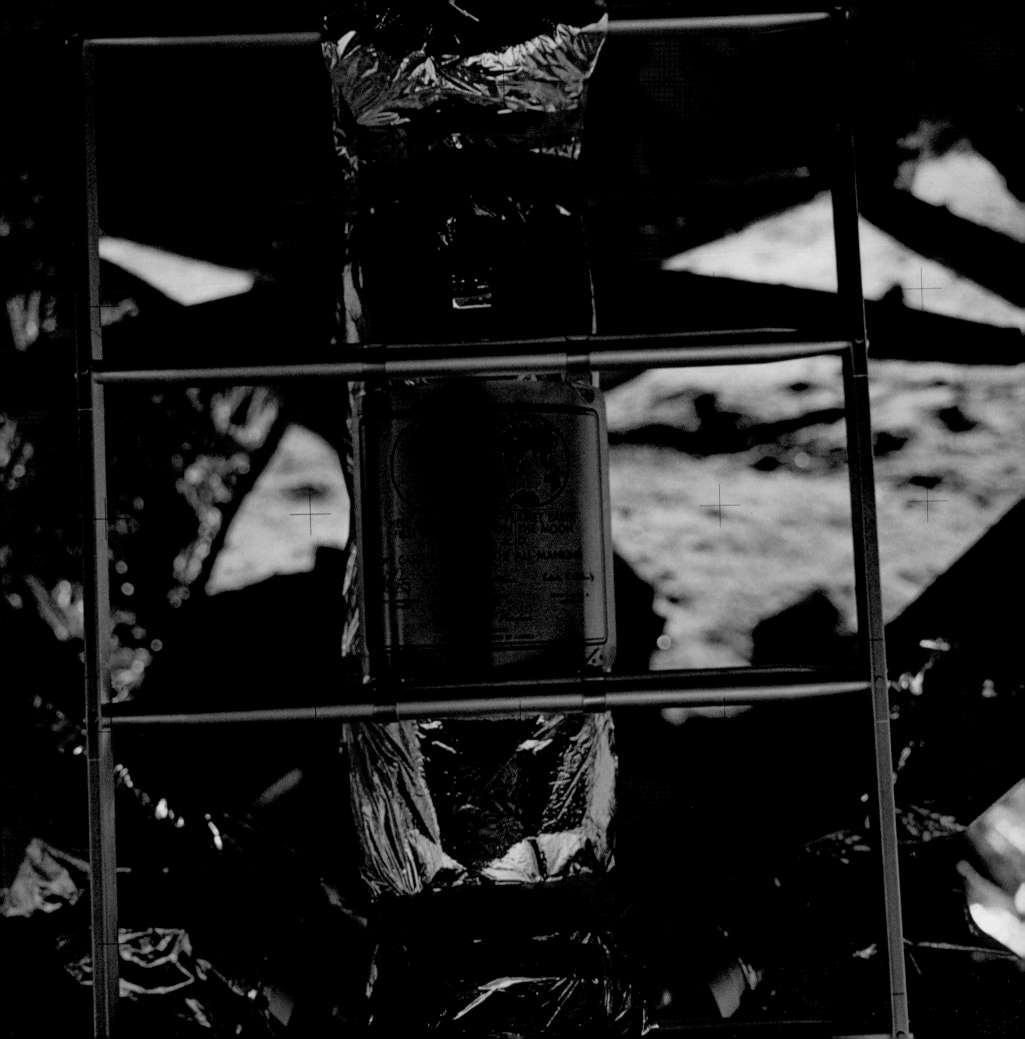

Walking on the Moon

Armstrong and Aldrin were scheduled to take a five-hour sleep break after landing. Understandably, neither man was convinced that he would be able to do so. After two-and-a-half hours, Aldrin's voice come over the intercom, expressing what all of NASA, the US and the world were thinking:

'I'd like to take this opportunity to ask every person listening in, whoever and wherever they may be, to pause for a moment and contemplate the events of the past few hours and to give thanks in his or her own way.' Aldrin, a devout Christian and elder of his local church, now quietly and privately took Communion with the holy wine and wafer which he had packed in his PPK.

Armstrong and Aldrin now prepared themselves to leave the module. Once they were both secure in their space suits, Armstrong depressurized Eagle and opened the hatch. It was 02:39 UTC on 21 July 1969, 22:39 Eastern Daylight Time (EDT) on 20 July in the USA. Pausing as he descended the nine steps of the simple ladder, Armstrong did two things. First, he activated the video camera which relayed grainy pictures to a global television audience of 600 million people.

Second, he uncovered an engraved panel mounted on Eagle's descent section, the part which would be left behind when Aldrin and he returned to Columbia. It showed the eastern and western hemispheres of the planet from which they had come, the names and signatures of the crew and of President Nixon, and the legend: 'Here men from the planet Earth first set foot upon the Moon, July 1969 AD. We came in peace for all mankind.'

At 02:56 UTC (22:56 EDT), Neil Armstrong stepped off the ladder and on to the dusty surface of the Moon.

Left: Buzz Aldrin in Apollo 11's Lunar Module, moments after walking on the Moon
Right: 'We came in peace for all mankind' – plaque left on the Moon by Apollo 11

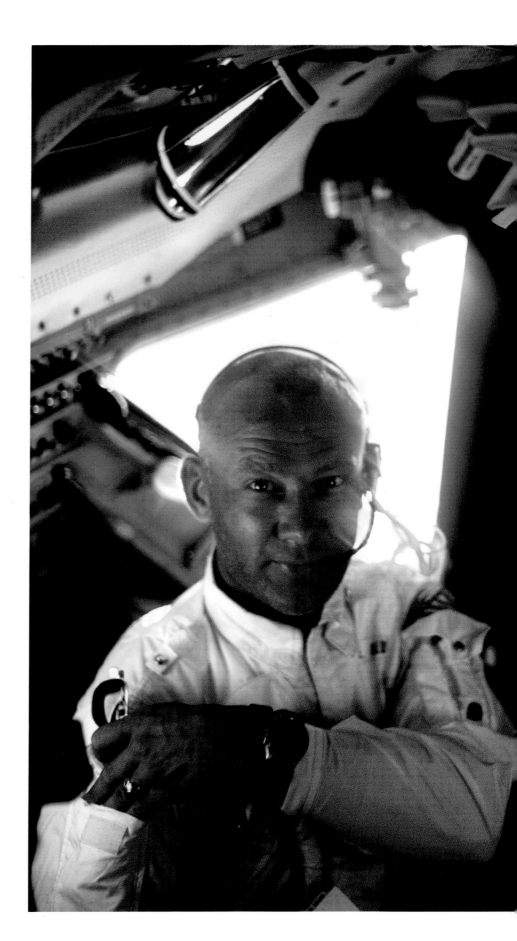

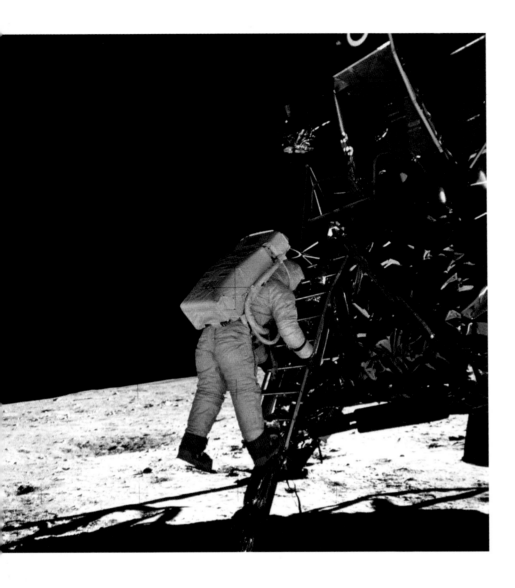

His first act was to gather a small sample of moondust, a contingency in case they suddenly had to return to Columbia before completing any other tasks. Aldrin joined him to share the moment and they tested their ability to move around. Walking, it turned out, was easier than expected, and the best technique seemed to be a sort of half-run elongated stride. Stopping was harder, as the dust was loose and slippery.

Aldrin planted the Stars and Stripes, and President Nixon spoke to them from the White House. He remarked, 'It inspires us to redouble our efforts to bring peace and tranquillity to Earth. For one priceless moment in the whole history of man, all the people on this Earth are truly one.'

Leaving the Moon

Apollo 11 was first and foremost a human achievement, but it was also a scientific expedition. Over the next two hours, Armstrong and Aldrin installed a seismometer to measure geological activity and a laser reflector to monitor the Moon's distance from Earth. They collected over 21 kg (46 lbs) of rock and soil samples, from which subsequent analysis revealed three previously unknown minerals. They were named pyroxferroite, tranquillityite and armalcolite – the latter an amalgam of ARMstrong, ALdrin and COLlins. All three have since been found on Earth too, lending support to the theory that the Moon was originally born of Earth (*see* page 39).

The astronauts then returned to Eagle, leaving behind on the Moon a memorial package containing a golden olive branch and a badge bearing the insignia of the fatal Apollo 1 mission, as well as equipment for which they had no further use. At 05:01 UTC, two hours and twenty-two minutes after he had opened it, Neil Armstrong closed the Eagle's hatch and re-pressurized the capsule.

One Giant Leap

'That's one small step for a man, one giant leap for mankind,' Armstrong said as he felt the dusty ground under his feet.

Much has been made of the inaudibility of the sixth word when it was radioed to Columbia and relayed nearly 384,633 km (239,000 miles) back through space to Earth. The sentence does not mean much without it and Armstrong certainly said it. His heart was pounding at that moment faster than at any other point in the mission and he was a little breathless as he expressed perfectly the enormity of what he had just done.

Above left: Buzz Aldrin, photographed by Neil Armstrong, takes his first step on to the Moon's surface
Right: Buzz Aldrin, photographed on the Moon by Neil Armstrong, beside the Stars and Stripes

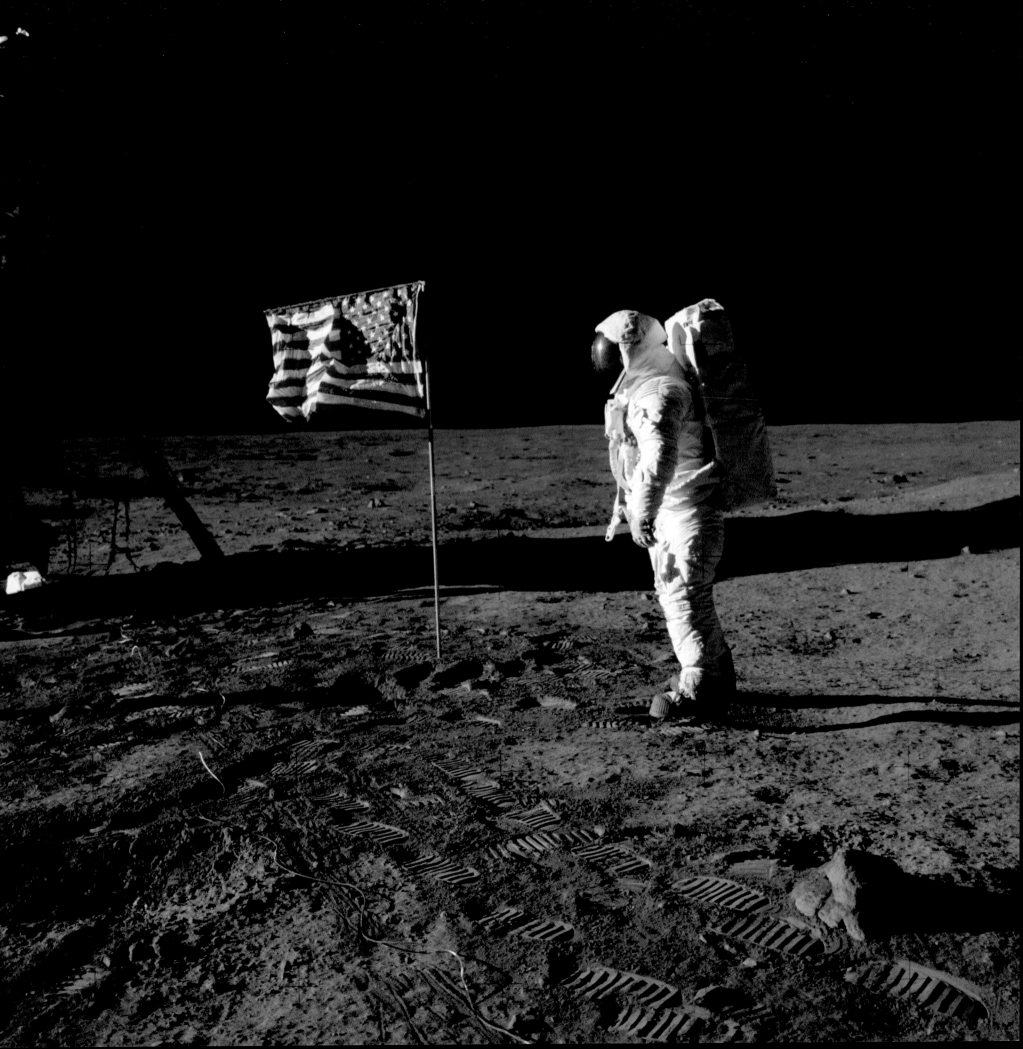

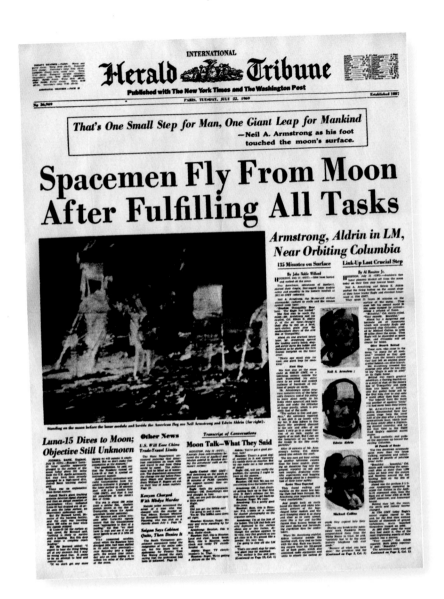

INTERNATIONAL

Herald ☙☙ Tribune

Published with The New York Times and The Washington Post

PARIS, TUESDAY, JULY 22, 1969

That's One Small Step for Man, One Giant Leap for Mankind
—Neil A. Armstrong as his foot
touched the moon's surface.

Spacemen Fly From Moon After Fulfilling All Tasks

Armstrong, Aldrin in LM, Near Orbiting Columbia

135 Minutes on Surface

Link-Up Last Crucial Step

Standing on the moon before the lunar module and beside the American flag are Neil Armstrong and Edwin Aldrin (far right).

Luna-15 Dives to Moon; Objective Still Unknown

Other News

Moon Talk—What They Said

A seven-hour rest period was scheduled, and this time, the astronauts took full advantage of it. They were woken by Mission Control in Houston and prepared to ascend to the command and service module. As they blasted off from the Moon at 17:54 UTC, the exhaust from the ascent jet toppled the precariously planted American flag.

Eagle successfully re-docked with Columbia three-and-a-half hours later. Having transferred their lunar samples to the command module, the crew

Above: Front page of the Herald Tribune on 21 July 1969 after Apollo 11's historic moonwalk
Right: The approaching Eagle prepares to dock with Columbia after ascending from the Moon's surface

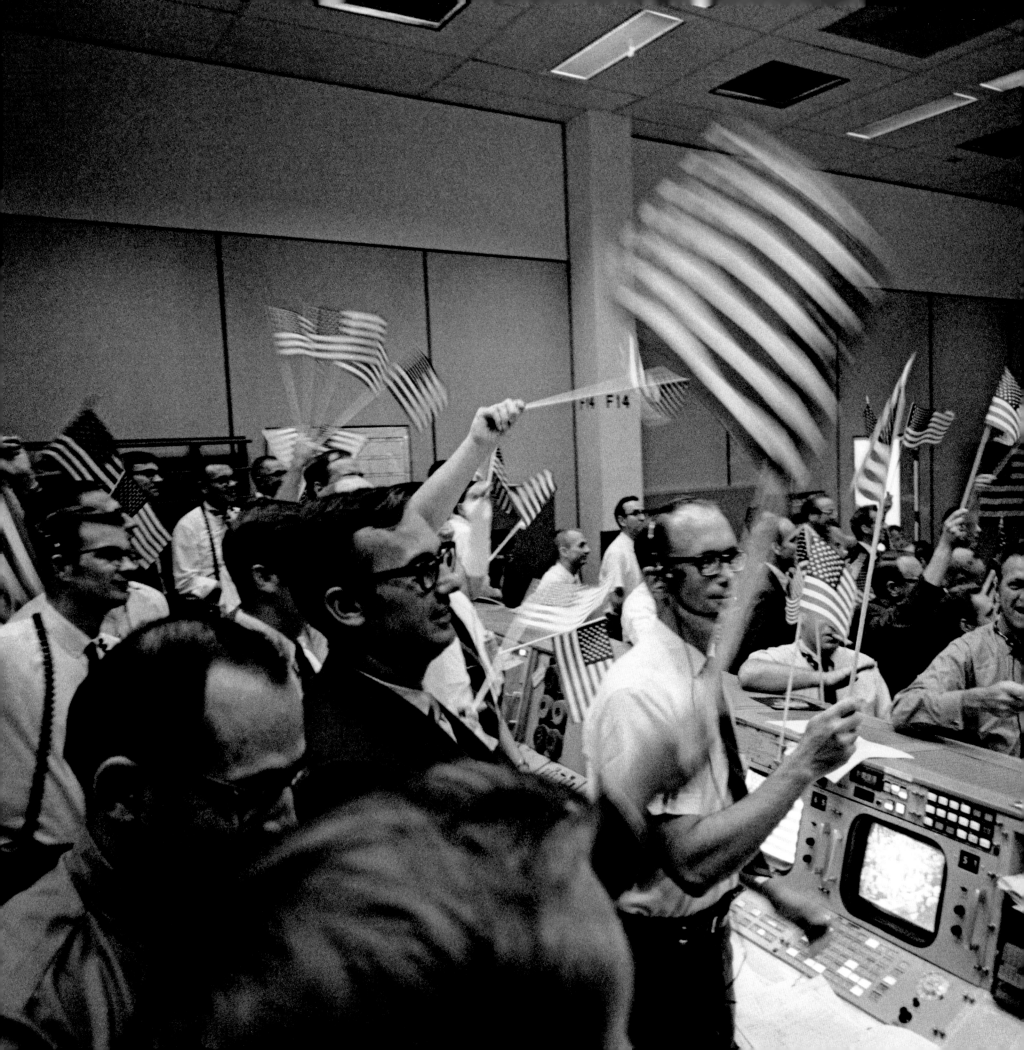

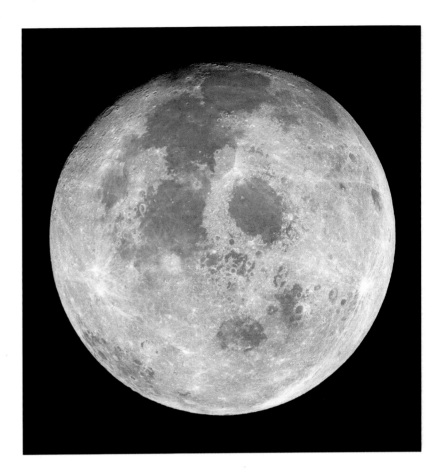

Above: *Already 10,000 miles from the Moon, Apollo 11 captured this view during its return home*
Left: *Flags are waved as Mission Control celebrates the safe return of Apollo 11 to Earth*

bade a final farewell to Eagle at 23:41 UTC. After undocking, it remained in orbit around the Moon for some months before decaying and crashing on to the Moon, the first object to land on the Moon twice.

Splashdown

At 04:54 UTC on 22 July, Apollo 11 left lunar orbit and began the long journey home. During the return flight, the crew made one last broadcast from space, giving credit to the unseen army of technicians, scientists, programmers and designers who had put them there. Michael Collins said, 'All you see is the three of us, but beneath the surface are thousands and thousands of others.' Some estimates put the number of people on the ground supporting Apollo 11 in the air at around 18,000.

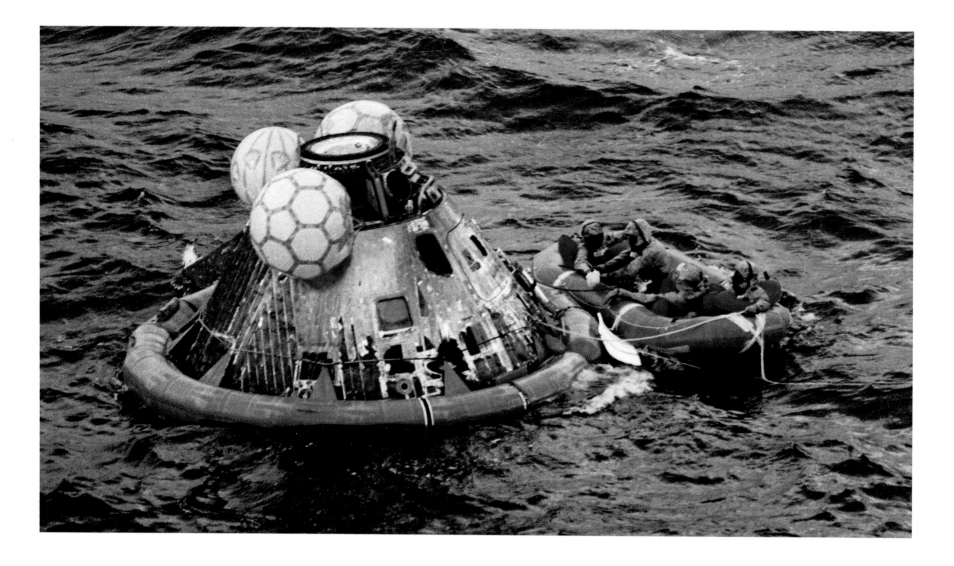

As they were pulled into Earth's gravitational field during re-entry, the crew were subjected to a force equivalent to six gravities. Once they were safely out of space and back in Earth's atmosphere, they deployed Columbia's parachutes. At 16:50 UTC (5:50 local time) on 24 July, Columbia splashed down in the North Pacific, midway between Guatemala and Vietnam, directly south of the Bering Strait which divides Russia and America.

Because of the remote possibility that they had been exposed to biohazards on the Moon, Collins, Armstrong and Aldrin were kept in quarantine for 21 days after their return. The crew and Columbia were scrubbed clean, and the life raft which rescued them after splashdown was sunk with all the decontamination materials on it.

As soon as they were released from quarantine, the three men were given tickertape parades in New York, Chicago and Los Angeles. They then undertook a 45-day world tour of honour, meeting heads of state and other representatives in 25 countries. The command module itself became a celebrity, touring 49 US state capitals before being installed as the star attraction at the Smithsonian Institute's National Air and Space Museum in Washington DC.

Above: The Apollo 11 crew, accompanied by a US Navy underwater demolition team swimmer, await helicopter pickup after splashdown

Right: President Nixon welcomes the Apollo 11 crew, in quarantine on the USS Hornet after splashdown

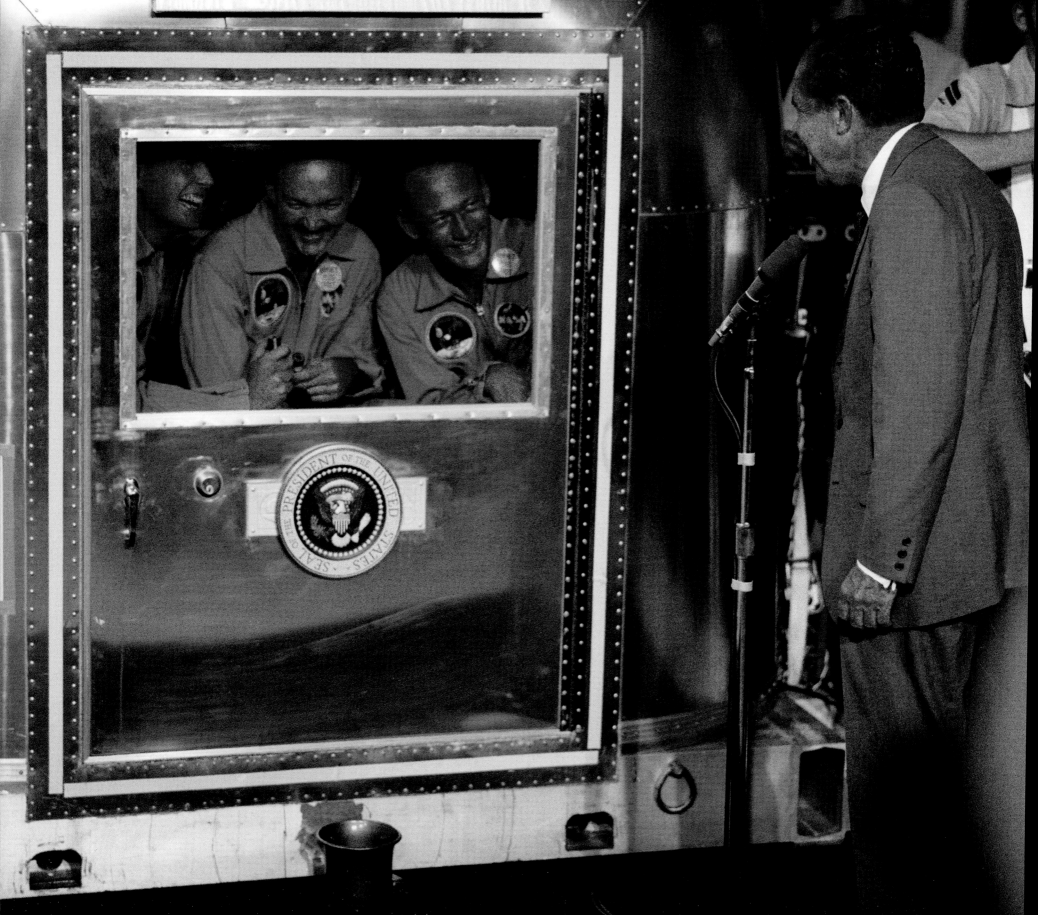

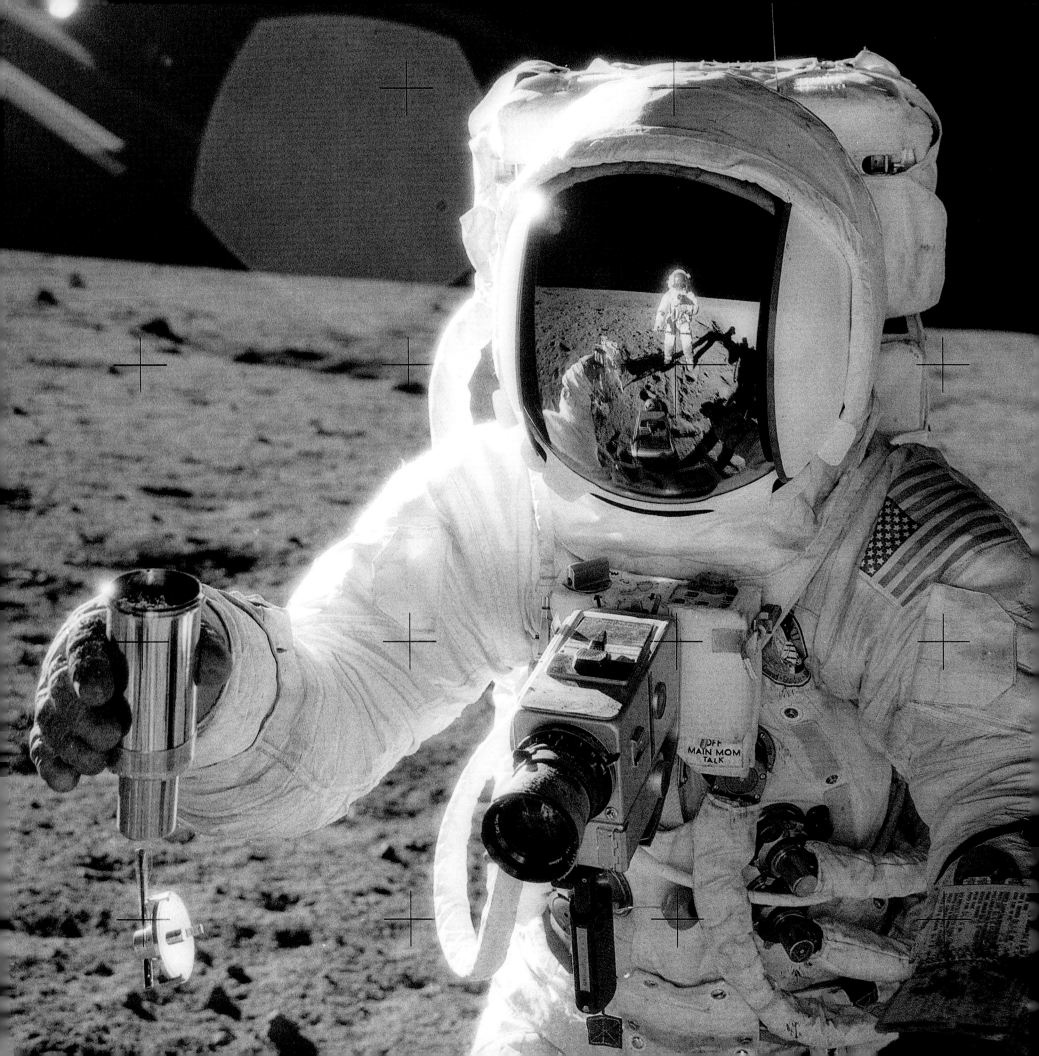

Moonstruck

Nine further missions to the Moon were planned, as Apollos 12 to 20. In the event, only six flew and only five reached their target. Budget cuts, accidents and re-assigned priorities took care of the rest. Now that the Space Race was won, public and political enthusiasm for space exploration gradually waned. However, while there remained the will to boldly go, there was still much to be learned from the Moon.

Apollo 12

In November 1969, Apollo 12, crewed by Charles Conrad, Richard Gordon and Alan Bean, achieved the first precise lunar landing, touching down within walking distance of the NASA unmanned lunar probe Surveyor 3, which had flown there in April 1967. Conrad and Bean retrieved parts of it to bring back with them and set up further lunar monitoring equipment.

Above: *The wives of the Apollo 12 astronauts, (l–r) Jane Conrad, Barbara Cernan, and Leslie Bean, at a celebration for the spacecraft's launch*
Left: *Astronauts Conrad and Bean – one reflected in the other's visor – collect samples during Apollo 12's mission*

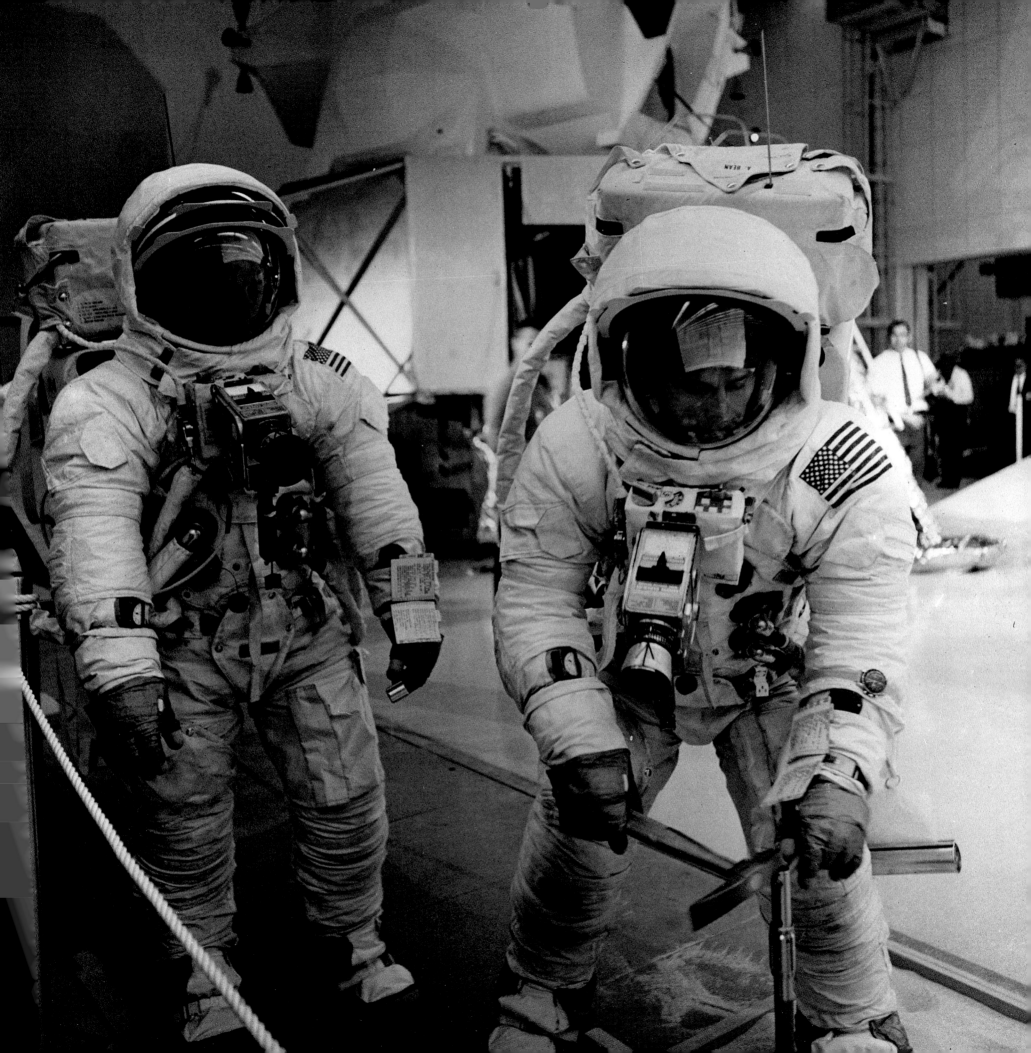

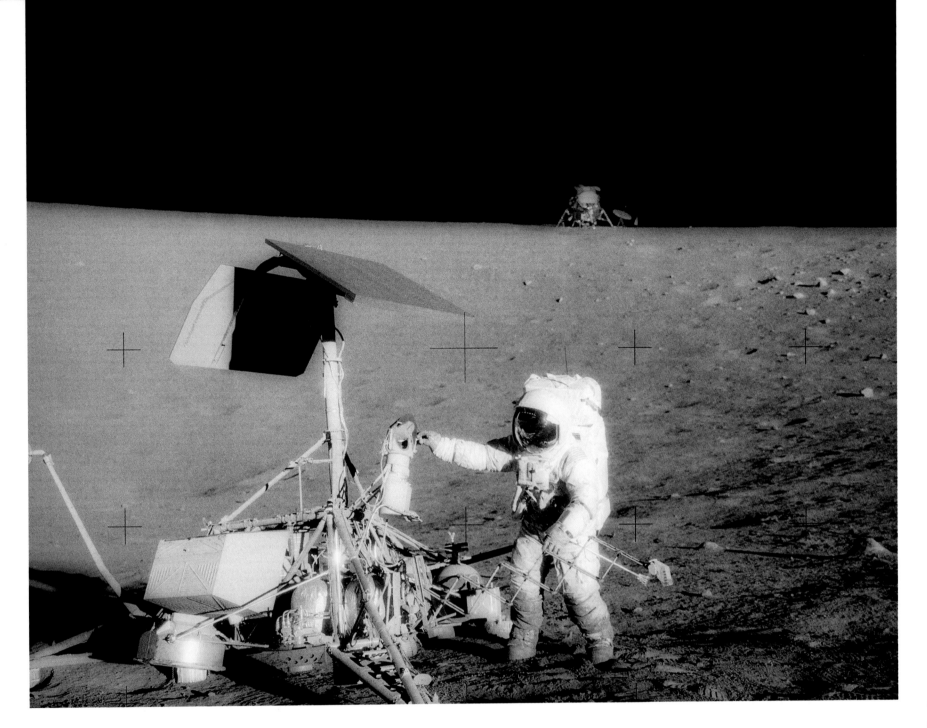

The mission was supposed to broadcast the first colour TV pictures from the Moon live, but unfortunately Bean accidentally pointed the camera at the Sun almost immediately and burnt out the tube. It was also Bean who left rolls of precious exposed camera film on the Moon by mistake at the end of the mission, and Bean who was knocked unconscious during splashdown by an unsecured cine camera.

Above: In 1969, near Apollo 12's LM, Charles Conrad inspects NASA's 1967 Surveyor 3 lunar probe
Left: Charles Conrad and Alan Bean of Apollo 12 practise the collection of lunar core samples

Apollo 13

Apollo 13 lifted off on 10 April 1970. Its mission was to explore a hilly area of the Moon called Fra Mauro, which might shed light on the nature of large object collisions in space. The launch went smoothly apart from an irregularity with the second-stage rockets of the Saturn V. On the third day of the flight, soon after a routine live broadcast for terrestrial TV, an oxygen tank in the service module exploded, causing voltage problems for

the electrical systems in the command module. Apollo 13's fuel cells created electricity by combining oxygen and hydrogen, and without oxygen, the command module suffered a crippling loss of power.

The damage caused by the explosion meant that the crew would have been unable to return to the command module from the Moon, so the disappointing decision was taken to abort the mission. It was commander Jim Lovell's fourth space flight, but his colleagues Jack Swigert and Fred Haise (who had settled Apollo 11's crew into their command module ahead of their launch) had never flown and would never do so again. This was their only chance.

Above: The hastily devised air filter which saved the lives of the crew of Apollo 13
Right: Jack Swigert holds some of the system improvised to remove carbon dioxide from Apollo 13

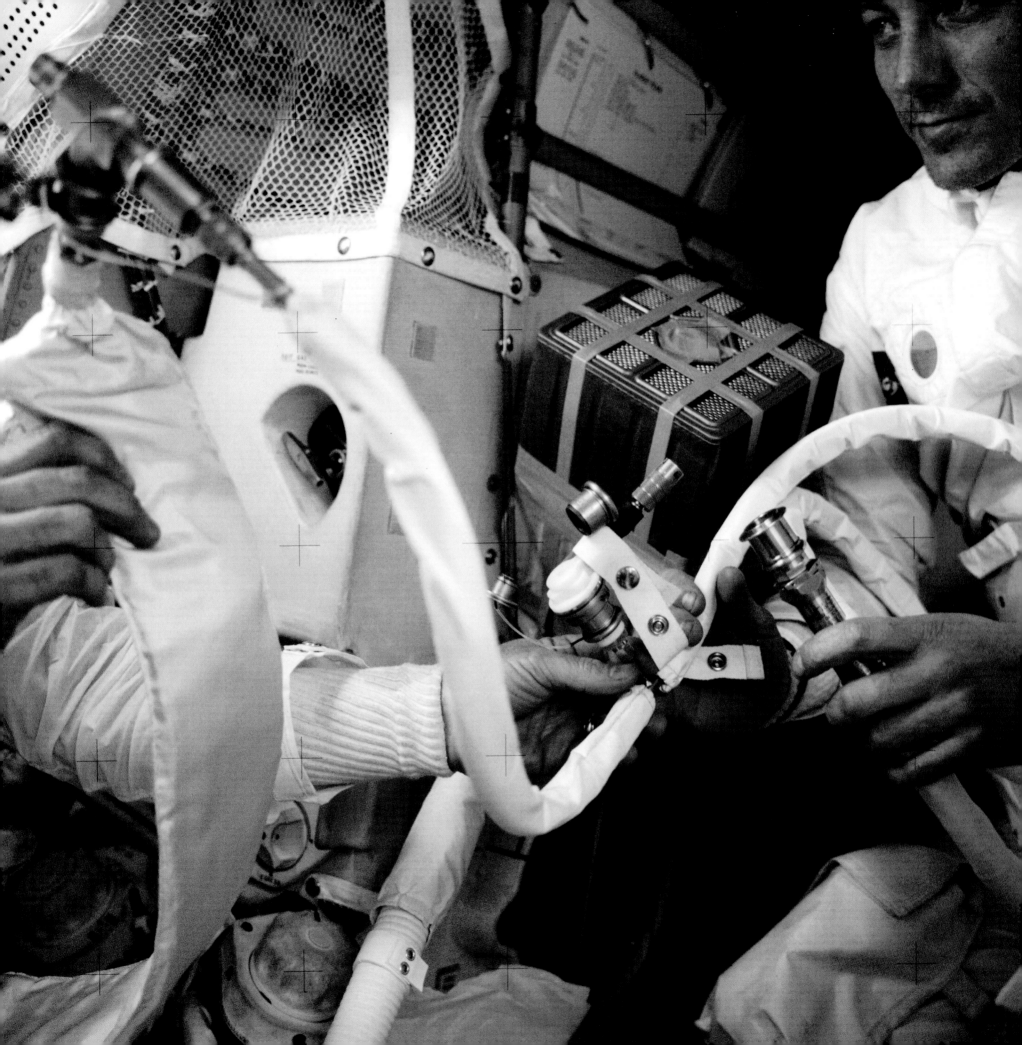

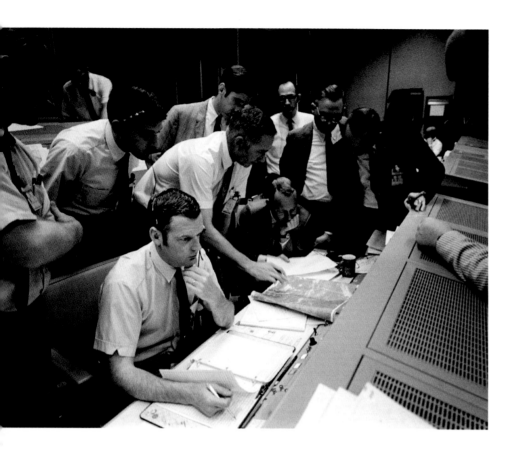

Apollo 13 continued around the Moon in a high orbit, in order to catapult itself back to Earth. At its furthest point on the dark side, Apollo 13 set a record for the greatest distance human beings had ever been from Earth – 400,171 km (248,655 miles).

The accident left the astronauts short of drinkable water in an unheated, confined space in which their breathing was causing a dangerous build-up of carbon dioxide. By raiding the now-redundant lunar landing module for equipment and power, they were able to improvise solutions to some of the problems, without which Apollo 13 would certainly have ended with the deaths of all three men. Instead, the successful return of Lovell, Haise and Swigert was hailed as NASA's finest hour. It is told with impressively accurate detail in the film *Apollo 13*, with Tom Hanks as Lovell, Bill Paxton as Haise and Kevin Bacon as Swigert.

Above: *Flight controllers focus on trying to bring the crippled Apollo 13 spacecraft back to Earth*
Right: *Fred Haise, Jim Lovell and Jack Swigert on USS Iwo Jima after Apollo 13's splashdown*

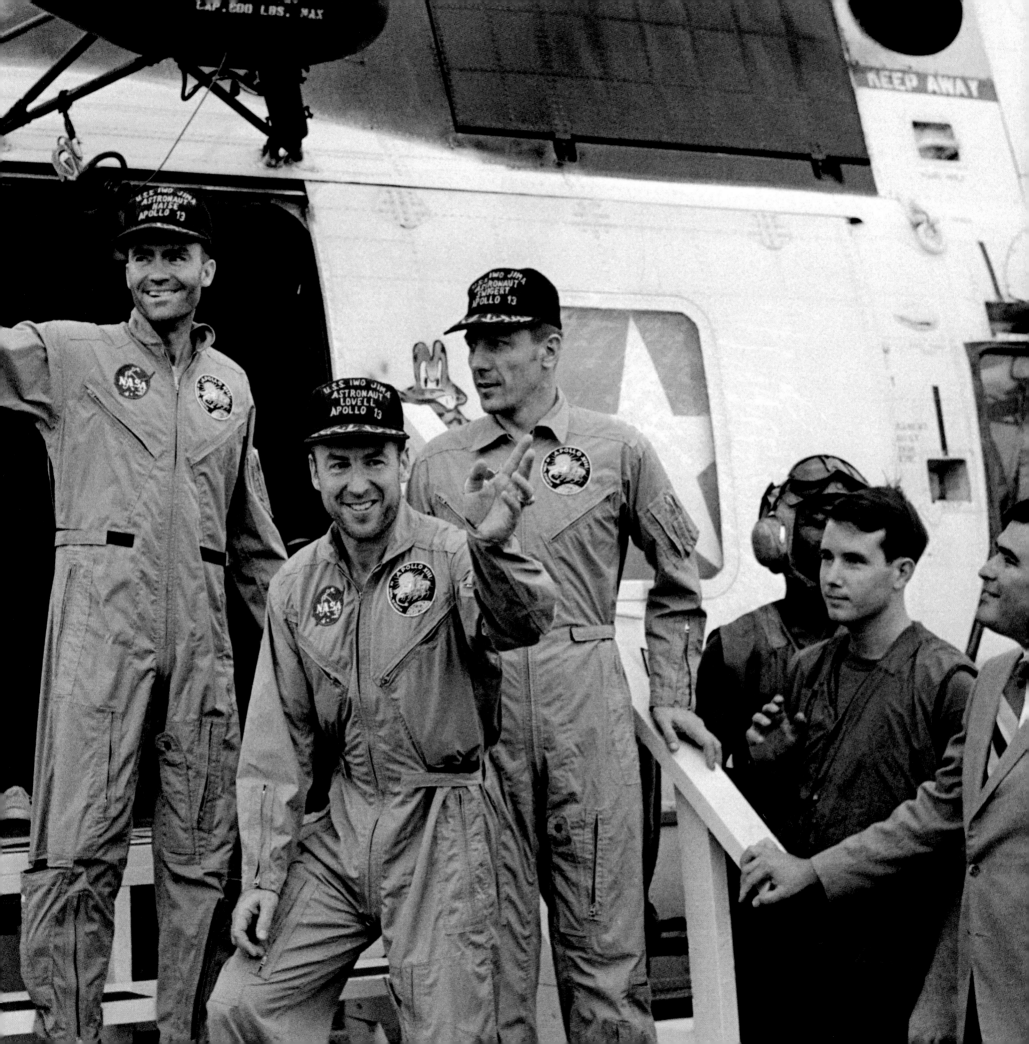

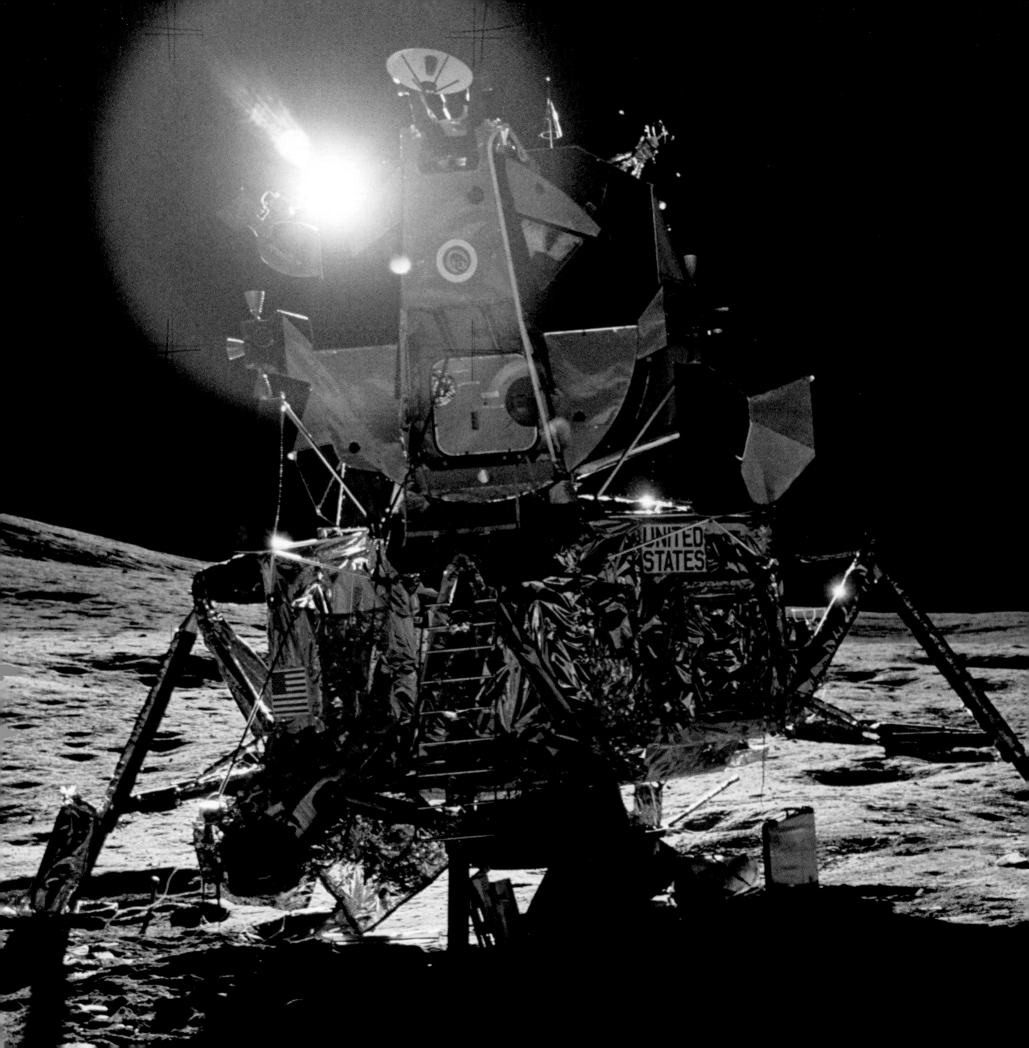

Above: Apollo 14 astronauts Alan Shepard and Edgar Mitchell practice in a lunar module simulator, July 15, 1970

The End of the Program

Only four more Apollo missions were flown. Apollo 18 and Apollo 19 fell victim to budget cuts, and the spacecraft allocated to Apollo 20 was instead used to launch the Skylab space station.

All four landed on the Moon. Apollo 14, delayed to accommodate the lessons of Apollo 13's failure, was launched in January 1971. It fulfilled Apollo 13's mission to Fra Mauro. Avoiding Bean's mistake, it was the first mission to broadcast colour TV pictures from the Moon. Its commander, Alan Shepard, the first American in space, played golf during his extra-vehicular activity on the Moon.

Left: The Apollo 14 LM Antares, *as seen by Alan Shepard and Edgar Mitchell during their first EVA, February 5, 1971*

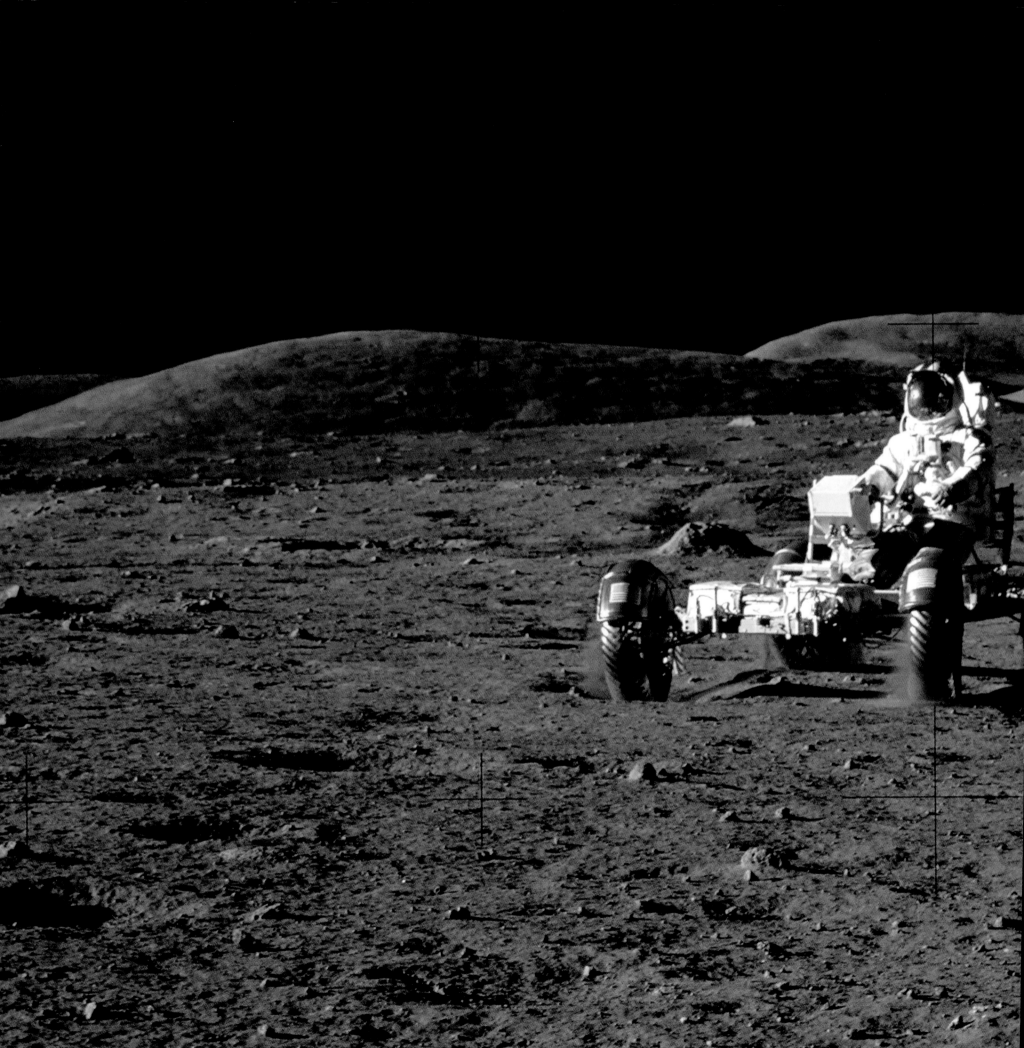

Apollo 15, crewed by David Scott, Alfred Worden and James Irwin, made an extended visit, remaining on its surface for three days in July and August 1971. It was the first mission to make use of the Lunar Rover vehicle to travel further than before from the lunar landing module. It was an expensive luxury: the total cost of the three Rover vehicles sent to, and left on, the Moon by the end of the Apollo program was around $40 million.

The longer stay and the Rover meant it was possible to do more serious scientific work. The crew left a small statuette on the Moon called 'The Fallen Astronaut', with a plaque commemorating all the cosmonauts and astronauts who had lost their lives in the cause of space exploration. However, the reputation of the mission was damaged by a money-making scheme cooked up between the crew and a German stamp dealer, for whom they carried 400 unauthorized postage covers to the Moon to increase their value.

In April 1972, Apollo 16, crewed by John Young, Ken Mattingly and Charles Duke, made another extended visit to the Moon, again with a Rover vehicle, to collect rocks from the geologically older lunar highlands. Both Apollo 15 and Apollo 16 launched lunar satellites.

Because of the Moon's variable density and gravity, low lunar orbits are now known to be extremely unstable in their trajectories. This was not understood at the time. By sheer good luck, Apollo 15 managed to place its satellite, PFS-1, in one of only four stable low orbits, where – other things being equal – it can continue to circle the Moon indefinitely. Apollo 16's PFS-2, by contrast, was inadvertently placed in one of the least stable orbits of all. It soon adopted an extremely warped path, swooping from up to 122 km (76 miles) above the Moon to as little as 9.6 km (6 miles). Despite attempts to correct its course, it crashed into the surface after only 35 days.

Previous page: Gene Cernan test-drives the Lunar Rover during the first of Apollo 17's lunar EVAs
Right: The Lunar Rover enabled astronauts Young and Duke of Apollo 16 to visit Plum Crater

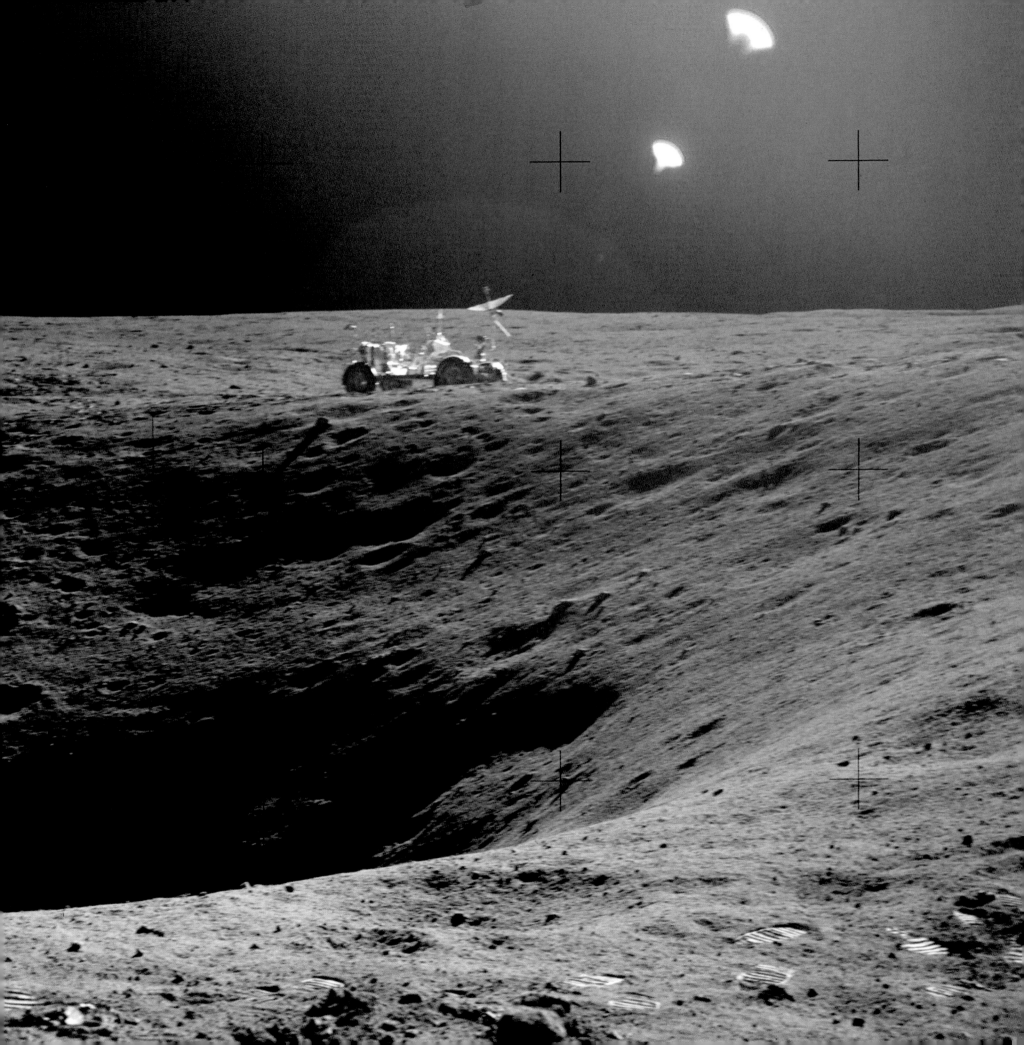

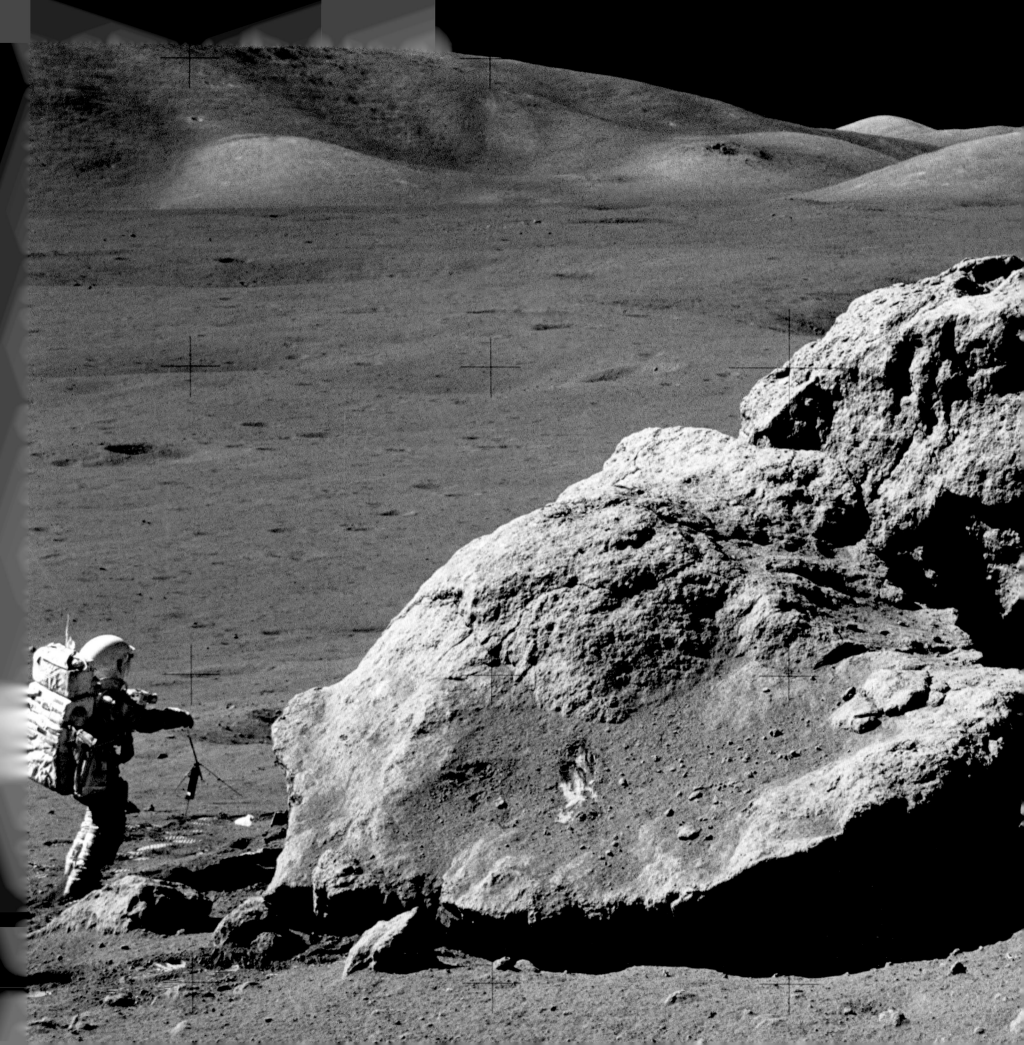

Above: *Gene Cernan and the Lunar Rover during Apollo 17's third and final EVA*

In December 1972, Apollo 17 took flight, crewed by Gene Cernan, Ronald Evans and Harrison Schmitt. Despite several earlier missions to bring back lunar samples, this was the first time a qualified geologist, Schmitt, had flown with Apollo. Once again, the crew explored the older rocks of lunar highlands with a Rover, looking for evidence of volcanic activity. They brought back 114 kg (251 lbs) more than any previous mission, having stayed on the surface for three days and three hours, the longest ever visit.

Since they lifted off from the Moon on 14 December 1972, no other humans have set foot there. The 12 men in the whole of human history to have done so – Neil Armstrong, Buzz Aldrin, Pete Conrad, Alan Bean, Alan Shepard, Edgar Mitchell, David Scott, James Irwin, John Young, Charles Duke, Gene Cernan and Harrison Schmitt – did so in a period of only three years. When will we see such a concentration of human endeavour and achievement again?

Left: *Harrison Schmitt stands next to a huge lunar boulder during the third Apollo 17 EVA*

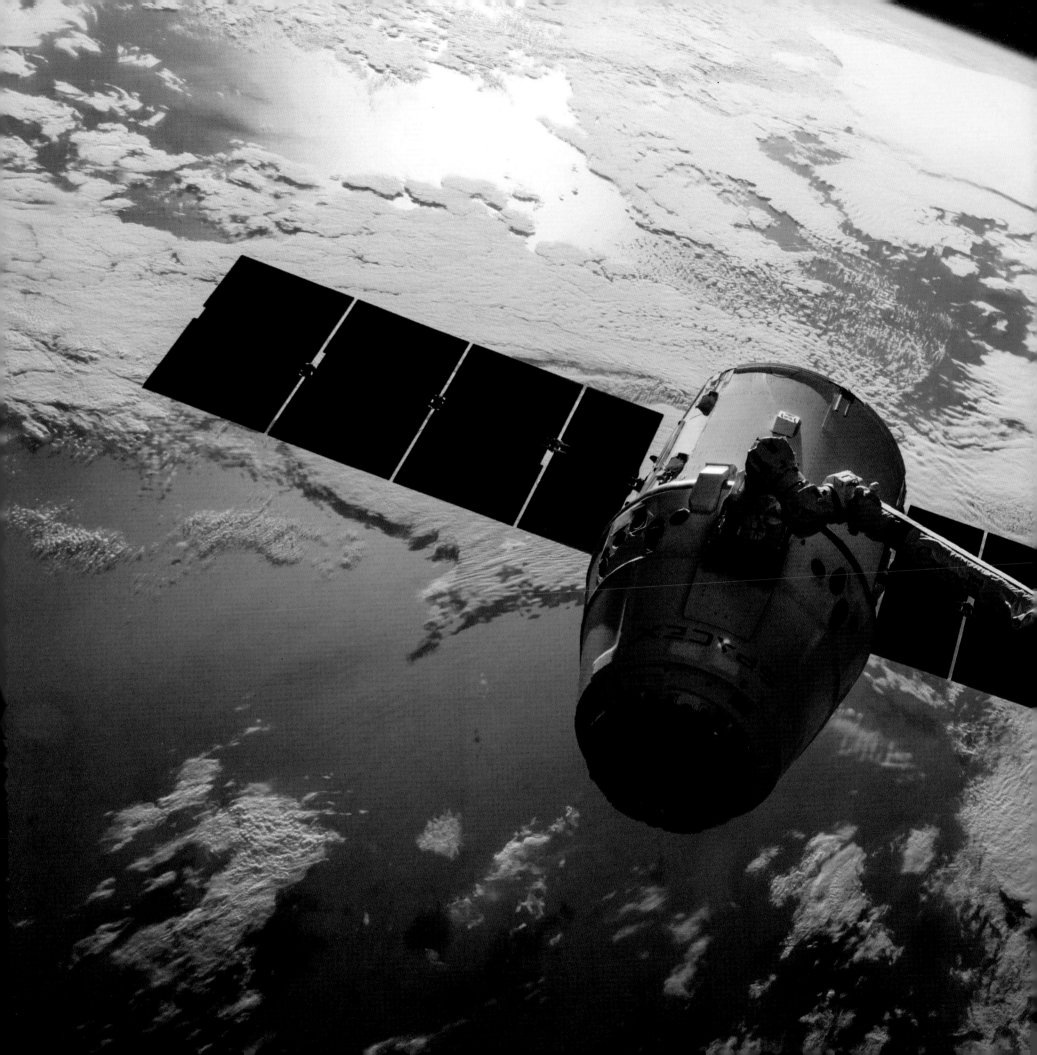

The Legacy of the Apollo Program

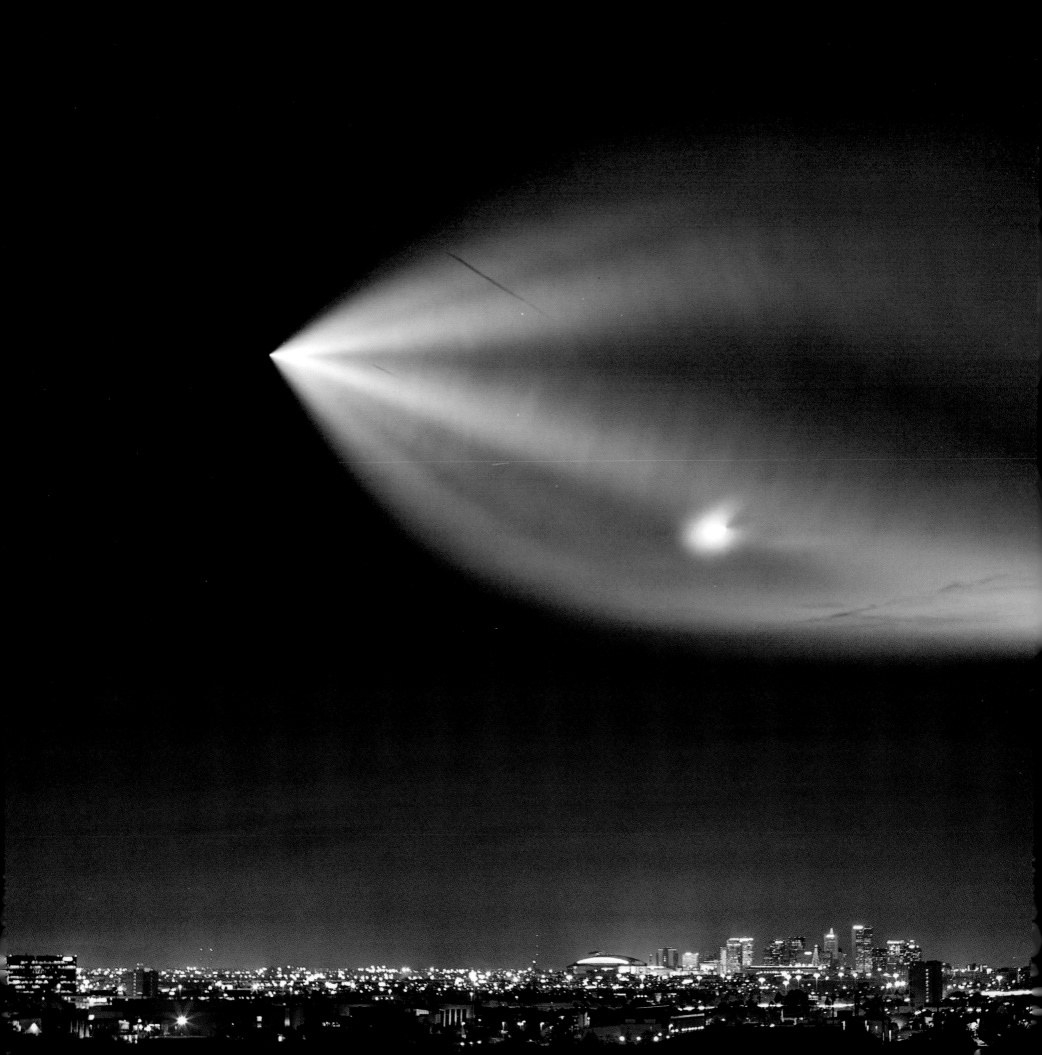

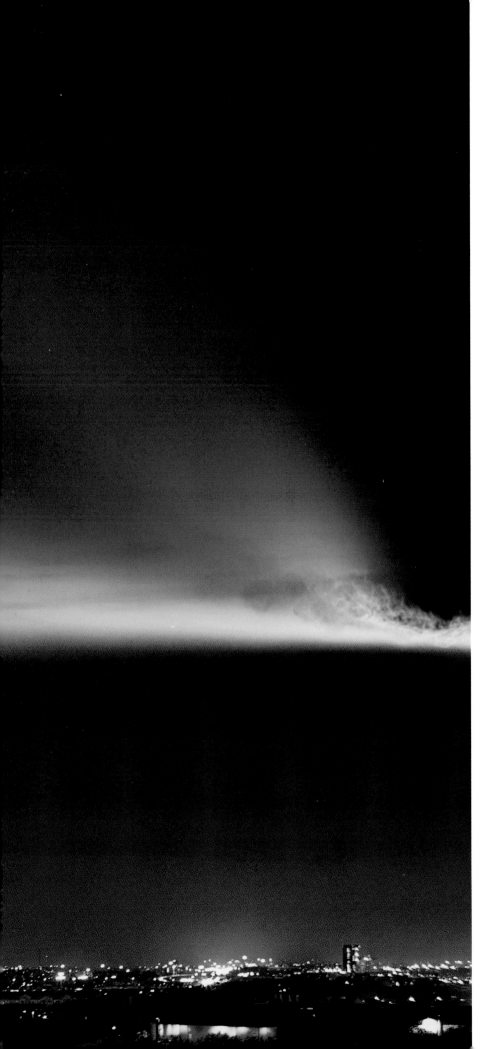

After the Race Was Won

The splashdown of Apollo 17 was not the end of space exploration. Unmanned probes continue to travel to the edges of our solar system and beyond, searching for life and for answers to questions about the origin of all things. Fifty years after Apollo 11 landed on the Moon, the United States, Europe, Russia and the United Arab Emirates are all building probes to land on Mars. Entrepreneur Elon Musk of SpaceX has grand ambitions and credible plans to establish a self-sufficient colony on Mars within five years.

Apollo showed that all this was possible, that humans could travel and land in space. Building on the innovative genius of the early rocket pioneers, the Apollo program led and directed the scientific developments necessary for its missions. It more or less created the technical sectors that service the twenty-first century space industry. The benefits have spilled over into civilian life, with thousands of everyday applications of space technology (*see* page 168).

Not the Only Ones

Where once the USA and the USSR had space to themselves, now other nations have their own space programs. Sixty-six countries have a state-run space agency, of which a dozen have the capacity to launch their own rockets. China launched its first satellite in 1970 and its first manned mission, Shenzhou 5, in 2003. Only China, Russia and the US have conducted manned flights, although 31 nations have trained astronauts. Only the 12 Americans of the Apollo landings have walked on the Moon (*see* page 159).

Previous page: A SpaceX Dragon cargo craft grappled by the ISS's robotic arm, Canadarm2, April 2016
Left: SpaceX's Falcon 9 rocket above Phoenix, AZ in December 2017, carrying a payload of satellites

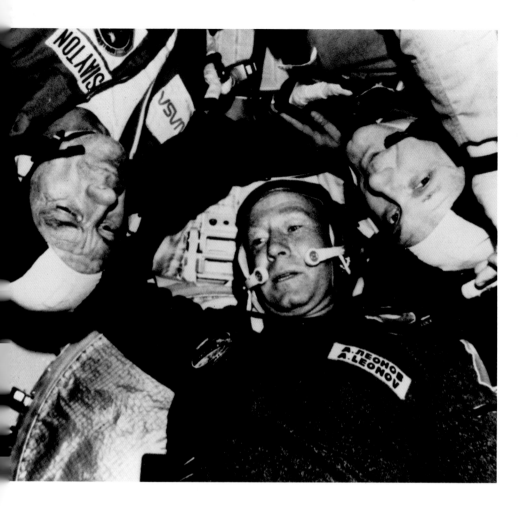

A Laboratory in the Sky

In July 1975, the US and the USSR flew a joint Apollo-Soyuz mission, in which the two spacecraft docked in a symbolic act of détente, fulfilling at last President Kennedy's wish for the two nations to pool their resources. In the months and years after the end of Apollo, both nations developed Earth-orbiting space stations – NASA's Skylab and Moscow's Salyut. Salyut and its successors, Almaz and Mir, greatly increased our understanding of long-term life in space, and Soviet technologies were at the heart of the International Space Station, a joint project by the US, Russia, Japan, Canada and the 11 European nations which fund the European Space Agency (ESA).

Above: US and USSR astronauts after a successful rendezvous in the 1975 Apollo-Soyuz Test Project
Right: Yang Liwei became the first Chinese astronaut, on board Shenzhou 5 in October 2003

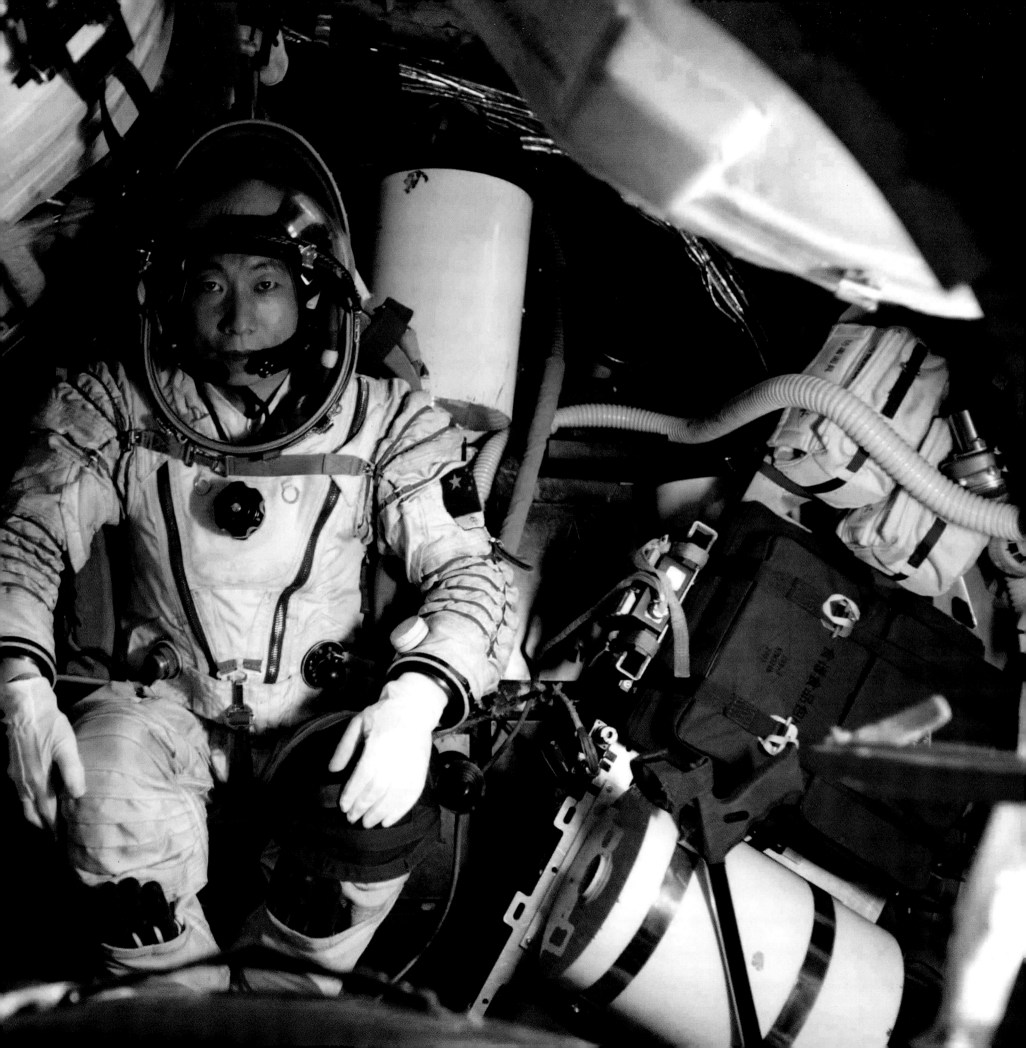

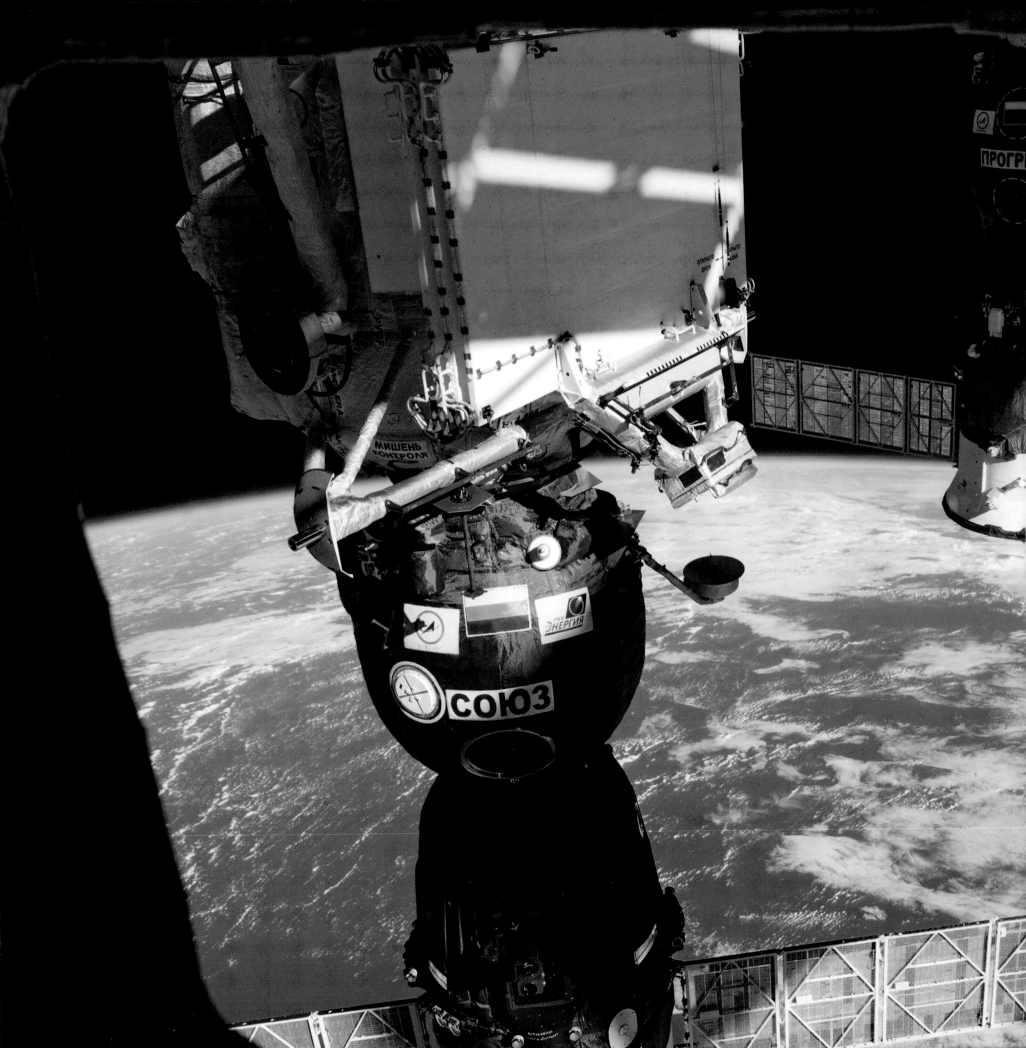

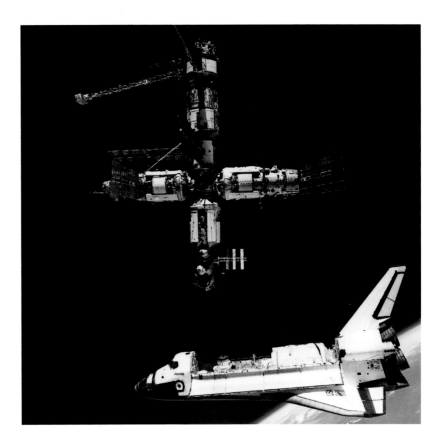

Above: Space shuttle Atlantis leaves Mir space station in 1995 after delivering its new Russian crew
Left: The ISS in orbit over Miami, Florida

Construction of the ISS began in 1998 and new components are still being added. Currently measuring around 108 m (354 ft) long and 72 m (236 ft) wide, it is often visible from Earth as a bright dot. It takes about 10 minutes to cross the sky from horizon to horizon. The ISS has been continuously occupied since November 2000 and will be in operation until at least 2028. It works as a scientific laboratory, conducting experiments in a space environment, and has hosted scientists, astronauts and tourists from 17 countries, delivered by US space shuttles (the first reusable spacecraft, which flew 135 missions between 1981 and 2011) and Russian Soyuz vehicles.

The joint venture of the ISS was made possible by the collapse of the Iron Curtain when the Cold War ended in 1989 and the fall of Soviet Communism in 1991. It is an enduring symbol of the possibility of international co-operation, despite persistent terrestrial tensions between nations.

Russia remains committed to the ISS, but is also planning a new Orbital Piloted Assembly and Experiment Complex (OPSEC, from the Russian *Orbital'nyj Pilotirujemyj Sborochno-Eksperimental'nyj Kompleks*), which will act as a staging post for lunar and interplanetary flights. It could be the first of a network of such stations enabling exploration of the whole solar system.

Earthly Benefits

NASA has generally avoided the commercial exploitation of technologies devised for space exploration, but it does make these technologies available to private industry. As the dust settled after the golden age of the Apollo missions, the main benefit to the public at large seemed to be the everyday spin-offs derived from new space technology.

To date, there have been thousands of them, including silver-foil emergency blankets and memory foam mattresses – just two examples of common materials first developed by NASA. The challenges of providing food in space drove the development of freeze-drying. Microalgae originally derived from bread mould as a way of recycling food on long space flights is now a nutritional supplement in baby formula.

Scratch-resistant spectacle lenses owe their existence to the visors of space helmets. The use of solar energy to power remote unmanned vehicles in space has resulted in cheaper, more widely available solar cells here on Earth. One of the most humanitarian spin-offs has been the development of a flare that disarms landmines – it is derived from rocket fuel left over after a launch, which solidifies and cannot be re-used by NASA.

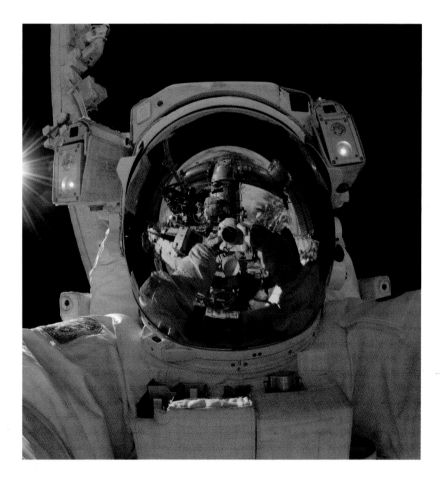

Above: Japanese astronaut Aki Hoshide takes a selfie during a spacewalk from the ISS, 2012

Above: A US soldier demonstrates a flare which uses unspent rocket fuel to disarm buried landmines
Right: NASA astronaut Jack Fischer experiments with food preservation in zero gravity on the ISS, 2017

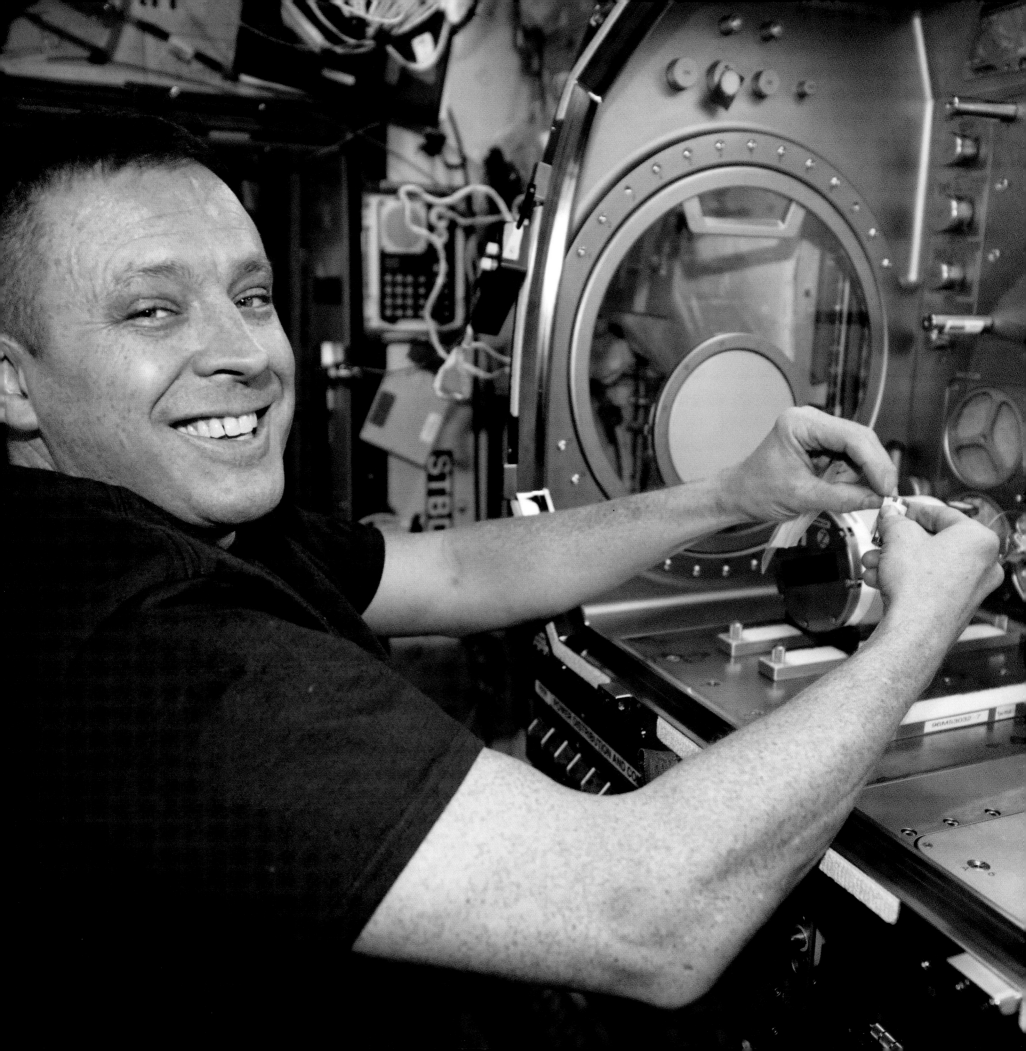

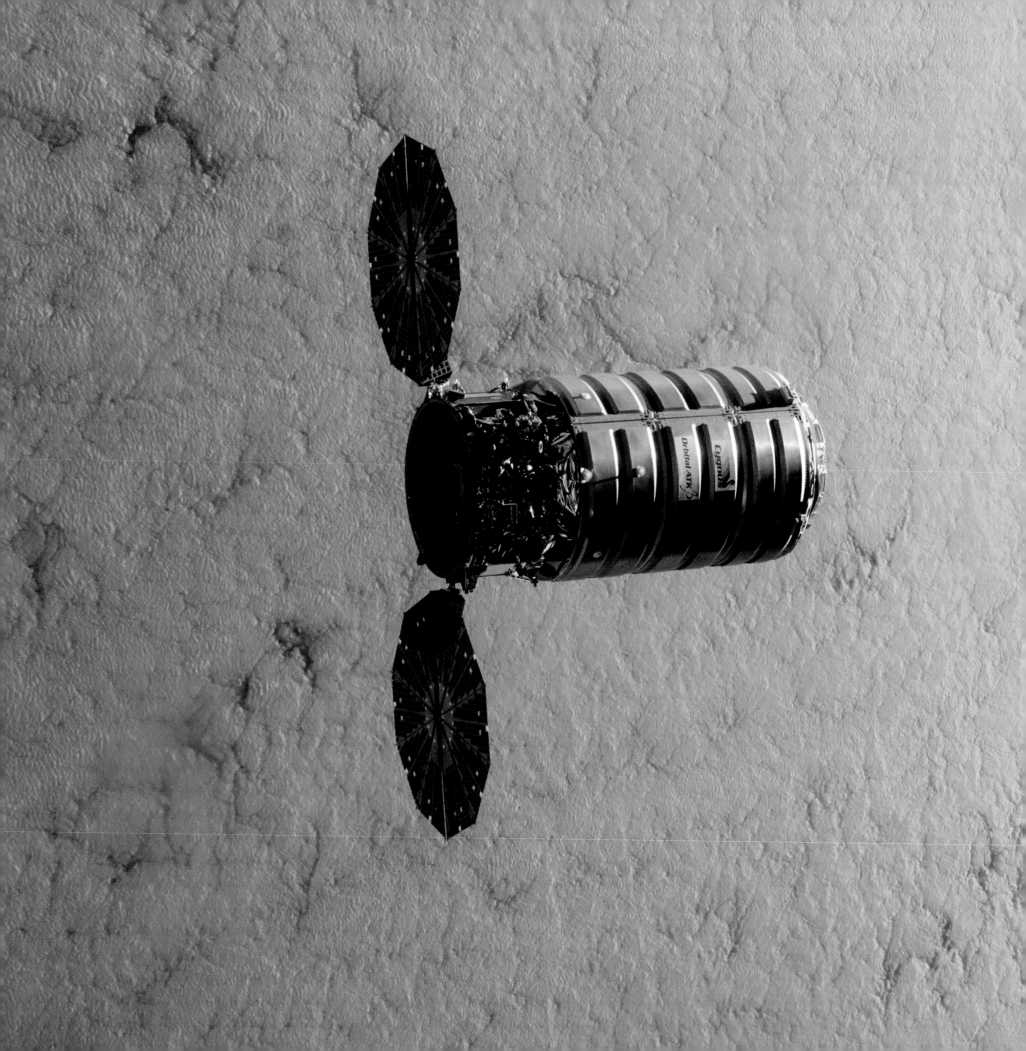

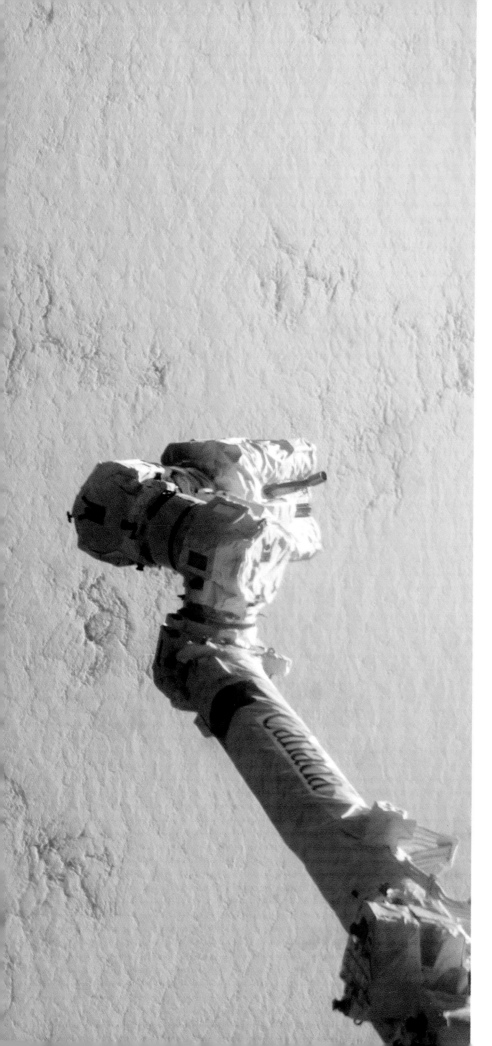

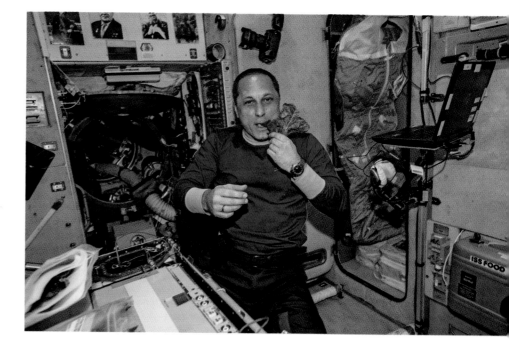

Above: *Expedition 55 Commander Anton Shkaplerov samples some lettuce grown as part of a space crop study aboard the ISS, 2018*

NASA did not invent the microchip – that honour goes to Texas Instruments – but its reliance on computers for all aspects of space exploration, from navigation to environmental analysis and control, has driven its development. The Apollo guidance computer had a memory of just 2,000 bytes, placing enormous demands on both hard- and software. From this successful early use of computers, our ubiquitous use of and reliance on pocket calculators, portable music players, social networking and smartphones has sprung. Of course, there are more serious applications of computer technology in every aspect of life in peace and war.

On the ground, NASA programmers have developed thousands of software programs which are available for industrial exploitation from its aptly named Computer Software Management and Information Center (COSMIC). One of the most popular is the NASA Structural Analysis Program (NASTRAN), which has found commercial uses in the design of everything from fairground rides to automobiles.

Left: *The ISS's robotic arm prepares to capture a cargo vessel delivering supplies for scientific experiments, 2015*

Discovering Earth

Astronaut William Anders has said, 'We came all this way to explore the Moon, and the most important thing is that we discovered the Earth.' Amidst all the spin-offs and the continued exploration of our solar system in the twenty-first century, one photograph had more impact than any other image or any other aspect of the Apollo program. Bill Anders' view of Earthrise in 1968 was profoundly affecting for the perspective it gave us of our home (*see* page 118).

Alone in a Dark Universe

It was the first time we had seen our big old world as a whole (albeit half in darkness), and suddenly it did not look so big. From the Moon, Earth looked rather small, and lonely, and fragile. Alexei Leonov, who first walked in space, reported that 'the Earth was small, light blue, and so touchingly alone, our home that must be defended like a holy relic'. Neil Armstrong remarked, 'I put up my thumb and shut one eye, and my thumb blotted out the planet Earth. I didn't feel like a giant. I felt very, very small.'

We already knew that the cosmos was huge, perhaps even infinite; but for most of us on Earth, the canopy of stars at night was little more than the rather beautiful tent under which we lived. With Earthrise, and the Blue Marble photograph taken by Jack Schmitt during Apollo 17 in 1972, we at last understood our humble place in the universe – small, insignificant and vulnerable.

Running parallel to the Apollo program in the 1960s was the rise of counterculture, the Hippy Movement, which adopted a concern for the environment. Earthrise and Blue Marble drew attention to the unity of our planet: inescapably, we all lived in the same world. No borders were

Left: Astronaut William Anders suits up ahead of the Apollo 8 mission, 1968
Right: Antarctica and Africa seen from Apollo 17, the last manned Moon mission to date, 1972

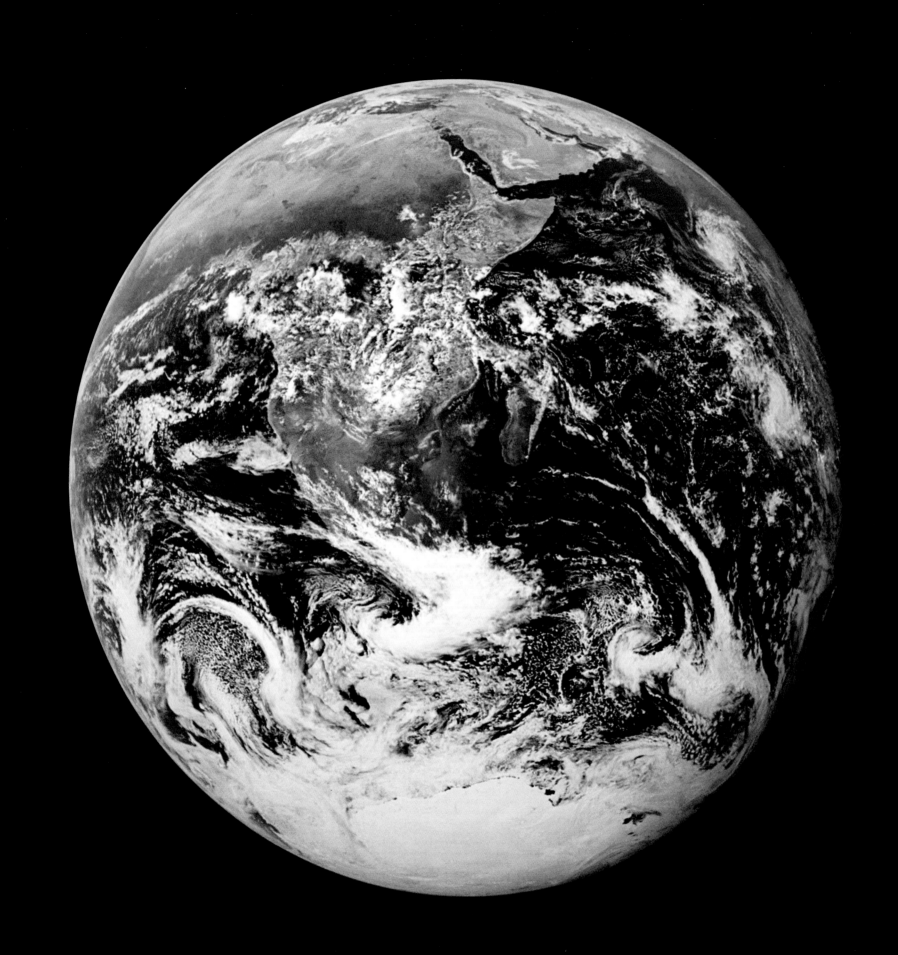

Above: The 1967 wedding of activists Abbie Hoffman and Anita Kushner – hippy counter-culture embraced environmentalism

visible from space, only land, sea and weather. And there was nowhere else like it. This was surely something for which we should take more responsible care?

As a direct result of 1968's Earthrise image, environmental campaigning organization Friends of the Earth was founded in London in 1969. After a deadly oil spill in Santa Barbara, California in 1969, US activists designated the first Earth Day in 1970. It is now celebrated annually on 22 April in nearly 200 countries. The Moon landings have encouraged us to take more responsibility for our own space object, the world. Fifty years after Apollo 11, Green parties are in the mainstream of European politics.

Left: Environmental campaigners in New York ahead of the first ever Earth Day, 20 April 1970

Peace on Earth

Rockets were developed for warfare, and most of those involved in space missions have been developed from frighteningly powerful intercontinental ballistic missiles. Ronald Reagan's Star Wars proposals and the USSR's military space stations raised fears that space, previously untainted by humanity, would become just another battleground for man's aggressive instincts.

However, the plaque left on the Moon by Apollo 11 reads: 'We came in peace for all mankind', and the Apollo generation who espoused environmental activism was also the draft-dodging generation who espoused peace. Astronaut after astronaut returned to Earth to speak with wonder of our world, fuelling a sense of the pettiness of conflict on Earth. Ron Garan, who fought in the Gulf War before becoming an ISS astronaut, said, 'Earth is a small town with many neighbourhoods in a very big

universe.' Sadly, we still fight wars, although more often against terrorist movements than with ideologically opposed nations. Are we the only neighbourhood in the universe to resolve our differences so violently?

The Moon in Popular Culture

From the earliest days of the Space Race, the public's imagination reflected its fascination with what was Out There in the universe. Science fiction already existed; the threat of Communism was metaphorically portrayed in horror films about aliens from outer space. But now there was something approaching science fact, an almost-reality, however imperfectly conceived and portrayed in film, fashion and song.

Above: President Reagan, First Lady Nancy Reagan and the crew of space shuttle Columbia after its final test flight, 1982
Right: Environmentalists protested against nuclear power, here at a huge rally in New York's Battery Park, 1979

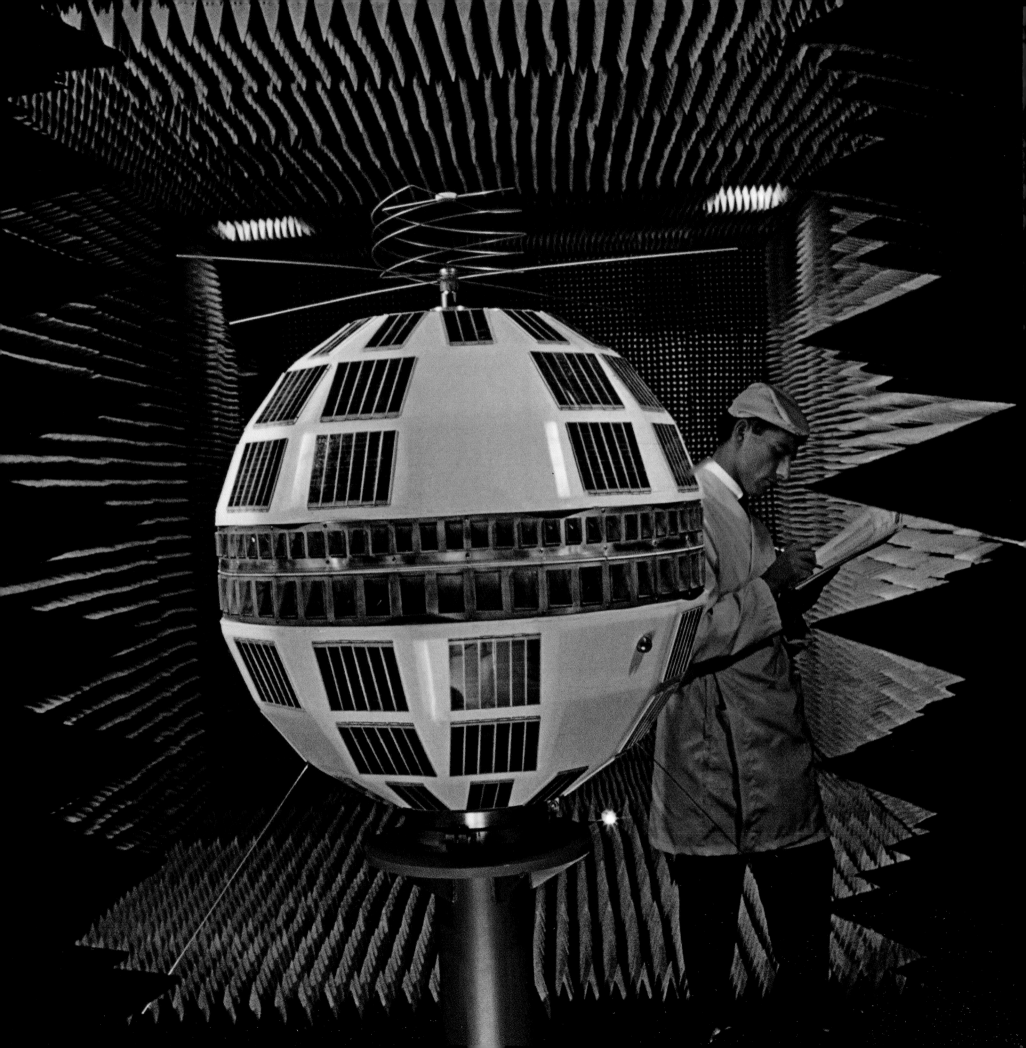

Telstar, a communications satellite launched in July 1962, inspired the Tornados' hit of the same name, which topped the charts on both sides of the Atlantic in December that year. Its unearthly instrumentation – not guitars or wind instruments, but a strange-sounding keyboard setting – paved the way for synthesizers and electronic music. Musicians experimented with computers to see if they could compose their own tunes.

Even Frank Sinatra got in on the act in 1964, when he covered an old song popularized in 1960 by Peggy Lee called 'Fly Me to the Moon'. And where would David Bowie have been without 'Life on Mars?' and 'Space Oddity'?

On TV, space was the perfect setting for fantasy. British children of the 1960s remember with fondness Bleep and Booster, the characters of a cartoon strip on the BBC's magazine programme 'Blue Peter'; and the stop-motion creatures the Clangers, who lived on a moon-like planet and made their debut in 1969. Puppeteers Gerry and Sylvia Anderson gave us a string of space-age series, including 'Fireball XL5' in 1962 and 'Thunderbirds' from 1964 to 1966.

On film, space became a plot element even in earthbound franchises such as the James Bond movies. *You Only Live Twice*, with its Gemini capsule kidnaps, was released in 1967. *Moonraker* was conceived in 1969, but postponed after Gerry Anderson turned down an invitation to write the script. It was eventually released in 1979 with a plot about the space shuttle, in the wake of the phenomenal success of the space epic *Star Wars*.

Clothing fashion, always at the forefront of modernity, seized on space suits for inspiration. It adopted new materials such as PVC, and new items of clothing like helmets, visors and, of course, moon boots. Fashion and film came together in the 1968 film *Barbarella* starring Jane Fonda as a forty-first-century emissary to space from the United Earth government, in futuristic costumes designed by the Spanish fashion icon Paco Rabanne.

Above: David Bowie, whose hits 'Life on Mars?' and 'Space Oddity' soundtracked the Space Age
Left: A technician checks antennae on a mockup of a Telstar communications satellite, early 1960s

New Horizons

The Apollo program was a golden age of space exploration and the Moon landings milestones in the history of mankind. It is often tempting to look back at a golden age with nostalgia as something unrepeatable; but it could be argued that we are entering a second stage of space exploration every bit as exciting as the first.

Interplanetary Exploration

Russia and the US continue to send probes to the edges of the solar system and beyond. More were sent to Mars in 2018 than ever before, and NASA aims to land a human on the red planet by 2037. Russia's Venera series and NASA's Pioneer craft have both landed on the surface of Venus. Galileo was NASA's Jupiter mission, and Messenger its first look at Mercury. Pioneer

Above: *One of the USSR's Venera probes being prepared for launch and landing on Venus, 1978*
Right: *An artist's impression of NASA's InSight lander, which landed on Mars in November 2018*

probes have also looked at Saturn, as did Voyager and a joint NASA/ESA project called Cassini. 2018 closed with NASA's New Horizons probe executing a fly-by of Ultima Thule, an object in the Kuiper Belt on the outermost fringes of our solar system, a billion miles beyond Pluto. The Kuiper Belt consists of unaltered debris left over from the formation of the solar system over four billion years ago.

Most plans for interplanetary flight intend to depart either from an Earth-orbiting waystation or from a lunar base. The Moon therefore continues to be a place of considerable interest. In 2019, China's Chang'e 4 unmanned probe was the first to land on the dark side of the Moon, from which future departures to outer space and transmissions from the universe will be more easily dispatched and received.

Space Tourism

Space travel is still beyond the reach of most ordinary people, but now – for the very wealthy – a space tourism industry is emerging. The price has

Above: Virgin Galactic's VSS Unity during its suborbital test flight in December 2018
Left: China's lunar lander Chang'e 4 on the dark side of the Moon, 11 January 2019

fallen, from up to $40 million for early trips to the ISS (for which eight people paid) to a mere $250,000 for places on the forthcoming services of Virgin Galactic and Blue Origin.

Above: *British entrepreneur Richard Branson in a replica of the Virgin Galactic commercial spacecraft in 2012*

It is one of the ideological ironies of the Space Race that both the winner and the loser took part thanks to public funds being invested and managed by centralized government. Now that the Soviet Union has fallen, it is private enterprise in Russia that accounts for most of the world's private space flights and America for very few. ESA also carries some paying passengers, and China entered the market in 2018.

NASA has always outsourced the building of its spacecraft to established commercial aerospace companies like Boeing and McDonnell Douglas. Now there is a new and serious player in the field, the maverick South African entrepreneur Elon Musk, who made his fortune with internet companies like PayPal and invested it in his company SpaceX. Formed in 2002, SpaceX makes regular supply runs to the ISS, reducing costs substantially by developing its own Falcon rockets and Dragon spacecraft.

Left: *Elon Musk presents his vision of a Mars colony to the International Astronautical Congress, 2017*
Right: *Elon Musk introduces SpaceX's Dragon V2 spacecraft, scheduled for manned flight in June 2019*

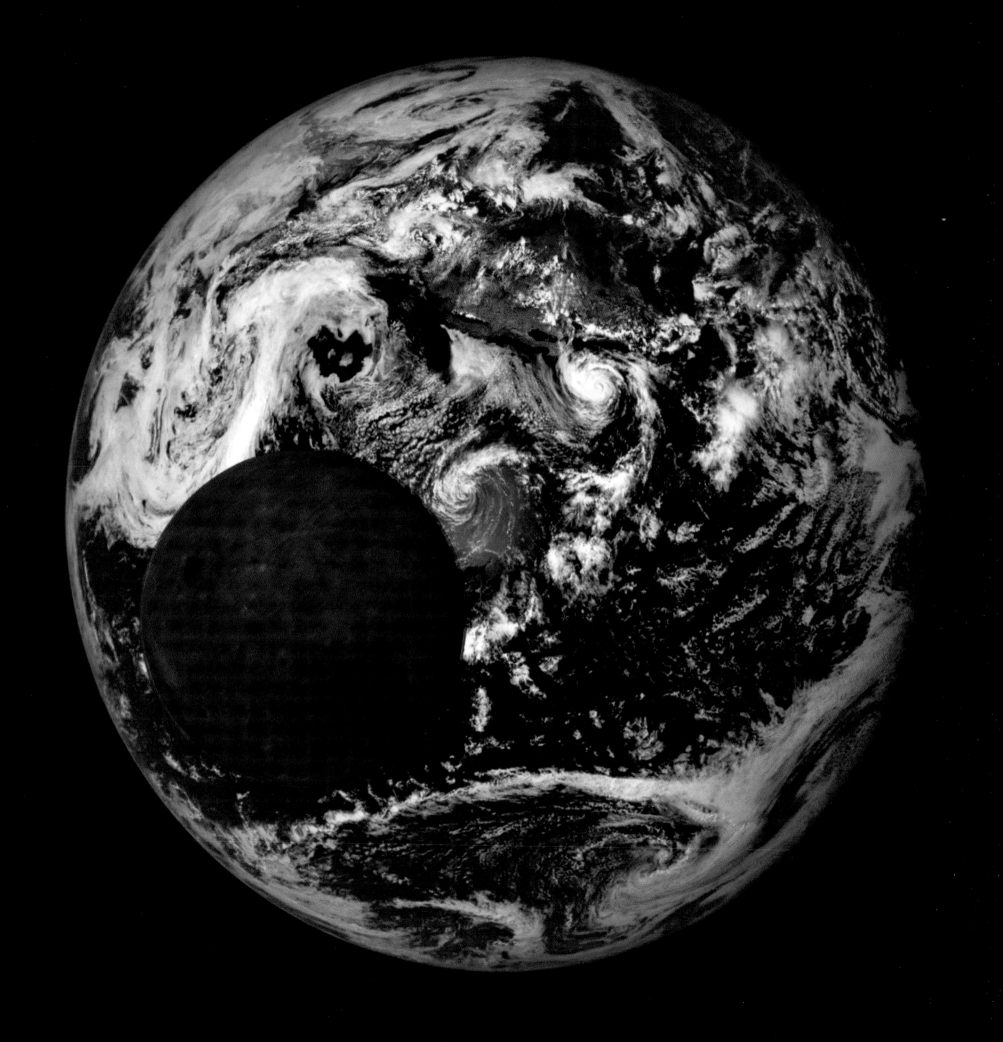

Musk's ambition is to revive public excitement about space travel. To that end, he spoke at the 2017 International Astronautical Congress in Adelaide, unveiling a detailed timetable for establishing a colony on Mars. He aims to land two unmanned cargo vessels on the planet in 2022, some 15 years ahead of NASA's earliest proposed manned mission to the planet.

Looking Back, Looking Forward

Neil Armstrong is quoted as saying, 'I fully expected that, by the end of the century, we would have achieved substantially more than we actually did,' and towards the end of his life, Gene Cernan, who flew on Apollo 17, complained, 'I'm quite disappointed that I'm still the last man on the Moon.' The first and the last man to walk on the Moon considered that, as Cernan

said, 'we have sacrificed space exploration for space exploitation, which is interesting but scarcely visionary'.

For both men, and for all the astronauts of the Apollo missions, it was the greatest achievement of their lives, and it did seem for a while after Apollo as if the US had given up on any further lunar ambitions. 'I find that mystifying,' said Armstrong. 'It would be as if sixteenth-century monarchs proclaimed that "we need not go to the New World, we have already been there".' As he pointed out, the parts of the Moon visited by the Apollo landings amount to no more than the area of a small town. 36,259,834 sq

Above: The first man on the Moon, Neil Armstrong, greets the last, Gene Cernan, in 2011
Left: The Earth and Moon from NASA's GoreSat satellite, launched on a SpaceX Falcon 9 rocket, 2015

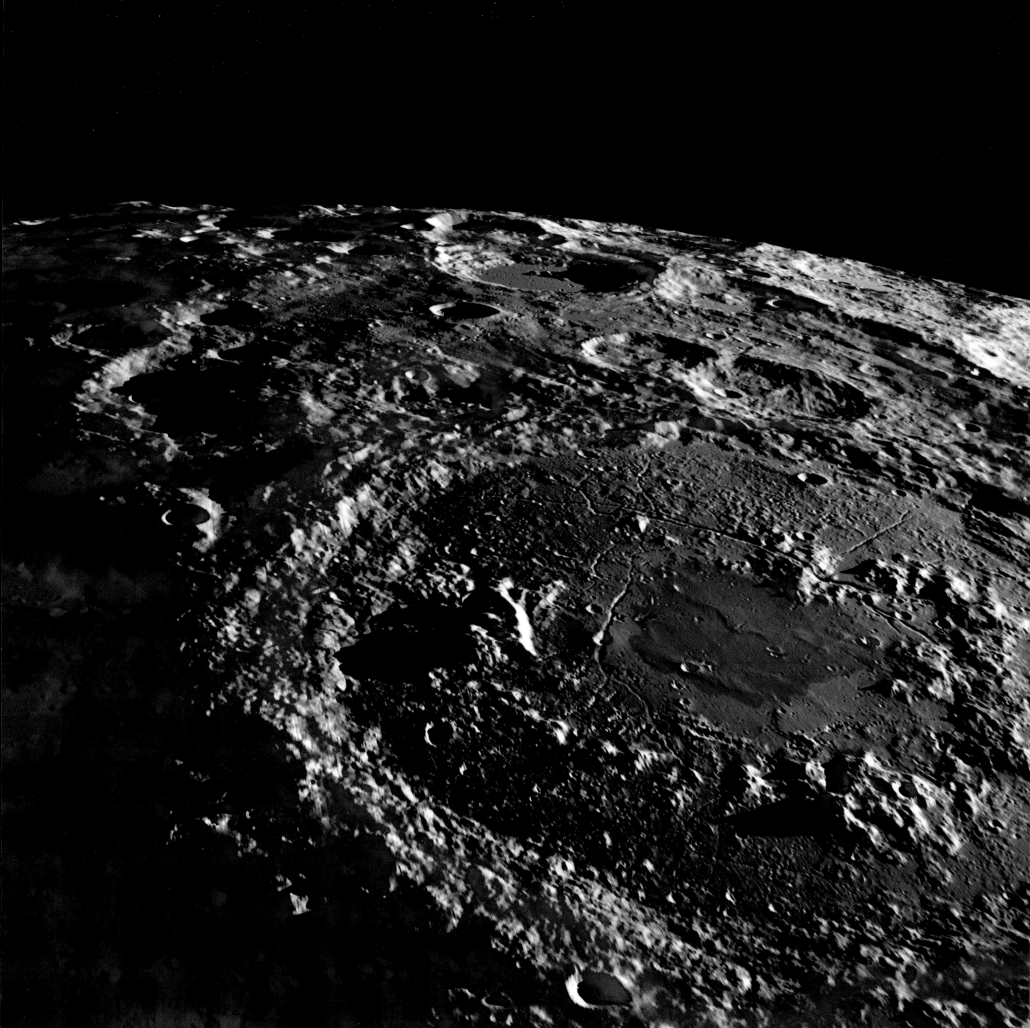

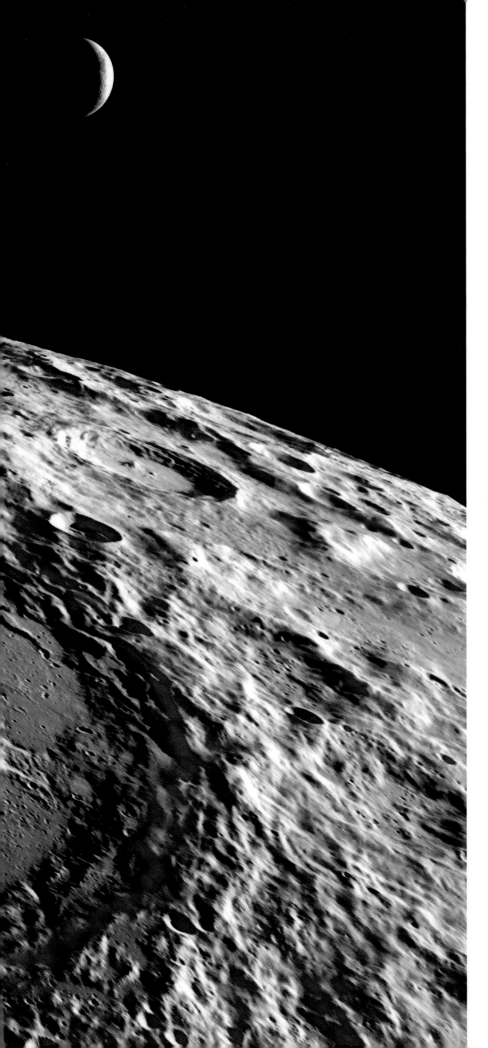

km (14,000,000 sq miles) of the Moon's surface remain to be explored. Today, however, there is renewed interest in the Moon, our only natural satellite. Geologically, it has much to teach us about the origins of our own planet. Physiologically, it regulates the cycles of our bodies and our seas, and perhaps even more than we yet understand. With its thin atmosphere and low gravity, it is a much more suitable place than Earth from which to launch interplanetary spacecraft.

We would not be fully human if we did not seek to satisfy our curiosity about the influence and potential of such a large landmass so close to our own. And so, despite the concerns of Armstrong and Cernan, the legacy of Apollo is alive and well 50 years after that curiosity was first, and only partially, satisfied. Where in the universe will we go in the next 50 years?

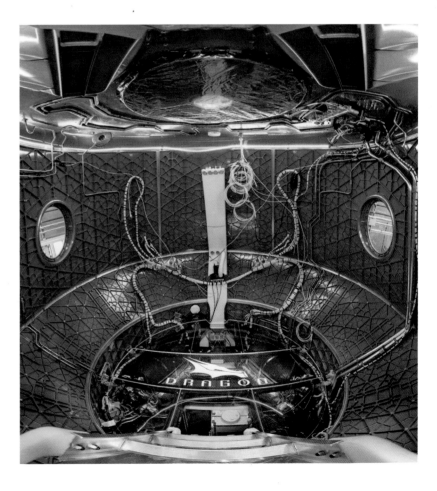

Above: The interior of SpaceX's Environmental Control and Life Support System (ECLSS), built to test the life support systems for the Crew Dragon spacecraft, 2016
Left: Regional variations in the Moon's gravity – here shown low (purple) to high (red) – affect lunar orbits

Index

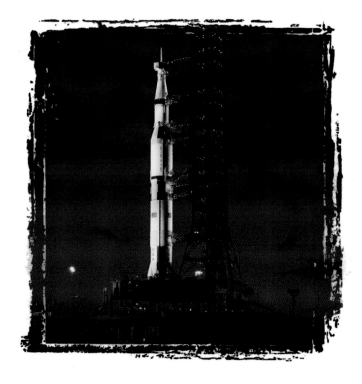

Full Moon before dawn on 9 November 1967, launch day for the unmanned Apollo 4

For further illustrated books on a wide range of subjects,

in various formats, please look at our website:

www.flametreepublishing.com